MAKING COLOR SING

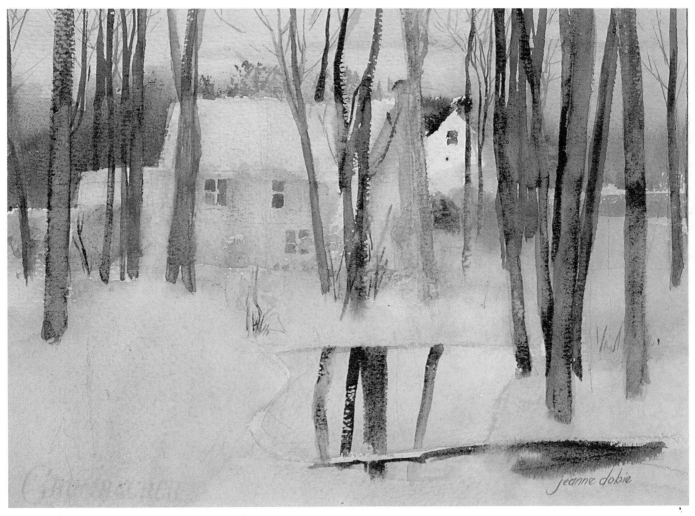

WINTER SUNSET
watercolor on Arches 140 lb.
cold-pressed paper, 11″ × 15″ (27.9 × 38.1 cm),
collection of Mr. and Mrs. Robert Rainey.

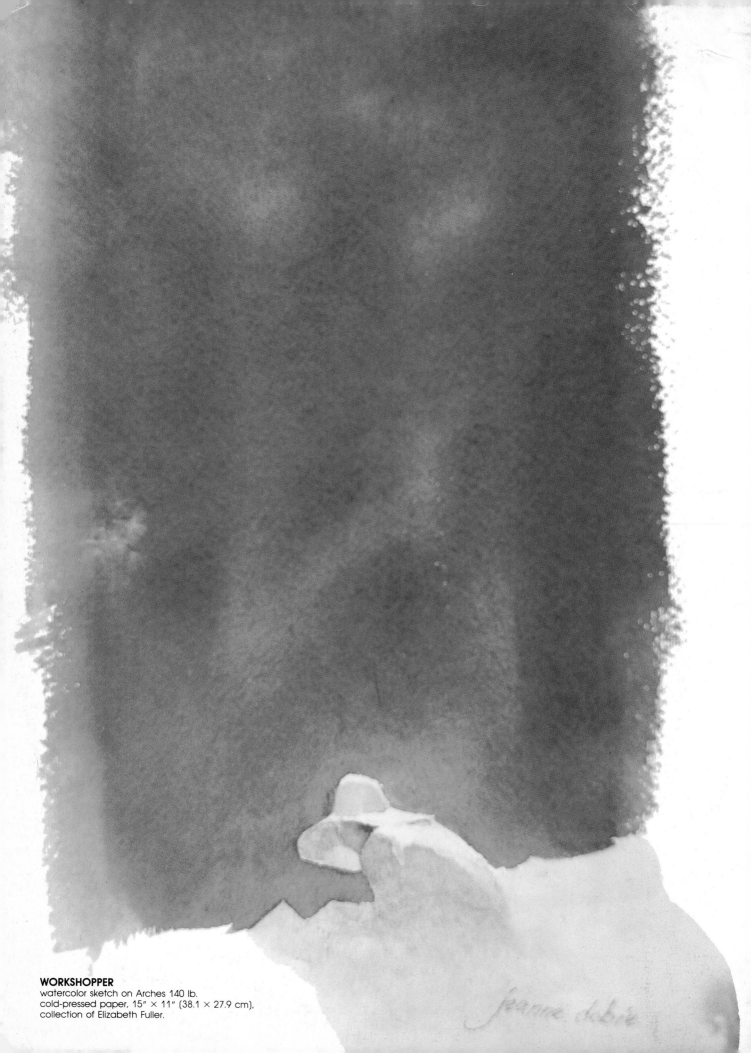

WORKSHOPPER
watercolor sketch on Arches 140 lb.
cold-pressed paper, 15" × 11" (38.1 × 27.9 cm),
collection of Elizabeth Fuller.

MAKING COLOR SING

JEANNE DOBIE, AWS

WATSON-GUPTILL PUBLICATIONS / NEW YORK

All rights reserved.
Published in the United States by Watson-Guptill Publications,
an imprint of the Crown Publishing Group, a division of
Random House, Inc., New York.
www.crownpublishing.com
www.watsonguptill.com

WATSON-GUPTILL is a registered trademark and the WG and
Horse designs are registered trademarks of Random House, Inc.

Originally published in the United States by Watson-Guptill
Publications, an imprint of Crown Publishing Group, a division
of Random House, Inc., New York, in 1986.

Library of Congress Control Number: 2010924462

ISBN 978-0-8230-3115-3

Printed in China

Design by Bob Fillie

10 9 8 7 6 5 4 3 2 1

25th Anniversary Edition

ACKNOWLEDGMENTS

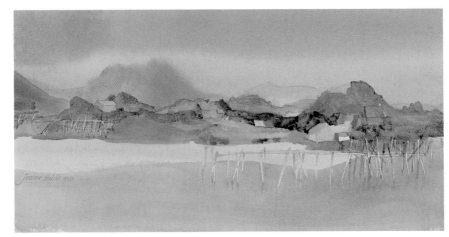

COLORS OF A RAINY DAY
watercolor on Arches
140 lb. cold-pressed paper,
7½" x 15½" (19 x 39.4 cm).

T HIS BOOK has been a project for many years and during that time some special people have helped bring it to fruition. I sincerely thank you all!

First and foremost is Barbara Millen, whose generous encouragement, help, and support never faltered throughout; Arwana Schoemer, who was responsible for launching the project; Pat Meehan, who pursued vital research; Kathy Dietsch, who donated endless hours of typing; and my husband, whose understanding was appreciated when the household did not run smoothly. My thanks also to the excellent Watson-Guptill editorial staff, especially to Bonnie Silverstein, Senior Editor, who guided the manuscript into its final form, and to Sue Heinemann, Ellen Greene, and Bob Fillie, who showcased it with great elegance.

I am honored to show the fine works of art by respected masters. My appreciation and thanks to the artists, the *American Artist* magazine, and the following museums and galleries, who made it possible for these outstanding paintings to be shared with readers of this book: Isabella Stewart Gardner Museum, Boston, Massachusetts; Vose Galleries of Boston, Inc., Boston, Massachusetts; Herbert F. Johnson Museum, Cornell University, Ithaca, New York; Memorial Art Gallery, University of Rochester, Rochester, New York; Newman and Saunders Galleries, Wayne, Pennsylvania; and Fischbach Gallery, New York.

CONTENTS

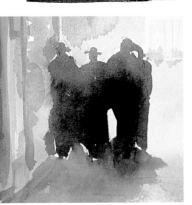

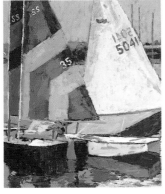

INTRODUCTION
Commitment to Excellence

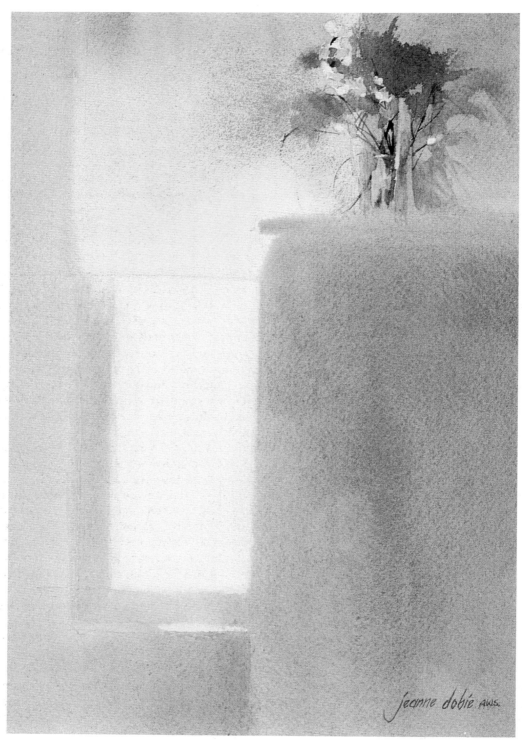

SCOTTIE'S REFRIGERATOR
watercolor on Arches 140 lb.
cold-pressed paper,
14″ × 10″ (35.6 × 25.4 cm),
collection of Antoinette Pressey.

Anything can be painted! The secret is not the subject, but how you perceive and design the shapes, values, and colors. At a workshop in South Carolina the participants were amazed at the varied subject matter: thundering waterfalls, inspiring verandas, a picturesque cotton gin, and more. On my day off, everyone wondered which location I would choose for some private painting. They were astonished that I decided to paint the refrigerator in the back room of the studio.

You CAN turn an ordinary subject—dishes in the kitchen sink or the scene from your own backdoor—into a painting if you are an artist. Do you believe that if you have a list of colors, brushes, paper, and know the painting formulas and triads, these will help you become a better artist? Actually, it would be more helpful if you could peer into the mind of a great master. How exciting it would be to know what such an artist is thinking, to understand his or her approaches, to be exposed to the imaginative insights that can make a painting come into being.

This book takes you into the elusive thinking processes that can transform an ordinary subject into an extraordinary painting. Using the brain more than the brush makes the difference! Although an image is clearly visible to the eye, it takes the mind to develop it into a rich, tangible brilliance, into an outstanding painting. Otherwise we merely reproduce mechanically what our eyes see. While teaching recently in the Midwest, I was delighted when a class sat around one morning *not* painting their landscapes. After a "mind-bender" lesson, they were engrossed in thought instead of diving headlong into their paints.

"Mind-benders" is the nickname my students have given my lessons—and for good reason. They are designed to stimulate new ways of approaching paintings; to challenge old habits, clichés, and mental blocks; in short, to exercise the mind. Unfortunately, we form our own limitations, our own boundaries. We lock ourselves into formulas, rules, triads that restrict, and by doing so, unconsciously set up barriers. Remember, the easier the formula, the less you use your mind. The less you use your mind, the less creative your painting becomes. As an alternative to rules, my lessons offer an understanding of how a painting is structured, so that you, the artist, can paint any subject, any place in the world. They provide a basis for crossing barriers and expanding beyond.

The ability to create is translated into concrete lessons, explained in plain, no-nonsense English. Essentially the book falls into two parts, allowing you to explore both color and composition in depth. I believe that these two disciplines are equal partners, equally important to the success of a painting. Unfortunately, all too often, composition is the first component to be taught and only much later are students told to "add" color. Instead, because artists respond naturally with emotion, I prefer to begin with exciting color approaches that unleash creative responses.

As you move through the initial lessons, the "mystery" of mixing color should disappear. Through using a pure pigment palette, you'll discover an array of clean, transparent mixtures. Each lesson expands your color vocabulary, from luminous grays to vibrant accents to glowing darks. There's also instruction on the art of *not* mixing (working with glazes), as well as information on color interactions and illusions. Whatever you do, don't skip the all-important "twelve shapes" lesson as a prerequisite to composing. This vital lesson shows you how to take your composition apart into shapes, values, and colors and put it together again—your way!

For me, the exhilaration of teaching is to watch talent explode into maturity. There is nothing so rewarding to an instructor as to see a class awed by the color and composition a newcomer captures and which even the pros in a workshop envy. After all, why not start from the beginning to direct your thinking into imaginative channels? Why wait until you are proficient at flowing washes and controlling other techniques? Art has very little to do with total output and a great deal to do with giving meaning and content to your painting. How many paintings you paint is not important. How well you paint them technically is not important. How thoughtfully you paint them *is*.

Have you ever wondered why some gifted artists remain just talented while others move right to the top? It is because the serious artists have dared to take that extra step—and still another step. Sadly, some artists will never be pacesetters because they are afraid to try new ideas. Don't be content to paint the same way, at the same level, relying on color triads and compositional formulas for safe, ho-hum paintings. Remember, no one begins as a winner. Dare to try new approaches to stretch your horizons!

Assuming that your goal is to become the most creative artist you can be, to distinguish yourself from the masses, you should benefit from having at your fingertips knowledge of all the painting facets, which you can use at will to shape and form your own individual creation. I hope this book will become a constant companion as you move toward that goal—a book to refer to, to guide you, to add new challenges, and to foster your growth in years to come.

1. THE PURE PIGMENT PALETTE
Creating with a Personal Palette

MICHELLE X SEVEN
watercolor on Arches
140 lb. cold-pressed
paper, 14″ × 24″
(35.6 × 70 cm).
Pure pigments make for unlimited color possibilities. You can create subtle colors or dynamic ones. Try choosing colors that convey the character of a scene, heighten a mood, intensify an emotion, or reflect your own personal response.

GETTING to know as much as possible about pigments and their "personalities" is important to any artist, and even more so to a watercolorist. Pigments, like people, have different idiosyncrasies. Some perform well in certain jobs and not at all in others. Take the time to become acquainted with your pigments. They can be your friends or enemies, depending on how well you know their characteristics.

Several years ago I was surprised to overhear an experienced artist remark, "I ran out of cadmium red. Oh well, I'll use alizarin crimson. One red is as good as another." Wrong! Cadmium red is a warm red; alizarin crimson is a cool red. Cadmium red is semi-opaque, while alizarin crimson is transparent. Alizarin crimson is also a staining pigment—if you make a mistake, it is there forever.

Color involves much more than the name on the tube. Learn to distinguish the behavioral differences of pigments. Not all pigments are transparent, not all are equal in intensity, not all have "carrying power," not all are permanent, and not all can be corrected. Most important, not all pigments mix well.

CHOOSE PURE COLORS

Liquid, fresh color that does not become opaque or "muddy" is what we seek. Contrary to common belief, this result does not depend wholly on the use of transparent pigments. My secret is the use of pure color pigments. By this I mean pigments without any color additives and as close to the raw state as possible. The illustrations on the next two pages show my personal color choices, selected for the greatest mixing possibilities.

A pure pigment palette gives you more control over your color mixtures. You have at your command raw, potent pigments that will mix into any color imaginable. Gone is the frustration of struggling with a pre-mixed commercial color that you can't seem to make vibrant enough.

If glowing, unsullied color does not make you enthusiastic about a pure pigment palette, here are some other advantages. With a knowledge of mixing, you no longer need to purchase a large assortment of tube paints. Because of their mixing versatility, you can take pure pigments with you anywhere in the world and capture the unique lighting of any location. How else could you portray the delicate pink sunsets of the Algarve or the penetratingly rich, stained-glass shades of the Nordic fjords?

FREEDOM FROM FORMULAS

Notice that my palette is uncomplicated; it leaves the mind uncluttered and free to create. The colors are simply divided into two categories: basic and occasional use. There are no triad limitations or formulas. The reason is that a triad presents the fewest options for creating.

Years ago, when I taught with triads, I found that students became entangled in the triad formulas and lost their original objective. Suppose, for instance, you want a vibrant blue in an area of your painting. But, to retain the triad formula, you religiously substitute a weaker

BASIC (TRANSPARENT)

This column contains the pure pigments that I use predominantly. All are transparent, and they mix beautifully—as you can see where I've overlapped them. With pure pigments, you don't need to purchase a large selection of tube paints. Every color is at your brushtip, just waiting to be mixed.

VIVID, STAINING TRANSPARENTS

Use these pigments full force for rich darks. Dilute them for light values or for mixtures with the basic transparent pigments.

SELECTING YOUR COLORS

AUREOLIN YELLOW (AY)

CADMIUM YELLOW (CY)

CADMIUM ORANGE (CO)

ROSE MADDER GENUINE (RMG)

CADMIUM RED (CR)

COBALT BLUE (CB)

FRENCH ULTRAMARINE BLUE (FU)

VIRIDIAN (V)

ALIZARIN CRIMSON (AC)

LIGHT RED (LR)

INDIAN RED (IR)

WINSOR BLUE (WB)

RAW SIENNA (RS)

WINSOR GREEN (WG)

BURNT SIENNA (BS)

OCCASIONAL USE (SEMI-OPAQUE)

These pigments can be added to a transparent pigment to obtain a particular desired color. Beware of mixing two of these pigments together, however, for the result is a heavy, opaque buildup—as you can see where the colors overlap here.

VERY OPAQUE

Indian red is in a class by itself. Because of its house-paint consistency, I use it only sparingly in mixtures.

TERTIARIES

These pigments are optional. Although transparent, they are not pure pigments. They are composed of the three primaries, so they do not mix well with other pigments and are best used alone.

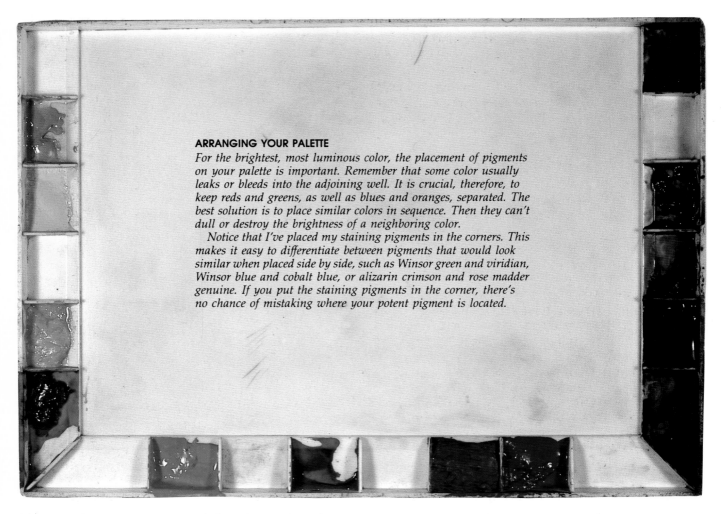

ARRANGING YOUR PALETTE

For the brightest, most luminous color, the placement of pigments on your palette is important. Remember that some color usually leaks or bleeds into the adjoining well. It is crucial, therefore, to keep reds and greens, as well as blues and oranges, separated. The best solution is to place similar colors in sequence. Then they can't dull or destroy the brightness of a neighboring color.

Notice that I've placed my staining pigments in the corners. This makes it easy to differentiate between pigments that would look similar when placed side by side, such as Winsor green and viridian, Winsor blue and cobalt blue, or alizarin crimson and rose madder genuine. If you put the staining pigments in the corner, there's no chance of mistaking where your potent pigment is located.

blue. Triads guarantee compatibility, but is that always desirable? Art is composed of contrasts—light against dark, large against small, warm against cool, the yin and the yang. Missing in a painting of compatible color are exciting interactions.

Look again at my pure pigment palette. Without becoming confused or restricted by rules about which color belongs with which, you can begin immediately with the "basic" colors and paint all the way through to darks.

TRANSPARENT OR OPAQUE?

As you explore the personalities of your pigments, you'll discover why some colors are more helpful than others in achieving your goals. Are you, for example, interested in capturing the effect of light, which is an inherent potential of watercolor? This illusion is best expressed through transparent pigments. Because transparent colors permit the greatest amount of light to pass through to the paper, reflecting back to the viewer, they impart luminosity. Moreover, they remain transparent when mixed together—so there's no mud! This is why I use the transparent pigments in the "basic" column as much as possible, especially in beginning a watercolor.

If you begin a watercolor with opaque pigments, you'll lose the effect of light. Opaque pigments are denser and heavier, which greatly reduces the amount of light transmitted through to the paper. Due to this "thickness,"

an opaque pigment does not mix well with another opaque color. It only becomes thicker! If you mix two opaque pigments together, you are flirting with a muddy mixture. Should you mix three opaque pigments together, the result may be too lifeless to call a watercolor.

With so many disadvantages, you may wonder why I include opaque pigments in my palette at all. I list the opaque pigments in the "occasional use" column with the hope that they will be considered separately from the basic palette. Although inadequate for many jobs, I find them indispensable in mixing certain colors, chiefly the green mixtures. When I use an opaque pigment for mixing, however, I combine it with a transparent pigment whenever possible. In this way I try to avoid the thick blanket built up by two opaques, where the light can't penetrate to the paper. Occasionally, of course, I may use an opaque pigment alone.

PIGMENTS THAT STAIN AND REMAIN

"Stain and remain" is the catchy phrase that helps my students remember the personality of the stronger transparent pigments: alizarin crimson, Winsor blue, and Winsor green. Although transparent, these pigments are tenacious—they stain and remain in the paper. They are also powerful—almost twice as powerful as other pigments.

To counteract this power when mixing the staining transparents with other colors, the secret is to generously

dilute them. I suggest starting with the weaker pigment and adding the stain a little at a time rather than vice versa. If you blend in reverse, you waste a lot of paint, for the staining pigment continues to dominate the mixture. On the other hand, undiluted, the enormous strength of these colors makes them an excellent choice for darks that are both rich and transparent. And if you need a special brilliant effect, a staining pigment will do the job!

AIM FOR CARRYING POWER

Just because a pigment is transparent, don't assume it will mix cleanly or look glowing and vibrant. Find out about its personality first. At the bottom of the "occasional use" column on page 11 are two tertiary pigments: raw sienna and burnt sienna. Both are transparent, but each is best used alone. Because tertiaries (the umbers and siennas) are not pure pigments, they do not mix well. They are composed of the three primaries, so that any color you add will be a complement of one of the primaries. Mixing two complements together produces a gray. Thus, any time you add another color to a tertiary pigment, you obtain a grayed mixture.

Also, since a tertiary color is not a pure pigment, it loses its strength at a distance. You may have used it in the past to impart a glow to the sails on boats backlit by the sun. It may come as a surprise, then, to learn that a tertiary does not have the carrying power of a pure pigment—that is, it dulls in brilliance beyond ten feet. For the greatest glow or carrying power in the sails, select a pure pigment mixture of rose madder genuine and aureolin yellow. This combination approximates burnt sienna, but it glows at a distance.

The secret of obtaining carrying power is to use pure pigments. Although important, transparency, clean water, and freshly squeezed paint are not enough. To paint glowing, vibrant watercolors, you must become familiar with your pigments' personalities. Selecting a pure pigment palette is just the start. Now you need to learn about color relationships to use your colors successfully.

BURNT SIENNA

RAW SIENNA

RMG + AY

AY + RMG

ALTERNATIVES FOR TERTIARIES

For glowing color, mix the pure pigments rose madder genuine and aureolin yellow to approximate burnt sienna and raw sienna. Because the pigments burnt sienna and raw sienna actually contain three primaries, the color dulls, resulting in a loss of carrying power. Prop the book up and step back ten feet to see the difference in carrying power in the examples here.

2. MOUSE POWER
Achieving Luminous Grays

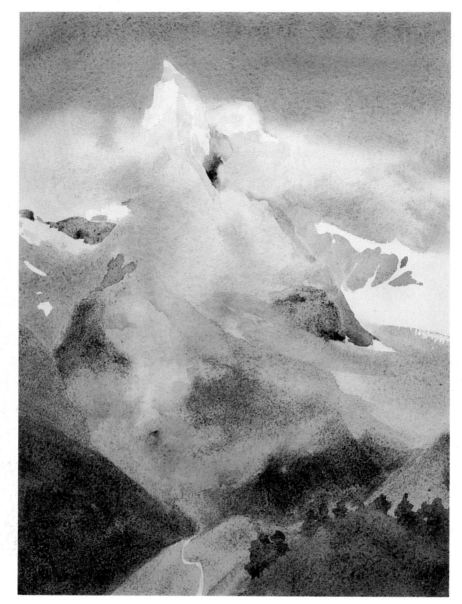

MATTERHORN MISTS
watercolor on Arches
140 lb. cold-pressed
paper, 11″ × 15″
(27.9 × 38.1 cm).
Look at your subject with imagination. Instead of painting the soft mists huddling around the mountain in dull grays, I employed mouse power. The warm grays draw attention to the focus and are accented by the purple-grays nearby. The cool blue-grays create a sense of drifting mists in the deep valley.

Colors are like jewels: each should be placed as carefully as a precious gem in a setting. The proper setting makes the jewel glow and enhances its qualities. Only when you are not conscious or aware of the setting, however, is it performing its job well, which is to remain subtle and not overpower the jewel-like colors. To form the setting, then, you need quiet, "mouse" colors in your paintings.

What is mouse power? Consider an artist who came to one of my workshops frankly admitting her frustration because her paintings were not successful. She had tried diligently to make every color as beautiful as possible. The colors would have been exquisite had each color been displayed alone, but together they did not work because each was too pretty. The viewer's eye was unable to enjoy one over the other in the confusion caused by competing colors. To complement the pretty colors, she needed unpretty colors—or what I call "mouse" colors, the nonbrilliant mixtures. Mouse colors are like the bit players who support the stars.

LEARN TO USE COMPLEMENTS

To help you develop a vocabulary of mouse color, you should understand about complements, the pigments that produce grays. From grade school on, the complements are taught as the color opposite a primary color on a color wheel (violet sits opposite the primary yellow, orange opposite the primary blue, and green opposite the primary red). But forget that. An easier way to remember the complements is this: the complement of the primary

HOW TO REMEMBER COMPLEMENTS

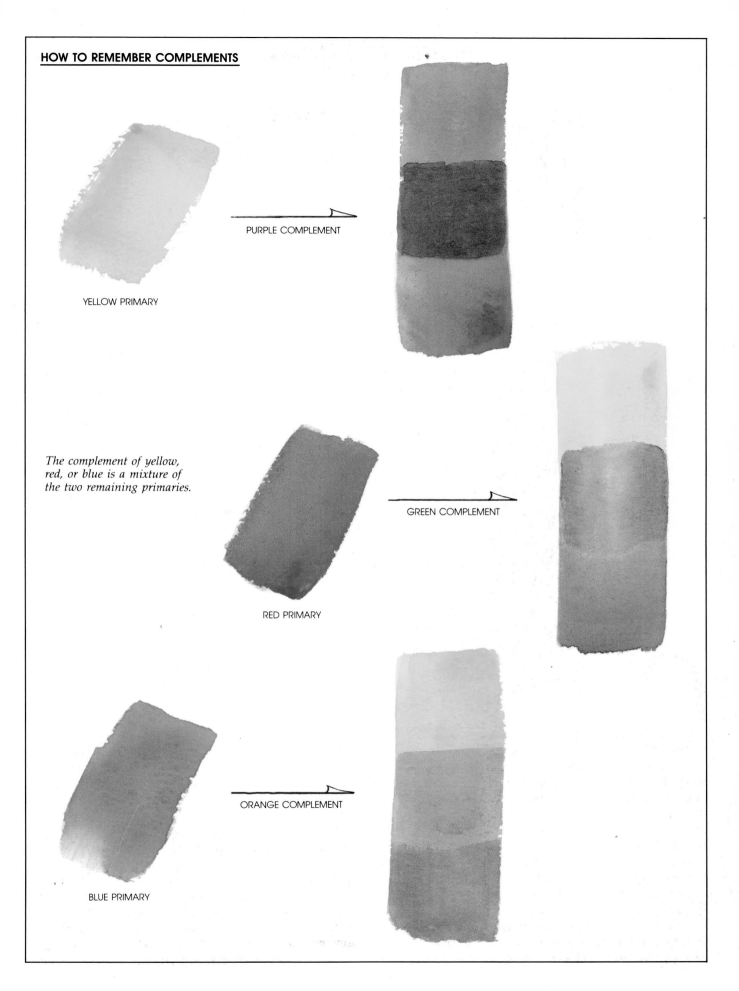

YELLOW PRIMARY

PURPLE COMPLEMENT

The complement of yellow, red, or blue is a mixture of the two remaining primaries.

RED PRIMARY

GREEN COMPLEMENT

BLUE PRIMARY

ORANGE COMPLEMENT

15

blue is simply the remaining two primaries mixed. Yellow plus red produces orange, which is the complement of blue. Try yellow next: the remaining two primaries are red and blue. Mixed together they become violet, which is the complement of yellow. The third primary color is red. Simply mix the other two primaries, yellow plus blue, for the complement, which is green. See how uncomplicated it is to know your complements.

Now let's use these complements. In the art of mixing, any time you combine a primary with its complement, the two pigments tend to "cancel" each other. In other words, they produce a gray. There is no need, then, to add purchased grays to your palette. Distinctive grays are at your brushtip waiting to be mixed. The grays mixed from the pure pigments are clear and free of sediment (not sooty). The range is unlimited and not restricted to a few tubes of "gray."

A good repertoire of grays is essential to landscape painting. The secret is to think of grays, not as neutrals, but as an entire spectrum of grays. Neutral means that a gray is not too warm, not too cool, not too yellow, blue, or red, but right in the middle, exactly mixed. You are not interested in perfecting a neutral gray. A neutral mixture is too equal to have a reaction against another color. You want to mix cool grays, reddish grays, and soft, warm grays. Strive to capture the subtle nuances that are a joy to the senses and thus avoid the lifeless, perfect neutral.

COMPARE LIFELESS AND LUMINOUS GRAYS

To discover the difference between lifeless and luminous grays, first mix an undesirable neutral gray from aureolin yellow, rose madder genuine, and cobalt blue, using equal parts of each. It requires a bit of mixing to achieve a gray that is not too warm or too cool, nor too red, yellow, or blue. Use your knowledge of your complements to achieve this result. If your mixture becomes too yellow, add more blue plus red (the violet complement) to gray

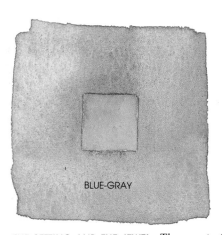
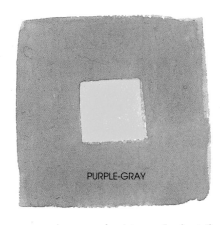
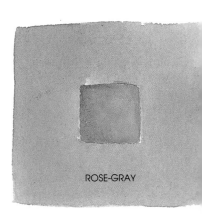

BLUE-GRAY PURPLE-GRAY ROSE-GRAY

THE SETTING AND THE JEWEL *The secret of luminous grays is unequal mixtures. Look at these squares from across the room and notice how*

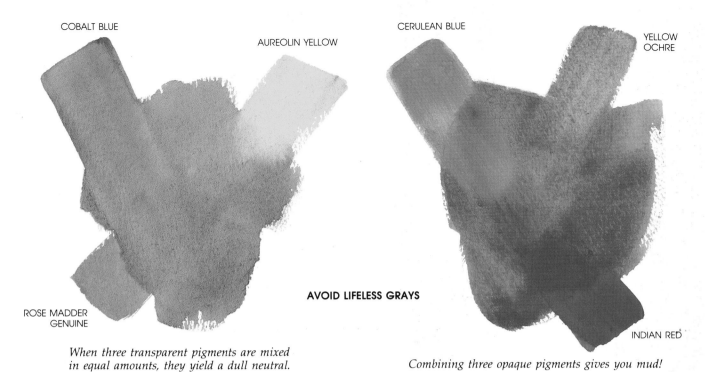

COBALT BLUE

AUREOLIN YELLOW

CERULEAN BLUE

YELLOW OCHRE

AVOID LIFELESS GRAYS

ROSE MADDER GENUINE

INDIAN RED

*When three transparent pigments are mixed
in equal amounts, they yield a dull neutral.*

Combining three opaque pigments gives you mud!

the color. Should it look green, simply add some red to cancel the green. If it turns orange, add a little blue to neutralize it.

Now let's turn that perfectly equal but neutral gray into a variety of luminous grays. The secret is to keep the ratio of pigments in the mixture unequal. Following the illustration below, we'll paint sample squares of six mixtures, although we'll leave the center of each square unpainted for the time being.

1. Begin by adding more blue pigment to your neutral gray mixture and watch it become a cool gray. Now paint a square with this first gray, remembering to leave the center unpainted.

2. Add a little rose madder genuine to the gray mixture in which the blue is dominant. This transforms it into a lavender-gray.

3. Adding still more rose madder genuine gives it a soft, warm glow, for another gray sample.

4. Now try adding yellow to produce an earthtone-gray (tan).

5. Make another sample by pushing more yellow into the gray and watch it become warmer.

6. Even more yellow plus blue gives you a cool green-gray.

Before we finish this exercise, take a moment to notice that each square is a different, subtle gray. None is neutral. By adding a little more of one color or less of another, you can mix the same three transparent pigments in different ratios for endless variations of mouse color. In addition, all the grays can be varied even further by the amount of water added. Less water for darker grays, more water for lighter grays. Beware of opaque pigments, however—especially if three are combined—for they cannot duplicate the same luminous, clear gray.

Now return to the white square left in the center. Each gray square is a setting just waiting for a color gem to

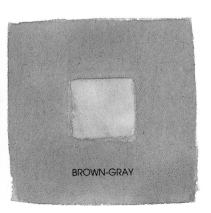

BROWN-GRAY

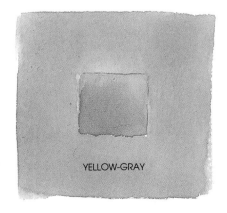

YELLOW-GRAY

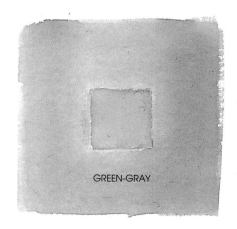

GREEN-GRAY

the centers vibrate. This is mouse power!

CURLEY'S BARN watercolor on Arches 140 lb. cold-pressed paper, 21″ × 27″ (53.3 × 68.6 cm).

be dropped into it. For your gem, select a color that is a complement of the dominant color in each gray. Start with the blue-gray square. The complement of blue is red plus yellow, or orange, so paint a luscious orange color in the square and watch the color vibrate. The purple-gray square might receive a golden jewel. The complement for the rose-gray square is a cool green. The warm, earthtone square is complemented by a true blue. Try to complete the last two squares yourself. If you choose a complement, the center color sparkles in its setting.

MOUSE POWER PROJECT

To discover how mouse power can enhance your painting vocabulary, do a watercolor using grays from each of the following categories:

1. Grays mixed from the three transparent primaries: cobalt blue, rose madder genuine, and aureolin yellow.

2. Grays mixed from complementary colors, such as viridian and rose madder genuine or cobalt blue and cadmium orange.

3. Grays diluted with water—for distant and light hues.

4. Grays that are saturated with pigment (and have very little water)—for darker tones.

These grays can be found in my painting *Curley's Barn* shown here. Remember that a predominantly gray painting is a perfect foil for a few intense color accents. Before you finish your painting, drop in some color gems, as you did in the gray square exercise, and watch them sing!

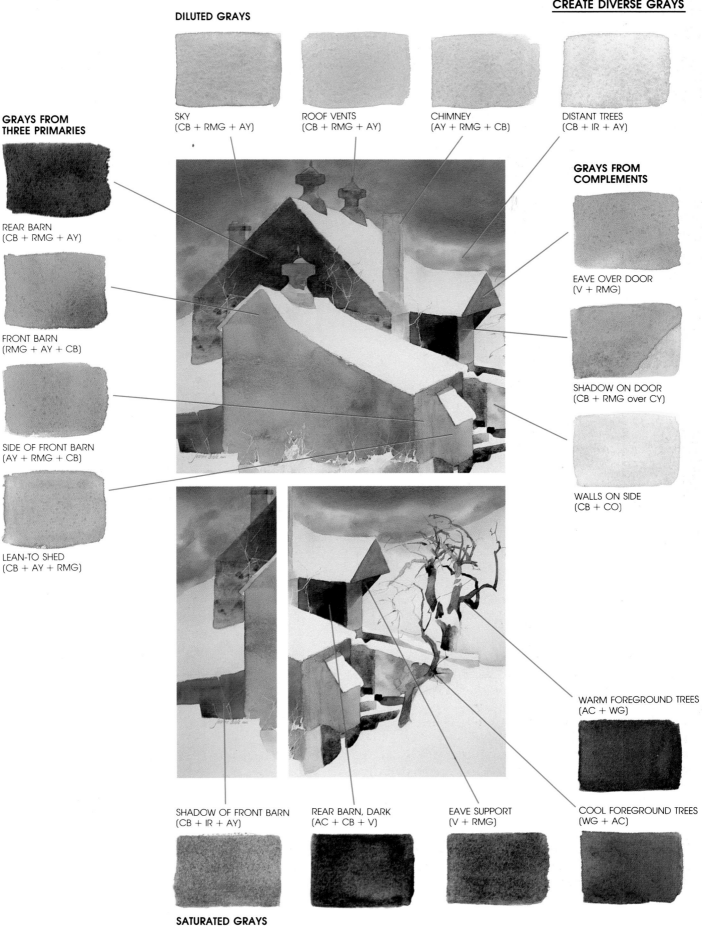

DILUTED GRAYS

SKY
(CB + RMG + AY)

ROOF VENTS
(CB + RMG + AY)

CHIMNEY
(AY + RMG + CB)

DISTANT TREES
(CB + IR + AY)

**GRAYS FROM
THREE PRIMARIES**

REAR BARN
(CB + RMG + AY)

FRONT BARN
(RMG + AY + CB)

SIDE OF FRONT BARN
(AY + RMG + CB)

LEAN-TO SHED
(CB + AY + RMG)

**GRAYS FROM
COMPLEMENTS**

EAVE OVER DOOR
(V + RMG)

SHADOW ON DOOR
(CB + RMG over CY)

WALLS ON SIDE
(CB + CO)

WARM FOREGROUND TREES
(AC + WG)

COOL FOREGROUND TREES
(WG + AC)

SHADOW OF FRONT BARN
(CB + IR + AY)

REAR BARN, DARK
(AC + CB + V)

EAVE SUPPORT
(V + RMG)

SATURATED GRAYS

3. OCTANIC COLOR
Mixing Powerful Color

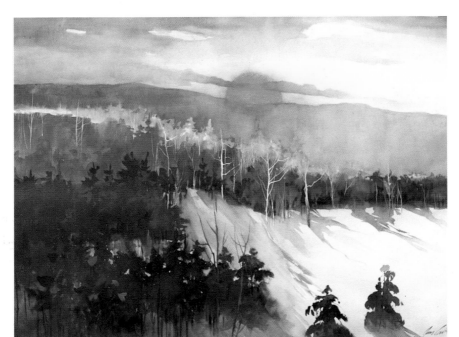

Safe isn't exciting. This painting show-cases an octanic, almost liquid, setting sun. How many of you would have toned it down? Or attempted to balance the pulsating color with additional strong reds? The artist chose to leave her interpretation unmo-lested and to bal-ance the strong color with large patterns of darks and whites.

HAVE YOU ever wanted to capture the vibrant burst of color when new blossoms emerge in the spring? In anticipation, you excitedly squeeze fresh color on your palette, make sure you have clean water, and select the most transparent pigments. Still, as you paint, you are disappointed that the flowers in your paint-ing refuse to bloom. You wish you knew how to obtain the fresh, radiant color.

"Octanic" is my expression for color with the greatest impact. Just as you use high-octane gasoline for extra performance power in your car, you often need a mixture that produces a powerful color. Mixing octanic color is a matter of selecting the right primaries for the vibrancy you want.

You may have assumed you could mix any red and blue for the bright violet flowers in your painting. But that isn't true. Some mixtures of red and blue give you a dirty purple. To capture an especially brilliant color, you must choose the primaries very carefully. Fortunately for artists, no pigment available is a perfect primary— that is, not too warm or too cool. As it is, we have prima-ries that are cooler and primaries that lean toward the warm side. You need both a warm and a cool of each primary on your palette to mix color effectively.

To discover the warm and cool personalities of the pri-maries, refer to the color circle illustrated here. Red is considered a warm color, but this is relative. Rose madder genuine and alizarin crimson, for instance, are cool reds, because they have some blue in them. On the other hand, cadmium red, light red, and Indian red are warm reds, because they lean more toward yellow than blue. With the yellows, compare cadmium yellow, which has red in it, with aureolin yellow, which is ever so slightly cool. As for the blues, cobalt blue is the color closest to a true primary, though just a bit on the cool side. Winsor blue is a cool blue, whereas French ultramarine is a warm blue, containing some red.

CHOOSE PRIMARIES FOR OCTANIC FORCE

How do you choose the correct primaries to mix a vibrant color? Let's start by mixing a violet hue (see page 22). First, select a blue pigment with some red in it, such as French ultramarine. Then choose a red pigment that leans toward blue, such as alizarin crimson. Because the blue primary contains red and the red pigment contains blue, a brilliant, octanic violet results.

But you cannot randomly choose any red or blue to get a violet that lives up to your expectations. Try mixing Winsor blue, which contains yellow, and cadmium red, which also contains yellow. The result is a disappointing grayish purple. Why? Because both primaries contain some yellow and, as you know, yellow is the complement of violet. Remember that when a complement is mixed with its primary, it cancels the intensity of the primary, resulting in a grayed color.

Now mix a bright, happy green. Choose two primaries that are free of any red color (as red is the complement of green). The best choice is aureolin yellow plus Winsor blue. Mixing aureolin yellow (which leans toward blue) with Winsor blue (which has some yellow in it) gives you a vivid green. But if you inadvertently use cadmium yellow (with some red in it) and French ultramarine blue

DISCOVER WARM AND COOL PRIMARIES

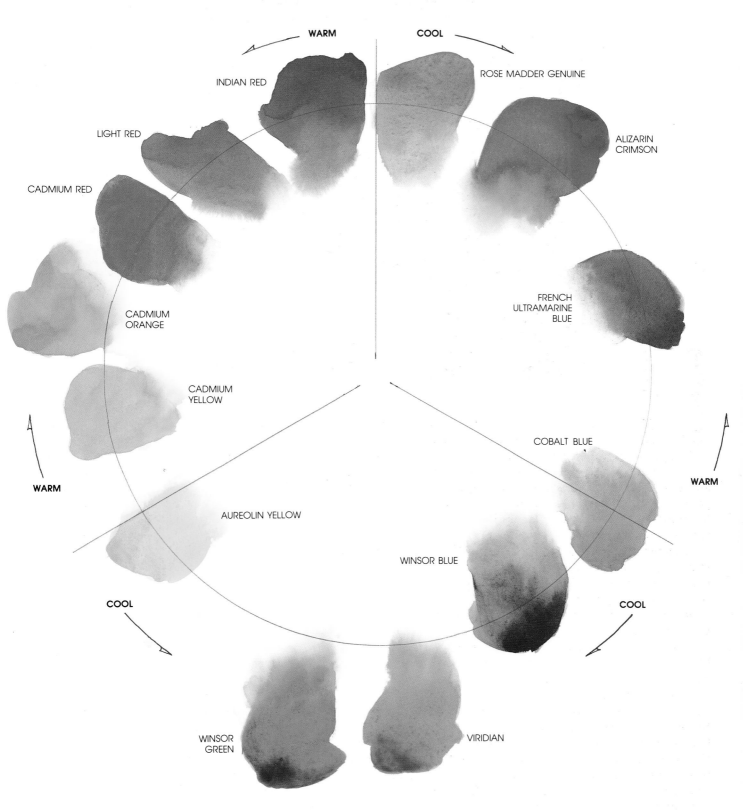

In mixing octanic colors, it is important to know if your primary borrows any yellow, red, or blue from the neighboring primary. This color circle clarifies whether a pigment is warm or cool, and also—by its position on the circle—the degree of borrowed color. You can see, for instance, that Indian red, light red, and cadmium red are all warm, but notice that Indian red, the coolest of the three, is placed near the dividing line. As the reds move toward the yellows, they gain more yellow content, with cadmium red becoming the warmest red. Observe that rose madder genuine, which is next to the divider on the cool side, is only slightly cool. Alizarin crimson contains more blue and thus is positioned closer to the blue pigments. Follow the other colors around the circle to see how much borrowed color is in each pigment.

(again with some red in it), the intensity of the green is compromised. Again, the reason is because red is the complement of green.

To obtain a clear orange is difficult and, for this reason, I include cadmium orange on my palette as a backup. For the warmest orange, mix a yellow with red in it (cadmium yellow) and a red with yellow in it (cadmium red)—both without any blue content. Since these two pigments are semi-opaque, however, the orange is not transparent. If you need a transparent orange, choose aureolin yellow with rose madder genuine. This gives you a luminous but cooler orange, due to the blue content in the pigments. The choice is yours. If, however, a lively color is your goal, avoid the coolest combination: alizarin crimson and aureolin yellow.

TECHNICAL TIPS FOR SUCCESS

With knowledge and practice, you will be able to capture the brightest bursts of color possible. Additional ways to maximize the brilliance include loading the brush with more paint and less water, painting with slower strokes, and holding the brush more nearly in an upright position.

Don't hesitate to paint intense color from the start. It is far easier to subdue a color later than to make a weak, lifeless area come alive again. When you add more paint layers over the original color, you build up thicker and denser color, losing the original, fresh glow.

There's another reason for placing the special octanic colors in your painting first. If these vivid colors are visible, then, as you continue, you will unconsciously relate succeeding colors to them. In Portugal I watched a painter leave spaces where he wanted to add vibrant red roses later. His watercolor was flawless until at long last he dropped in the luscious red pigment. He was dismayed as the roses quietly blended. The surrounding colors, which did not relate, negated the effect he had struggled all afternoon to attain. The moral of the story is: *Do not be timid.* Get that special vibrancy placed on the paper in the beginning and build the painting around it.

A final note. While it is a joy to produce these fresh, vivid colors, they can be mesmerizing. Too much glowing color in your painting can make it difficult to appreciate a special effect. Remember to balance jewel-like color with settings of mouse colors.

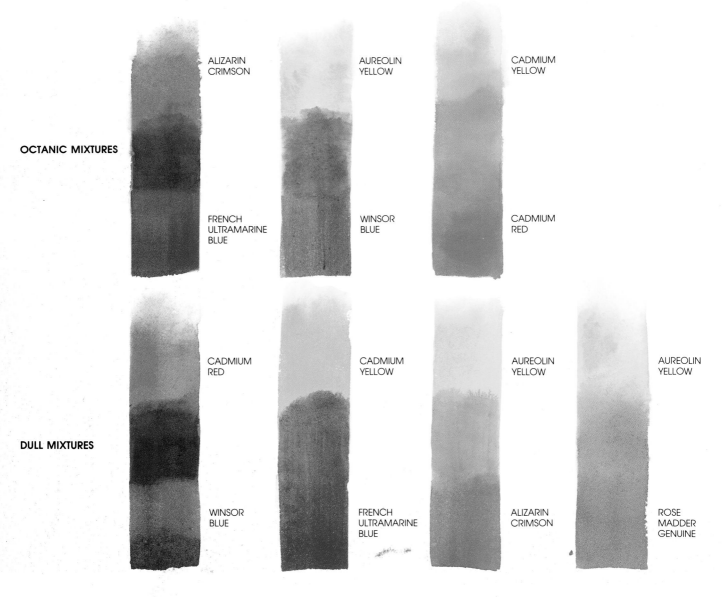

OCTANIC MIXTURES

ALIZARIN CRIMSON

FRENCH ULTRAMARINE BLUE

AUREOLIN YELLOW

WINSOR BLUE

CADMIUM YELLOW

CADMIUM RED

DULL MIXTURES

CADMIUM RED

WINSOR BLUE

CADMIUM YELLOW

FRENCH ULTRAMARINE BLUE

AUREOLIN YELLOW

ALIZARIN CRIMSON

AUREOLIN YELLOW

ROSE MADDER GENUINE

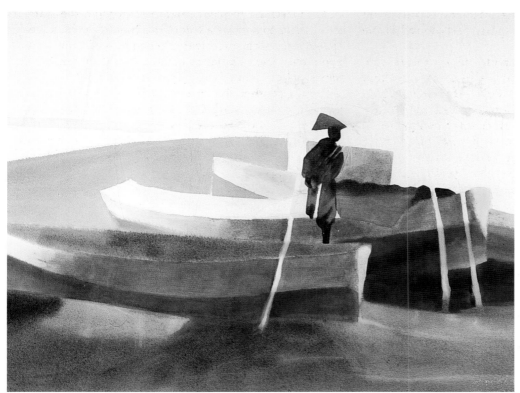

ISLAND BOATS (before)

*Find an old painting, executed
in your former palette. Repaint
it, using the pure pigments in
octanic combinations, and then
compare. The first version of*
Island Boats *shown here was
done nearly twenty years ago.
The muddy color I obtained
prompted me to abandon what
was otherwise a good
composition. The difference
octanic mixtures can make is
obvious.*

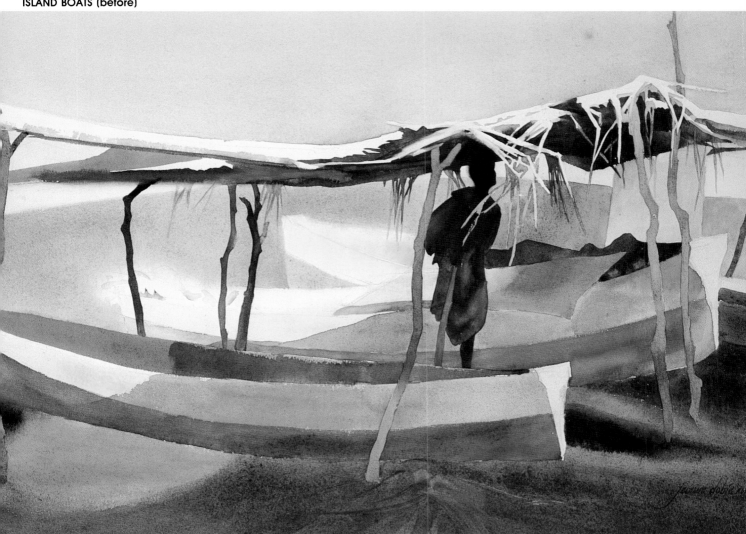

ISLAND BOATS (after) watercolor on Arches 140 lb. cold-pressed paper, 15" × 21" (38.1 × 53.3 cm).

4. GREENS, GREENS, AND MORE GREENS

Facing the Challenge of Green

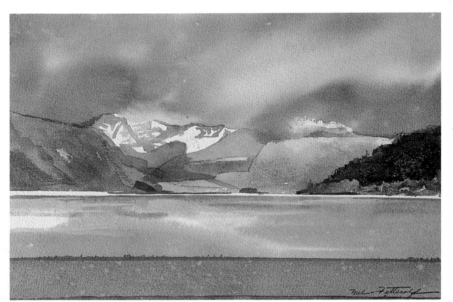

FJORD AND MOUNTAINS
BY MEL FETTEROLF
watercolor on Arches
300 lb. cold-pressed
paper, 11″ × 15″
(27.9 × 38.1 cm),
collection of the artist.

To be creative you must free yourself from old assumptions. Green is not just a subdued color—there are many different kinds of green, including lively ones. In this painting the artist has divided the landscape into broad bands of color. Notice that the choice of color bands increases the vibrancy of the rich green mixtures.

GREENS can be beautiful; greens can look natural; greens can even be transparent. Yet greens are probably the most challenging of all colors to mix. Do your attempts to make greens result in dull, grayed mixtures? Or do your greens become thick and chalky from overmixing? Even when a bright green is finally attained, does it seem too artificial for a landscape green? Sadly, one watercolorist I know solves the problem by avoiding the use of green altogether.

If you skirt around greens with substitutes, then you are missing out on some distinctive colorings. In Pennsylvania we have a saying, "You can't milk a cow by walking around the barn." So let's get down to business and learn how to conquer greens. The secret is the choice of pigments and the sequence in which the colors are mixed.

Let's begin by striving for clean, clear greens. There is nothing to equal the viridian pigment as the purest, most transparent green available. Viridian will not muddy your mixtures. There's more good news. Among all the green pigments, viridian is the only one that will lift out of the paper if you make a mistake or change your mind.

No pigment is perfect, however. The disadvantage of viridian is that it is a cool, acid green, rarely found in nature. Because natural greens are predominantly warm, lots of yellow and some red need to be forced into the green mixtures. But simply mixing any green, yellow, and red together will not give you what you seek.

BRING GREENS TO LIFE

What are the best pigments to mix with green? Begin by selecting aureolin yellow, the most transparent yellow pigment. Many students reach for yellow ochre to mix in their greens, believing it is a natural landscape or earthtone yellow. While quite natural-looking, yellow ochre is an opaque color and as such reduces the amount of light reflecting through it. Greens made with yellow ochre are not as luminous as greens made with aureolin yellow.

The mixing sequence and ratio now become vital. To counteract the cool effect of viridian, I automatically dip my brush into aureolin yellow and mix it with viridian before continuing. I try to keep this mixture as luminous as possible. This basic batch of color is transparent, warm, and bright—too bright actually for many greens in nature.

The next step is to slightly modify the intensity or "naturalize" the basic mixture. Add some red—but only a small touch, please. Again, the ratio is important. If you use too much red, the green mixture becomes dull and grayed because red is the complement of green. Try to avoid the mistake of adding as much red as yellow, for you will be disappointed with the result. Remember, a little dab will do it!

Now explore all the beautiful greens you can make by adding different red pigments (see page 25). To the basic batch of vibrant green, add a portion of rose madder genuine. See how easily the mixture is transformed into

MIX A FEAST OF GREENS

Naturalize the basic transparent green mixture (viridian plus aureolin yellow) with red pigments for bronze-toned greens.

VIRIDIAN + AUREOLIN YELLOW

+ ROSE MADDER GENUINE

+ LIGHT RED

+ CADMIUM RED

+ INDIAN RED

For richer greens, add reds to a green mixed from Winsor green and aureolin yellow.

WINSOR GREEN + AUREOLIN YELLOW

+ LIGHT RED

+ CADMIUM RED

+ INDIAN RED

+ ALIZARIN CRIMSON

Vary transparent viridian with reds.

VIRIDIAN

+ ROSE MADDER GENUINE

+ LIGHT RED

+ CADMIUM RED

+ INDIAN RED

Finally, enrich transparent Winsor green with reds for the darkest greens.

WINSOR GREEN

+ LIGHT RED

+ CADMIUM RED

+ INDIAN RED

+ ALIZARIN CRIMSON

25

ERIN PATCHWORK QUILT
watercolor on Arches 140 lb. cold-pressed
paper, 15″ × 21″ (38.1 × 53.3 cm).

These fields aren't simply green; they're a patchwork of color. I am always saddened when artists avoid a scene because they feel limited to disappointing greens. Don't be intimidated by greens. Discover the wide gamut of beautiful greens possible with pure pigments.

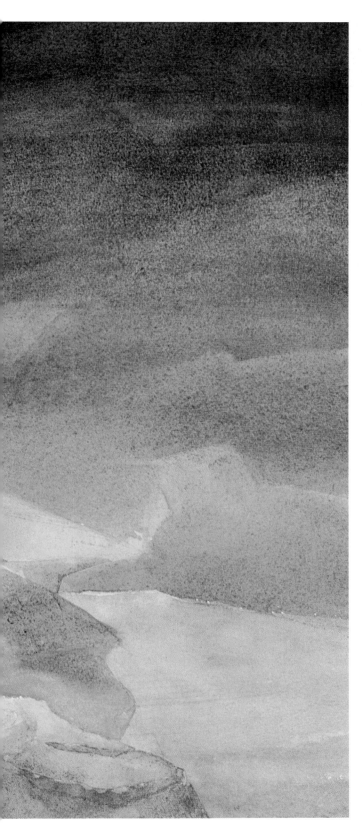

a natural landscape green. Because rose madder genuine is very transparent, the green mixture always remains transparent, without danger of becoming mud.

Light red is my favorite pigment for changing the basic green into richer, warmer variations. The greatest variety of greens—spinach, olive, and rich earth-toned greens—can be made with this pigment. If you need a deeper green, cadmium red is a good choice. Indian red also gives you a darker green, but one that is grayer. Since alizarin crimson is a very cool red, I reserve it for a very cold, dark green.

As you can see, it is not always the colors used but the way they are used. For colorful greens, develop a habit of adding yellow and green together first, then naturalizing the basic mix with a small amount of red.

For an inventory of even richer, deeper greens, use the same mixing procedure but substitute Winsor green for viridian. Because Winsor green has more carrying power than viridian, it gives you very transparent darks. It also stains the paper, but since most darks are added as the watercolor is completed, the dark areas are already known.

This time, establish a vivid basic mixture using aureolin yellow and Winsor green. With the exception of rose madder genuine, add different red pigments as before to naturalize the green. (Because Winsor green is highly saturated and stronger than most pigments, it would be foolish to mix the weaker rose madder genuine with it.) Make a middle-value mixture using light red, followed by darker mixtures with cadmium red and with Indian red, which yield yet more greens. For the absolutely darkest green possible, add alizarin crimson. Although the transparent aureolin yellow has little effect in deepening the dark mixtures, I like to include it to enrich the result and prevent the greens from looking lifeless. Since aureolin yellow is transparent and not a complement, it won't muddy the darks.

You can multiply the number of greens yet again. Eliminating the aureolin yellow in all the mixtures mentioned provides much cooler greens. To do this, simply modify viridian with a small amount of rose madder genuine (without any aureolin yellow) or vary it with light red or cadmium red or Indian red. The greens mixed with Winsor green can also be dramatically deepened by eliminating aureolin yellow altogether.

Notice that we have been using no more than three colors to mix the greens. Don't add a fourth pigment, for it obscures the reflective quality of the white paper and results in a sullied mixture.

WHAT ABOUT BLUE AND YELLOW?

It may seem incredible that there is a better way of making greens than the usual mixture of blue and yellow. But the ratio of warm and cool in your mixes is of the essence. With the ordinary method of mixing blue and yellow, the green color is half warm yellow and half cold blue. If, instead, you start with viridian, which is half blue and half yellow, and add an equal amount of yellow

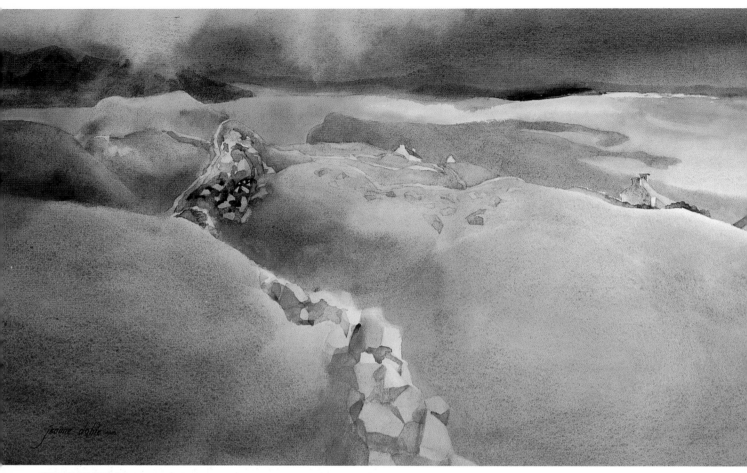

ERIN DRUMHILLS watercolor on Arches 140 lb. cold-pressed paper, 14″ × 29″ (35.6 × 73.7 cm).

(warm) plus some red (warm), the blue or cool content is drastically reduced. The result is greens that are kept warm and lively. This knowledge is especially valuable when mixing darker greens so that the color remains rich, not dead-looking.

PERSONALIZE YOUR GREENS

To develop a repertoire of your own distinctive greens, experiment with mixing and then choose a scene that invites you to color it green. Just look at my painting *Erin Drumhills.* What country could be better than Ireland for inspiring greens? Here I purposefully placed the stone wall in the center of the composition as a challenge. Notice how the wall leads the eye through the velvety green hills, which are the center of interest. Working with a vast panorama like this gives you an opportunity to observe how greens are affected by light and space. Even the sky must be considered. The trick in *Erin Drumhills* was to mix a gray-green sky without making it "look" green—using mouse power.

As you paint your own landscape, see if you can make the brightest, most intense greens the center of interest. Try to make your greens slightly grayer or cooler in the distance. Then mix as many other greens as you wish for the rest of the scene. How refreshing it is for a juror, or any other viewer, to see a painting without the same familiar greens in the foreground, middle ground, and background.

THE MANY COLORS OF GREEN

(WG)

(AY + WG)

DISTANT MOUNTAINS
(V + IR)

MUTED DISTANT GREEN
(AY + RMG + V)

RICH WARM GREEN
(AY + RMG + WG)

(AY + RMG + WG)

DEEP GREEN-TINGED SKY
(AY + CB + RMG)

VIBRATING GREEN
(AY + WG next to CB)

MIDDLE-GROUND HILL
(V + LR)

SHADOW ON LEFT
REAR HILL
(WG + CR)

LIGHT ON LEFT
FOREGROUND HILL
(V + IR)

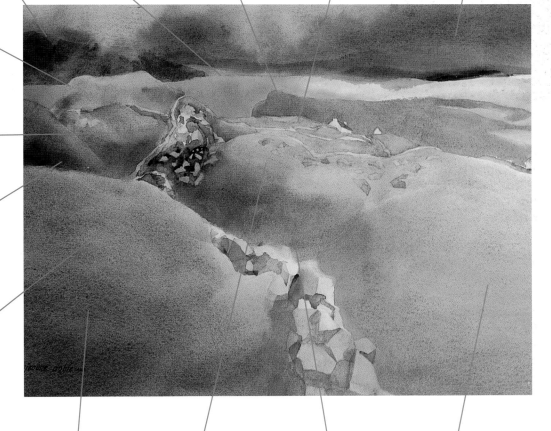

LEFT FOREGROUND HILL
(AY + LR + V)

MIDDLE-GROUND HILLS
(AY + LR + V)

SHADOWS ON HILL
(AY + LR + V)

RIGHT FOREGROUND HILL
(AY + RMG + V)

5. PUSH-PULL WITH WARM AND COOL
Creating Distance and Atmosphere

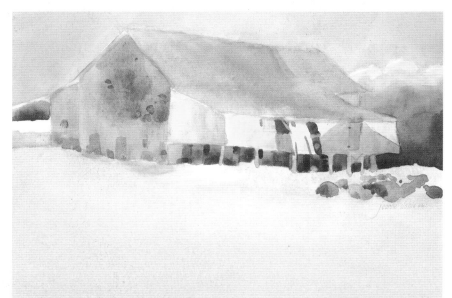

DECEMBER DUSK
watercolor on Saunders
300 lb. cold-pressed paper,
8½" × 11" (21.6 × 27.9 cm).
Color does not always match our expectations. Be daring and use it to recreate the feeling of a particular time of day, as in the pink snow here. Try to imagine the different atmosphere if the snow were a cool blue.

MASTER artists do not describe a color simply as red, yellow, or blue. Instead, they qualify it as a warm blue or a cool red, a muted or an intense yellow. They are aware not only of light and dark contrast, but also of the push and pull of colors in a painting. Pushing color into a cooler shade causes it to recede, while pulling its neighbor into a warmer color makes the neighbor advance. Side by side, the two colors no longer appear to be on the same plane. You create space in your painting!

This push-pull relationship with color can be used effectively in landscape painting. To describe vast distance, try pushing the background fields into cooler tones as they disappear over the horizon. Then pull the foreground fields forward with warmer colors.

The greatest stumbling block to creating a push-pull reaction with color is assuming that a particular color is warm or cool. Yellow, for example, is usually thought of as a warm color and blue is assumed to be cool. But there are yellows that are cooler than others and blues that are warm. The temperature of the color is always relative, because it depends on its neighboring color. Suppose you place French ultramarine blue next to cadmium red, as on page 31. Here there's no trouble identifying the blue as a cool color and the red as a warm one. But now suppose you place the same blue next to lemon yellow. In this case, the yellow is the cool hue and the blue appears warmer than usual. In fact, the blue begins to look almost purple next to the cool yellow. The first thing to learn is to judge your color in relation to its neighbor.

Also question your assumptions about local color. I have seen students walk up to a tree trunk and faithfully match a color. Unfortunately, they are still thinking in local color. Instead, observe how the light and atmosphere enter a scene to affect and change the local color. Here is an opportunity to use warm and cool color to intensify the atmosphere. Under an early evening light, for instance, a brown tree trunk may turn pink. Open your eyes! Local color can fool you. Is a road really dark and gray? After a rainstorm it may turn lavender and, under other conditions, even deepen to a rich red-purple. Is the sky always blue? Look for grayed-yellow, pink, or purple skies. Does snow always have blue shadows? Not in Pennsylvania at four in the afternoon—then the snow turns an incredible pink from the low angle of the sun. Viewers of my snow paintings remark that they never noticed pink snow before. Unfortunately, it is our assumptions, our mental blocks, that restrict our enjoyment of color.

STUDY THE OUTDOOR LIGHT SEQUENCE

Understanding the natural sequence of light keeps you from adding color arbitrarily. Outdoors, the sky color touches every plane uplifted to the sky. As the hills recede in the distance, more of the sky color (usually a blue tone) is added to the atmosphere between you and the hills. This creates a veil of light, which, as you look through it, changes the color of the hills to a cooler green. Far hills often look completely blue rather than green as even more atmosphere drastically changes their color.

Rooftops, too, reflect the color of the sky. And trees turn a bit cooler as they reach toward a cool sky. To indicate this means simply that you add a little cool or

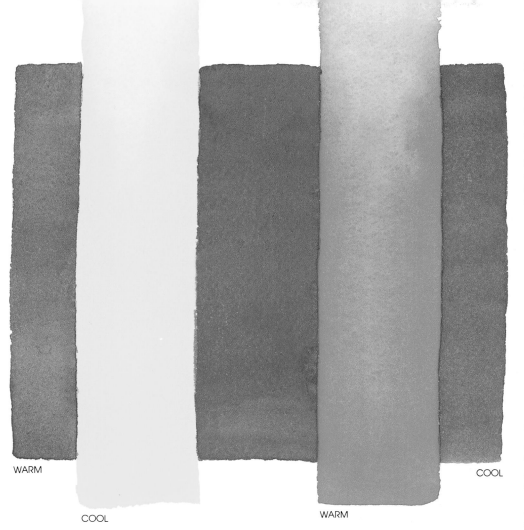

WARM

COOL

COOL

WARM

COOL

IS A COLOR WARM OR COOL?

Learn to judge color in relation to its neighbor. When you compare the red and blue in this example, there's no doubt which color is warm and which is cool. But when you study the yellow and blue neighbors, you may have difficulty. The yellow here seems to recede (cool) while the blue advances (warm).

EXPERIMENT WITH PUSH-PULL REACTIONS

Merely painting a color lighter or darker does not give it a push-pull relationship. Change the same greens to warm and cool to create a push-pull reaction. Repeat this exercise with other colors, such as purple or blue.

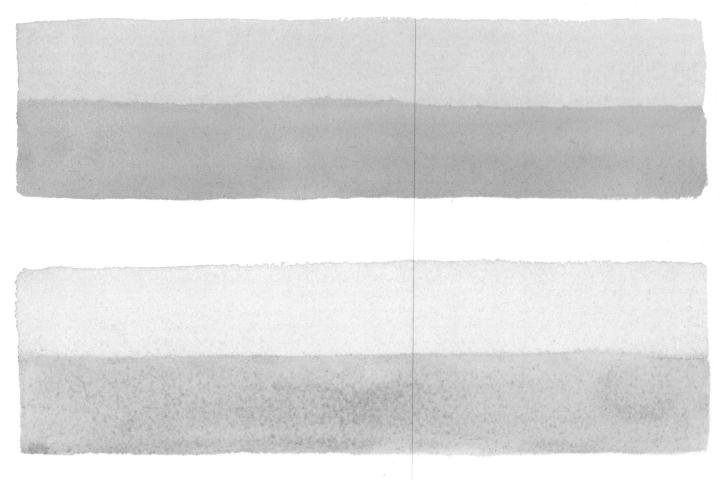

EXPLORE WARM AND COOL VARIATIONS

By mixing pure pigments, you can create cool and warm, as well as gray, variations of the same color.

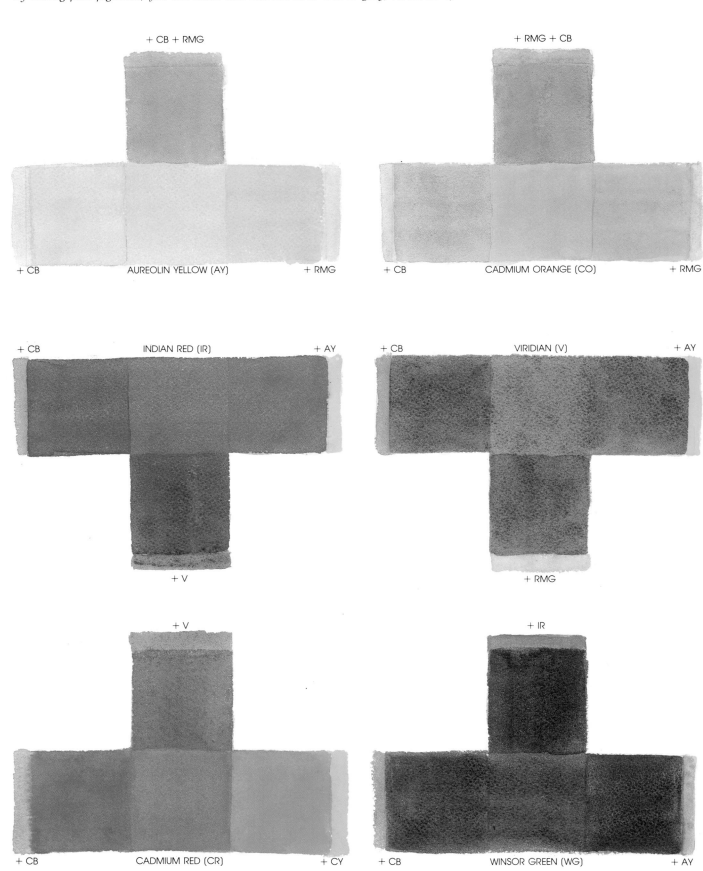

+ CB + RMG

+ RMG + CB

+ CB AUREOLIN YELLOW (AY) + RMG

+ CB CADMIUM ORANGE (CO) + RMG

+ CB INDIAN RED (IR) + AY

+ CB VIRIDIAN (V) + AY

+ V

+ RMG

+ V

+ IR

+ CB CADMIUM RED (CR) + CY

+ CB WINSOR GREEN (WG) + AY

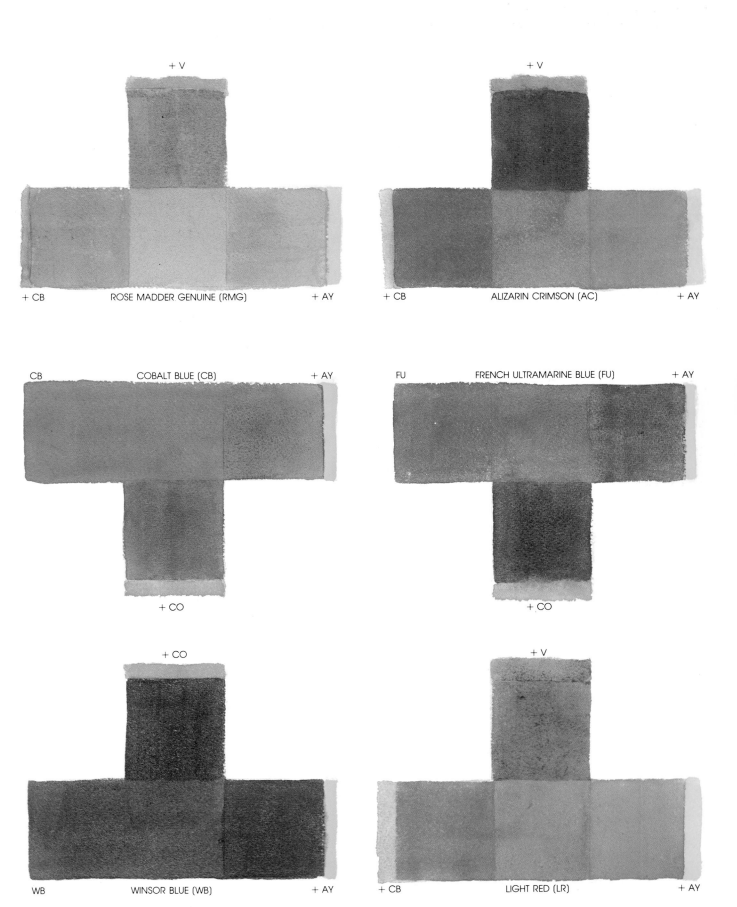

+ V

ROSE MADDER GENUINE (RMG)

+ CB + AY

+ V

ALIZARIN CRIMSON (AC)

+ CB + AY

CB COBALT BLUE (CB) + AY

+ CO

FU FRENCH ULTRAMARINE BLUE (FU) + AY

+ CO

+ CO

WINSOR BLUE (WB)

WB + AY

+ V

LIGHT RED (LR)

+ CB + AY

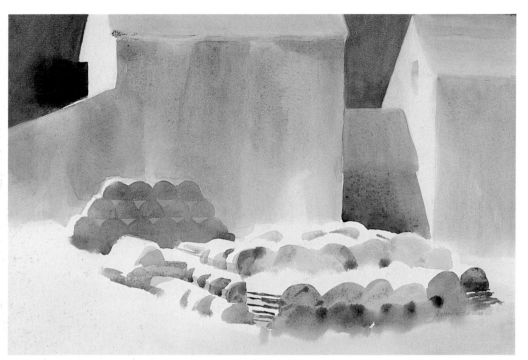

LOBSTER POTS A LA MAINE
watercolor on Arches 140 lb.
cold-pressed paper, 14½″ × 21″
(36.8 × 53.3 cm), collection of Mr.
and Mrs. James W. Nickerson.

In actuality the two piles of lobster pots here were not too far apart, yet I gained a feeling of spaciousness by using warm and cool colors. By selecting warm colors for the front pots and cool tones for the rear ones, I immediately activated a push-pull tension.

warm (or whatever the sky color is) to slightly modify the local color of the top portions of roofs and trees. It does not mean changing a roof or tree to the sky color.

And what about the sky? Directly overhead it has the most intense color and the strongest value. As it nears the horizon, it appears grayer because the atmospheric curtain gathers more dust particles and thus mutes the color. You can capture this effect by adding the complement of the sky color.

Under a blue sky, the ocean, like the receding hills, becomes bluer in the distance—and for the same reason. As the water moves toward the horizon, its color takes on more light and atmosphere from the sky. In contrast, in the foreground, where the ocean becomes shallow, the water is greener because the sand beneath reflects into and alters its color.

But do white clouds and other outdoor whites become bluer or cooler as colors do when they move into the distance? No! You may be surprised to learn they actually become warmer. To explain this seeming contradiction, remember that as the sky recedes, it collects more and more of the dust particles in the atmosphere and becomes grayer. White is at its purest as a bluish white, but this purity becomes contaminated as it moves into the background. Therefore, distant whites become creamier. When you observe the subtle differences in white colors and include them in your painting, making some whites recede and others advance, you increase the feeling of space throughout your landscape.

LOOK FOR THE SPECIAL ATMOSPHERE

Painting under a different lighting condition can force you away from the mundane. At one of my workshops, the rain clouds threatened constantly and the workshop participants painted with one eye glued to the skies. Later, at the critique, everyone was surprised—the paintings were loaded with atmosphere! The artists had been forced to become conscious of atmospheric conditions, albeit unwillingly.

A special atmospheric light can heighten the mood you wish to depict. Look at my painting *Midnight Sun,* which depicts a small fishing village in Norway. Under ordinary light, the village seemed an undistinguished subject. But at 11:30 P.M., under the unbelievable midnight sun, the scene was spectacular. By focusing on the push-pull of warm and cool, I was able to capture the feeling of vast space.

What transforms a landscape or subject into an inspiration? Quite often it is the specialness of a place at a certain time of day, in a specific light or atmosphere, viewed with a receptive attitude. This synthesis ignites a response and sets in motion the artist in you. With a knowledge of the push-pull of warm and cool, you can then recreate the exciting interplay of light and space.

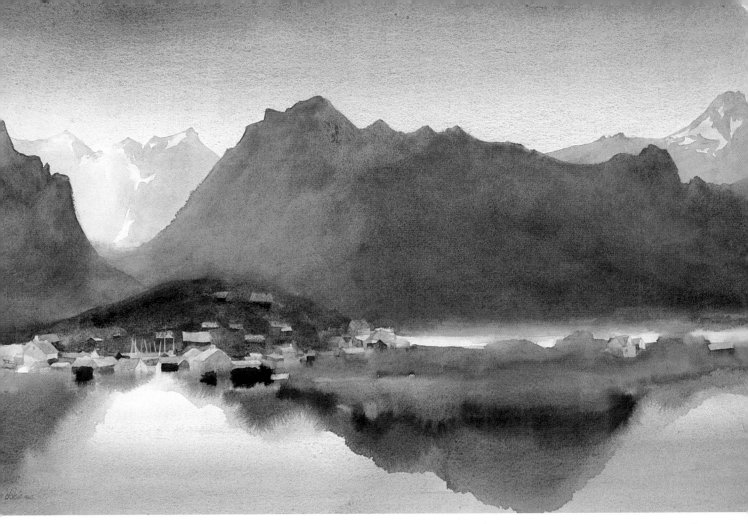

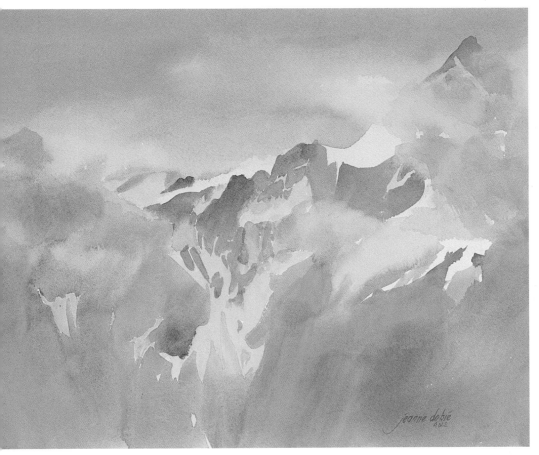

MIDNIGHT SUN
watercolor on Arches 140 lb.
cold-pressed paper,
19" × 29" (48.3 × 73.7 cm).

The warm colors here pull the village and reflections in the water forward, into the limelight. The cool colors then push the mountains back to create a boundless space. To emphasize this feeling of space, I added another stratum of warm colors in the distance. To prevent these warm but distant mountains from protruding, I was careful to make them less intense than the foreground reflections and lighter in value than the cool mountains.

CLOUD CAULDRON
watercolor on Arches 140 lb.
cold-pressed paper,
11½" × 15½" (29.5 × 39.4 cm).

Remember that whites do not follow the same sequence as other colors as they recede. Here it is the cool clouds that pull forward and the warm ones that push into the background.

6. PUSH-PULL AND TURN
Making Form Appear Three-Dimensional

ALONG MARCO POLO'S CARAVAN ROUTE
watercolor on Arches 140 lb. cold-pressed paper, 11½" × 15½" (29.2 × 39.4 cm).

Enlarge your painting vocabulary and discover all that color can do. This Arabian Nights town sparkled; even the water beyond appeared greenish blue with the warmth of the atmosphere. To describe the forms without any loss of brilliance, I used the push-pull of warm and cool. Rendering and shading the objects might have dulled the color.

WITH A knowledge of push-pull, you can give any form volume through color alone. Resorting to modeling may lead you to overwork pure washes. Or, in trying to deepen a shadow, you may dull or deaden the effect. Instead, by using a push-pull interplay between warms and cools, you can achieve the same results and still keep your colors lively.

To employ push-pull reactions effectively, you need to distinguish between the cool and the warm light sequences. I've found that a good way to demonstrate these differences to my art students is with a model. In the morning I place her in a sunlit courtyard in natural light, and later in the afternoon I bring her inside under studio lights. I deliberately choose an outdoor situation to demonstrate the cool light sequence because landscapes are generally affected by a cool light reflected from the sky. On the other hand, I prefer an indoor lighting condition to explain the warm sequence because artificial lighting is usually warmer than outdoor lighting. Situations can vary, however. A blazing sunset, even though outdoors, may necessitate a warm light sequence, while a large studio skylight may dictate a cool light sequence. Be cognizant first of your light source and decide whether it is cool or warm before you proceed.

To understand how the two light sequences affect the skin tones, look at the illustrations on pages 38–39. I've chosen a simple light and shadow pattern on an arm to show you how to create volume through color alone under both lighting conditions. You are invited to paint along, following the diagrams for guidance.

COMPARE COOL AND WARM LIGHT SEQUENCES

Let's start with the cool light sequence. The first step is to describe the light on the form. An easy way to identify the cool light sequence is to remember that the cool light source creates cool accents. In contrast, the main form is predominantly warm, in both light and shadow. Notice in the first diagram on page 38 that the highlight (no. 1)—where the cool light from the sky first strikes the form—is cool. The local color (no. 2) is warm, but modified slightly by the highlight—although only where the light touches it, not all over. A hint is to keep the highlight lighter and cooler than the local color to convey the effect of the light.

The next step is to add the shadow (no. 3). To avoid painting the arm in two or three unrelated colors, do not introduce a foreign color as a shadow. Instead, first paint the whole arm with local color, both the part in light and the part in shadow. Before you mix the shadow color, bear in mind that it is merely a deeper shade of the local color, not a different color. Since the arm is a warm color, keep the shadow predominantly warm so that it belongs to the arm. A common error is to assume that shadows are always cold. Instead, shadows repeat the warmth or coolness of the local color. Notice on page 38 that both the local color (no. 2) and the shadow (no. 3) are warm and compatible.

For the final step, put in the remaining cool accents. Now we can modify the shadow. The shadow is cooler at the edge, where the light is at first obliterated as it turns from light to shade. This change (no. 4) is added

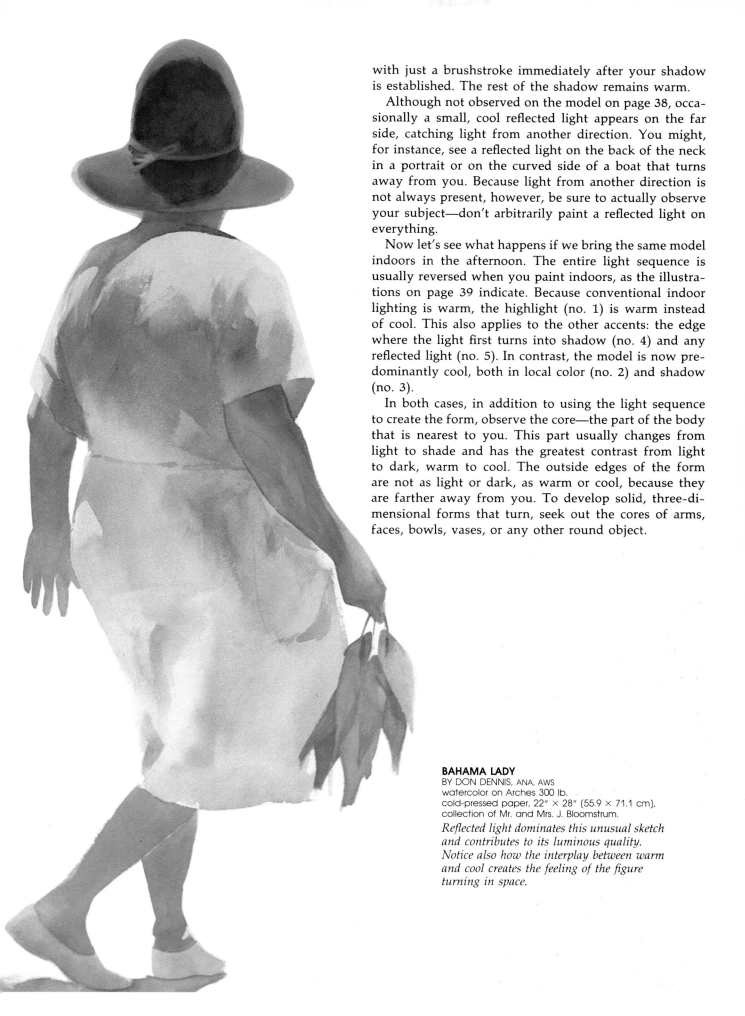

with just a brushstroke immediately after your shadow is established. The rest of the shadow remains warm.

Although not observed on the model on page 38, occasionally a small, cool reflected light appears on the far side, catching light from another direction. You might, for instance, see a reflected light on the back of the neck in a portrait or on the curved side of a boat that turns away from you. Because light from another direction is not always present, however, be sure to actually observe your subject—don't arbitrarily paint a reflected light on everything.

Now let's see what happens if we bring the same model indoors in the afternoon. The entire light sequence is usually reversed when you paint indoors, as the illustrations on page 39 indicate. Because conventional indoor lighting is warm, the highlight (no. 1) is warm instead of cool. This also applies to the other accents: the edge where the light first turns into shadow (no. 4) and any reflected light (no. 5). In contrast, the model is now predominantly cool, both in local color (no. 2) and shadow (no. 3).

In both cases, in addition to using the light sequence to create the form, observe the core—the part of the body that is nearest to you. This part usually changes from light to shade and has the greatest contrast from light to dark, warm to cool. The outside edges of the form are not as light or dark, as warm or cool, because they are farther away from you. To develop solid, three-dimensional forms that turn, seek out the cores of arms, faces, bowls, vases, or any other round object.

BAHAMA LADY
BY DON DENNIS, ANA, AWS
watercolor on Arches 300 lb.
cold-pressed paper, 22″ × 28″ (55.9 × 71.1 cm),
collection of Mr. and Mrs. J. Bloomstrum.
Reflected light dominates this unusual sketch and contributes to its luminous quality. Notice also how the interplay between warm and cool creates the feeling of the figure turning in space.

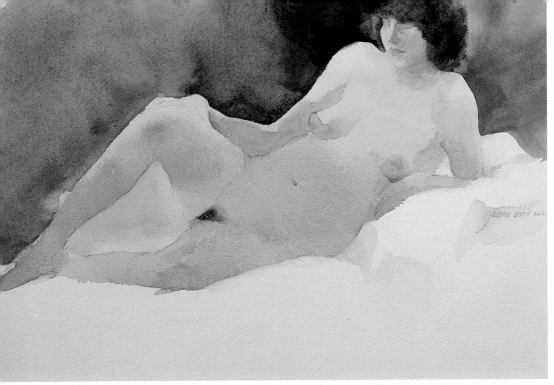

These two sketches, painted on the same day, clearly portray the effect of different lighting on the same model's skin tones. In A.M. Nude the warmer shades are influenced by the cool morning light, while in P.M. Nude the tones are generally cooler under the warmth of incandescent light. Observe how I used a continuous wash from head to toe, accounting for light variations en route. Although there may be a loss of anatomy here or there, this is a better approach than painting parts of the figure hinged together. Also remember that nudes should be painted freshly, to look as if they could be pinched. Pure pigments help to make them look luscious.

A.M. NUDE watercolor sketch on Arches 140 lb. rough paper, 11½″ × 18″ (29.2 × 45.7 cm).

DEFINE THE COOL LIGHT SEQUENCE

Describe the Light on the Form.
Keep the arm simple for a first-time trial. Be sure to paint the wash over the entire body mass—describing the parts will come later. Begin with the lightest skin tones (no. 2) and include the cool highlights (no. 1) on the top of the shoulder and hand.

Continue with the Shadow. *As you add the shadow (no. 3), keep it warm and be careful to relate it to the local color.*

Finish with Cool Accents.
Immediately modify the shadow edge with a cool transition (no. 4), where observed. With this pose, there is no reflected light—I did promise to keep it simple.

Paint the Light Skin Tones and Highlights. *With incandescent light, the skin colors (no. 2) are cool while the highlights are warm. Keep in mind, however, that although the skin tones are not as warm as on the* A.M. Nude, *they do not turn completely blue.*

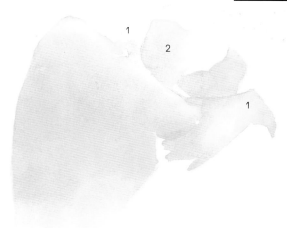

Add the Shadows and Reflected Light. *Notice how cool the shadow (no. 3) is on the shoulder. Don't worry, this can be modified in the next step. At this point I like to add any reflected light (no. 5) so that it can blend into the skin tones.*

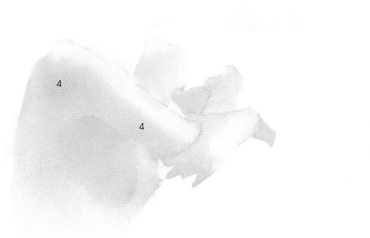

Warm the Shadow Edges. *By brushing in the warm shadow edge (no. 4) on the shoulder, you can create a "core" and make the body turn.*

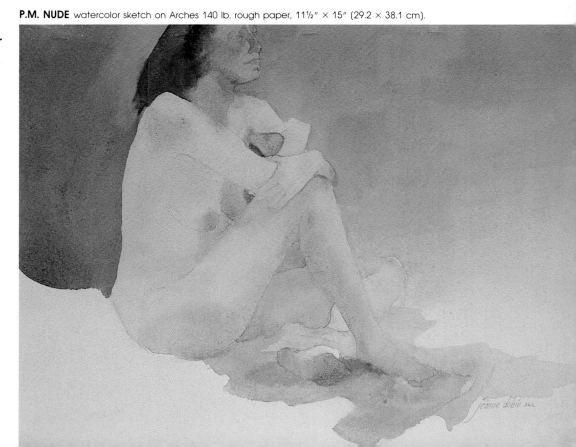

P.M. NUDE watercolor sketch on Arches 140 lb. rough paper, 11½" × 15" (29.2 × 38.1 cm).

GIVE LANDSCAPES FORM

The push-pull of warm and cool also creates solid volumes in landscape paintings. Dropping color indiscriminately over a foreground or a group of trees does not give them form, just some fancy tap dancing on the surface. I find it helpful to think of hills, fields, and trees as if they were rounded like watermelons or grapefruit—anything fully rotund. If you view trees as silhouettes, you forget that some branches move toward you and others away from you, in a circular motion. Substituting the image of fruit helps you to describe the tree or hill as a volume.

Imagine where the light in your scene would highlight an orange and then duplicate that highlight touching the hill. Paint this highlight on the hill as you did with the model's arm. Then add the local color and gradually change or deepen the value on the remainder. By thinking of hills as rounded forms, you can create rolling volumes (see my painting *Erin Drumhills* on page 28).

Remembering that shadows are usually warm in outdoor light, you may notice that the undersides of trees are warmer than you originally assumed. Seldom is an extremely cold, blue shadow found in nature. The cool light from the sky only modifies planes that directly face it. Shadows are usually blocked from the rays. To emphasize this, I sometimes hang a deep blue towel from a tree branch so that my students can compare shadow colors to it.

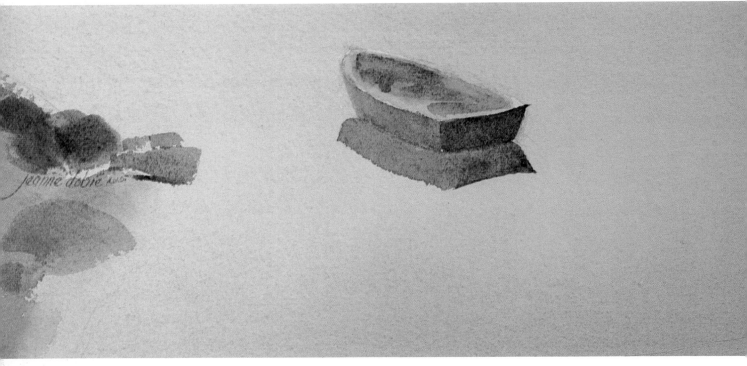

LONE DORY
watercolor sketch on Arches
140 lb. cold-pressed paper,
4½" × 10½" (11.4 × 26.7 cm),
collection of Scottie Hodge.

With a sharply turned object, there is no transition at the shadow's edge (no. 4), as you can see in this sketch and the accompanying diagram of the light sequence.

HOW TO TREAT SHARPLY TURNED OBJECTS

Not all objects are rounded, however. You may wonder, for instance, how to describe a form with sharp corners, like the boat in my sketch *Lone Dory* (page 40). Here the light source is directly overhead, and the surface of the boat is uplifted to the sky so that it collects large amounts of the cool highlight (no. 1). On the top of the boat, therefore, the highlight modifies the local color (no. 2) to a greater degree than usual. (You can also see this effect on roofs or other planes directly facing the sky.) Note that, as with a rounded object in the cool outdoor light sequence, the shadow (no. 3) is warm. The shadow cast by the boat on the water is also warm. Unlike a rounded object, however, a sharply turned object does not have a cool accent at the shadow's edge (no. 4). Because the object turns a corner abruptly into shadow, this transition is bypassed. If observed at all, it is reduced to a small portion at the shadow's edge, where the light is first cut off. Remember that if light reflecting from another part of the sky (no. 5) appears on the far side of the boat, it is only a nuance of cool light. (For a subject under a warm light, simply reverse the sequence.)

If the light source is not directly overhead, then there is a slight variation. This time I'll use a house for a simple example. Any plane tilted toward the light source, such as the roof, is modified by the cool light. The house, however, will not turn its corner if both sides are the same value. Observe the warm and cool variations, even if slight, to pull one side forward and push the other back. Now study the windows on the two sides. On the warmer side, they are affected by the same light that makes the wall warm. On the cooler side, the windows mirror a different color of the sky, from another direction. Use the push-pull concept on the windows as well as the walls to make the house turn.

ADDITIONAL ADVICE

So far I've given you guidelines for both cool and warm light sequences, which you can select to suit your particular situation. You'll find a variation, however, in the cool light sequence when you are confronted by a *stark* white object or snow, which has a cool local color. Here, under a cool light, the accents are cool, as are the main form and shadow. In order to create a reaction and emphasize the cool white local color, I occasionally push some warmth into one of the other cool areas. A pure white under a warm light, however, presents no problems.

Simply using your favorite colors because you like them or because they create intriguing effects doesn't necessarily give them a chance to work for you. Knowing how to use push-pull with warm and cool gives you colors that do more than look pretty. They can move forward and backward in space and even turn.

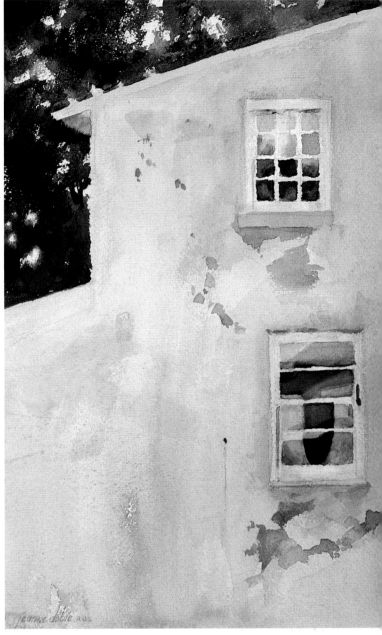

SEPTEMBER
watercolor on Arches 140 lb. cold-pressed paper,
21″ × 15″ (53.3 × 38.1 cm), collection of Barbara Millen.
Because windows reflect the light source, they can add atmosphere to your painting. Here the cool lavender light mirrored in the windows hints at an overcast day.

7. DARK GLOWS
Getting the Most from Darks

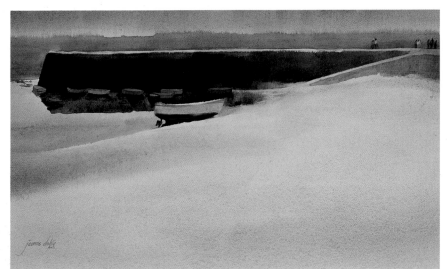

QUIBERON HARBOR
watercolor on Arches
140 lb. cold-pressed
paper, 12½" × 21"
(31.7 × 53.3 cm)
Darks don't have to be drab and unexciting. Think of darks as colors that can enliven your paintings and turn the lights into something special. Here, for instance, the greenish shadow cast by the pier reacts with the pinkish sand to make the colors glow.

CAN DARKS be luminous, bright, and powerful all at the same time? Yes—*if* you mix them from pure pigments instead of relying on ivory black, Payne's gray, or other purchased colors. Darks should do more than supply a dark value. They are the catalysts for the effect of light. The function of a dark color is to complement the light and help it emit a glow. That means that a dark should not only provide a contrast, but also animate the light. This enlivening quality is effected through the complements—remember them?

In Lesson 2, on mouse power, we learned that when complements are mixed together in equal amounts, they cancel each other out and produce an undesirable gray. If, however, you do not mix them but place them side by side, each enhances the other. To make a light color brighter, try choosing a dark that is the complement of the light. The problem with choosing an ordinary black pigment or just any dark color is that you limit yourself to merely a strong contrast. But if you make the dark color a complement, you immediately create a reaction that transforms the light into a radiant light.

I have been asked why there aren't any browns, blacks, or purples on my palette. That's because I prefer to mix my own darks from pure pigments. The result: mixes that are glowing, alive, and contain enormous strength. My darks are *colorful* darks. To duplicate these powerful darks, look to the staining pigments at the bottom of the first column of the pure pigment palette on page 11. Remember that no other pigments compare with the strength of the staining colors—they are almost twice as potent as the other pigments on my palette. And they have enormous carrying power, with an electric effect

that can pulsate beyond ten feet. Amazingly, they remain transparent in spite of their great saturation, making them excellent choices for intense darks. Vibrant mixtures, without any sediment, are guaranteed with the pure staining pigments.

POTENT BLUES AND PURPLES

To enliven an orange-toned light, you need a deep blue. To make a potent dark blue, slide your brush into Winsor blue. Notice that the color is too powerful in its raw state; it needs naturalizing. Add some Indian red to modify it to a more acceptable dark blue. Sometimes this color looks more natural in a landscape painting than a bright, dark blue.

Another, slightly different dark blue can be made by adding cadmium red to Winsor blue to naturalize the blue. Now mix Winsor blue with a little alizarin crimson. Notice the result is a more intense dark blue than in the previous mixtures. The reason for this added vibrancy is that the Winsor blue and alizarin crimson are both transparent staining pigments, while Indian red and cadmium red are opaques. Increasing alizarin crimson to an equal amount in the mixture gives you a bright, dark purple choice.

Now start with ultramarine blue, which is very slightly opaque, to discover another range of dark blues. Modify it as you did Winsor blue, with Indian red, cadmium red, or alizarin crimson. Once again, the brilliance of alizarin crimson produces the brightest dark blue. Now reverse this mixture, using more alizarin crimson, for a rich, dark purple. All the dark purple mixes are great foils for golden glows.

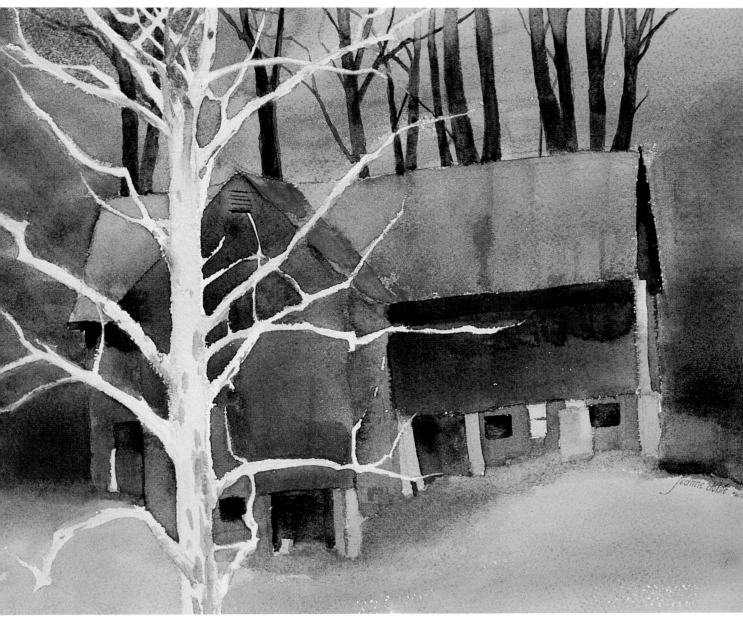

HILLCLIMB FARM
watercolor on Arches 140 lb. cold-pressed
paper, 11″ × 15″ (27.9 × 38.1 cm).

*Although this is a "dark" painting, it has a lot of color. In your
next watercolor, make your darks varied and rich colors.*

ANIMATE LIGHTS WITH DARKS

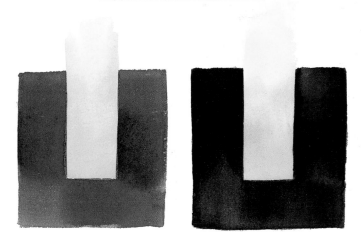

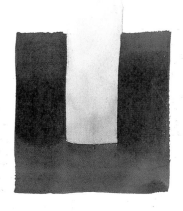

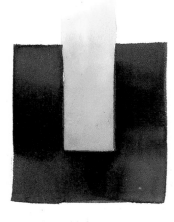

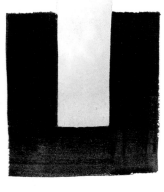

Darks should be a catalyst for lights. Again, the secret is the interaction of complements. Use these examples as a guide and explore other possibilities.

VELVET BLACKS

For the deepest velvet black mixture possible, one that outshines any purchased pigment, mix alizarin crimson with Winsor green. Because both pigments are staining and transparent, you get a particularly lustrous dark. Very subtle black variations can be made by changing the ratio. Using more alizarin crimson than Winsor green produces a warmer black, while adding more Winsor green than alizarin crimson yields a colder, seemingly deeper black.

These subtle variations can help you describe form. In my painting *The Three Bretonnes* (shown on page 155), a large wash of black was needed for the women's garments. Although at first glance this appears as a matte or unvaried dark wash, the shoulders and hunched upper torsos are actually painted with a warm black. Gradually, the wash changes to a cool black at the feet. The effect is extremely subtle, so that the viewer slowly becomes aware of the form of the women's bodies under the seemingly simple wash.

Variations of the rich, velvet dark made from Winsor green and alizarin crimson complement skin tones exquisitely. Pale pink or red tones can be accented by a cooler mixture (predominantly green), and golden skin tones by a warmer mixture (predominantly alizarin crimson). To see some other possible darks made with Winsor green turn back to Lesson 4 on greens.

CLEAN, CLEAR BROWNS

Would you believe that the very same pigments we used to make a variety of eye-pleasing greens can also be used to make a variety of browns? Again, it is not just the colors you use; it is the way they are mixed.

If you use pure pigments, your brown mixtures will be transparent, free of sediment, and certainly not dull. The secret is to establish a basic orange mixture. Start with aureolin yellow on your brush and add rose madder genuine. Once the basic orange is established, carefully add viridian until the mixture turns a lovely soft brown. This brown is on the light side. Introducing more water then produces a variety of soft tans and earthtones.

Next make a middle-value brown by selecting light red and mixing it with aureolin yellow. When this orange color satisfies you, add viridian, mixing it until you arrive at a bronze brown. Now load your brush boldly with more of each pigment to produce richer browns. Don't worry about the mixture becoming muddy. Aureolin yellow and viridian are transparent and outweigh the addition of opaque light red. Develop still another brown with cadmium red mixed in the same manner.

For a deeper, cooler brown, try Indian red added to aureolin yellow. Indian red is a very opaque pigment, bordering on house-paint consistency, so add it gingerly to the transparent aureolin yellow to avoid overpowering the yellow. Produce an orange mixture first, then add viridian. You'll gain a cooler brown. Invent golden browns by increasing the amount of aureolin yellow in any of the mixtures, or add more red to create warm, reddish browns.

Add alizarin crimson to your blue for a bright, dark hue. Then reverse the ratio for an entirely different dark from the same pigments.

WINSOR BLUE +
ALIZARIN CRIMSON

PIGMENTS
REVERSED

FRENCH
ULTRAMARINE BLUE +
ALIZARIN CRIMSON

PIGMENTS
REVERSED

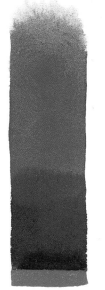
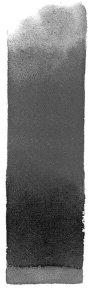

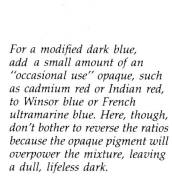

For a modified dark blue, add a small amount of an "occasional use" opaque, such as cadmium red or Indian red, to Winsor blue or French ultramarine blue. Here, though, don't bother to reverse the ratios because the opaque pigment will overpower the mixture, leaving a dull, lifeless dark.

FRENCH
ULTRAMARINE BLUE +
CADMIUM RED

FRENCH
ULTRAMARINE BLUE +
INDIAN RED

WINSOR BLUE +
CADMIUM RED

WINSOR BLUE +
INDIAN RED

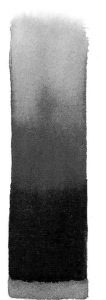
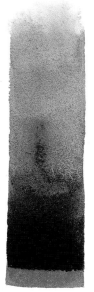

A mixed black is richer than any commercial pigment. Use transparent Winsor green and alizarin crimson. Experiment with different ratios for warm or cool blacks.

For natural dark greens, modify Winsor green with an "occasional use" red. Again, reversing the ratios is not advised because the opaque pigment will dominate and dull the final dark.

ALIZARIN CRIMSON +
WINSOR GREEN

PIGMENTS
REVERSED

WINSOR GREEN +
CADMIUM RED

WINSOR GREEN +
INDIAN RED

45

CREATE LUMINOUS BROWNS

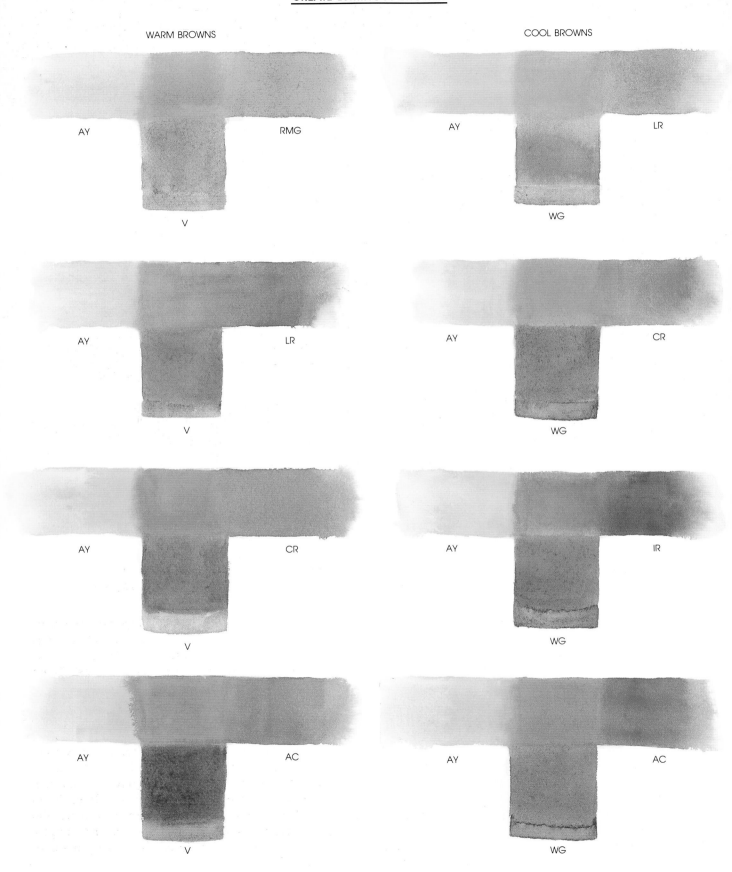

WARM BROWNS

AY — RMG — V

AY — LR — V

AY — CR — V

AY — AC — V

COOL BROWNS

AY — LR — WG

AY — CR — WG

AY — IR — WG

AY — AC — WG

Browns made with pure pigments are transparent and alive. Begin with an orange mixture; then add viridian for a variety of warm browns or Winsor green for cooler browns. Only some of the possibilities are illustrated here.

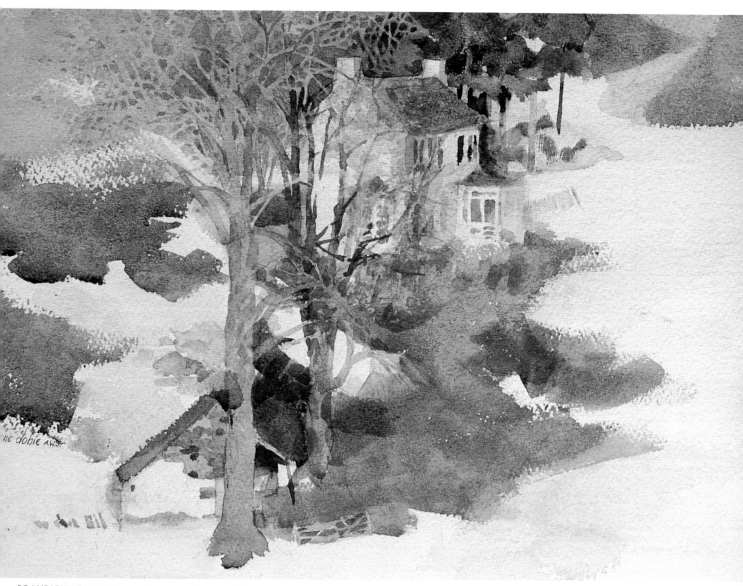

BRANDYWINE VALLEY watercolor on Arches 140 lb. cold-pressed paper, 11″ × 15″ (27.9 × 38.1 cm).
Don't be afraid of brown. Paint a predominantly brown painting to try out the variety of new mixtures you have discovered.

An even richer brown is begun with alizarin crimson (a staining pigment) and aureolin yellow. The resulting vibrant orange may make this one of your favorite brown mixtures. Now add viridian. If you keep your brush saturated (without too much water), the brown is wonderfully intense and rich.

From the same basic pure pigments of yellow and red—with the exception of the weak rose madder genuine—you can make cooler browns by substituting Winsor green for viridian. Again, mix an orange color first and then add Winsor green. Always begin with aureolin yellow because it is the weakest pigment and add the red to it, then continue with the green pigment. Since Winsor green is so powerful, it tends to permeate the mixture more than viridian does and results in cooler browns. Should your color turn green, simply add more red and yellow,

or start over. Whatever you do, don't dip into other pigments to adjust the brown. As soon as any mixture has a total of four pigments, the luminosity is in jeopardy. Keep the mixture to two or three pigments at most. There are endless combinations with only three pigments.

Because browns are predominantly warm, even the cooler browns, they best complement a cool light. Like the mouse grays, subtle browns have many indispensable uses throughout a landscape scene. Just look at the variety of browns in my painting *Brandywine Valley* above.

Never underrate the role that darks play in a painting. If a dark is large, an interesting shape, or placed in an important spot, it should say something more than "I'm a dull, dirty dark." By using pure pigments and complements, you can create a luminous relationship between lights and darks.

8. SINGING COLOR
Making Color Pulsate

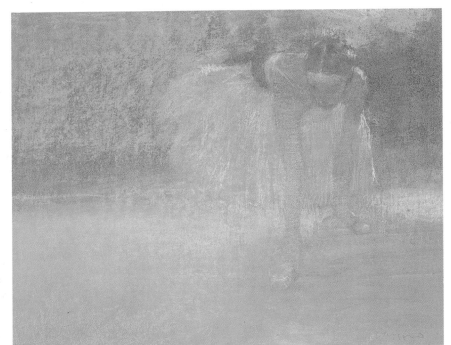

ANKLES
BY HENRY CASSELLI, AWS, DF
pastel, 10″ × 13″
(25.4 × 33 cm),
collection of Holly
and Arthur Magill.

Composing a painting resembles an orchestration. Not every musician can blow a horn—harmony is needed. Singing color is not the same as bright, loud color; instead, it depends on color reactions. Notice how this artist has achieved luminosity through color expertise rather than the usual dark contrast.

MAYBE you've heard the expression, "You have color but no color." It sounds paradoxical. What it means is that the painting is filled with bright colors, but they are not working together; they are merely sitting there, side by side, staring back at you. You cannot make colors sing, you cannot give them a glow, just by using bright mixtures. You need to arrange color reactions.

Don't confuse intensity with singing color. Color may be bright and intense, yet opaque and nonluminous. Yellow, especially, seems to mislead watercolorists. Too often it is applied strongly for brightness, but adding more pigment does not necessarily increase the glow. When the yellow is too heavy, the light cannot penetrate through to the paper and help the color shine. Also, when yellow is thickly applied, it appears as a middle value rather than a light. If you take a black-and-white photograph of your painting, you may be surprised to note that the yellow has lost its luminous quality and become a middle value. What you need to strive for is not intensity, but glow.

CREATE COLOR THAT SINGS

Again, to make a color sing, you need to create a reaction with the color surrounding it. Let's try out different possibilities to see which combinations work best. The illustration on page 49 shows the results.

1. *Start with a pure transparent light.* Select both a warm and a cool yellow light, a warm pink light, and a cool

CONCENTRATE ON THE GLOW *Although more intense, the heavily painted yellow on the right is less luminous than the one on the left. Aim for a color that emits light if you want it to sing.*

COMPARE COLOR REACTIONS

The black squares here merely create a contrast.

With a complementary dark, the colors begin to vibrate.

For even more glow, use warm and cool complementary dark contrasts.

Try grayed mid-value complements to reinforce singing color.

CADMIUM YELLOW

COMMERCIAL BLACK

AC + FU (equal amounts)

FU (more) + AC

FU + AC + AY

AUREOLIN YELLOW

COMMERCIAL BLACK

AC + FU (equal amounts)

AC (more) + FU

AC + FU + AY

ROSE MADDER GENUINE + SOME AUREOLIN YELLOW

COMMERCIAL BLACK

WG + IR

WG + WB

WG + WB + RMG

VIRIDIAN

COMMERCIAL BLACK

AC + WB

IR + AY + V

LR + AY + V (more)

DALMATIAN LACEMAKER

watercolor on Arches 140 lb.
cold-pressed paper,
23″ × 28″ (58.4 × 71.1 cm).

The Dalmatian coast is one of the few places left where lace is lovingly made by hand. In the medieval towns, the lacemakers work outside, seeking the sunlight. My interest was in capturing the glowing reflected light, so I placed its special colors on the paper first. When I then let the heavy darks flow, they began to overpower the delicacy of these special tones (see first attempt). Yes, I was creating a contrast, but I was losing the glow. A quick sponge bath removed the darks and gave me a second chance. This time I chose a softly grayed, dappled-sunlight background to better complement the skin and lace nuances and make them sing.

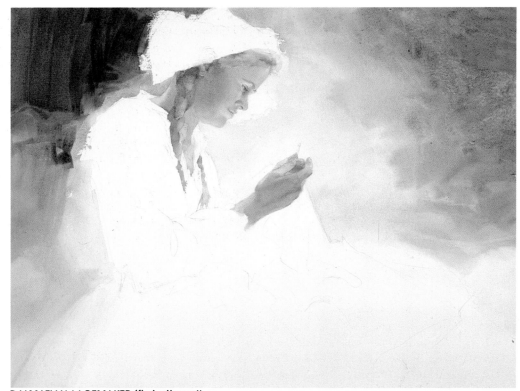

DALMATIAN LACEMAKER (first attempt)

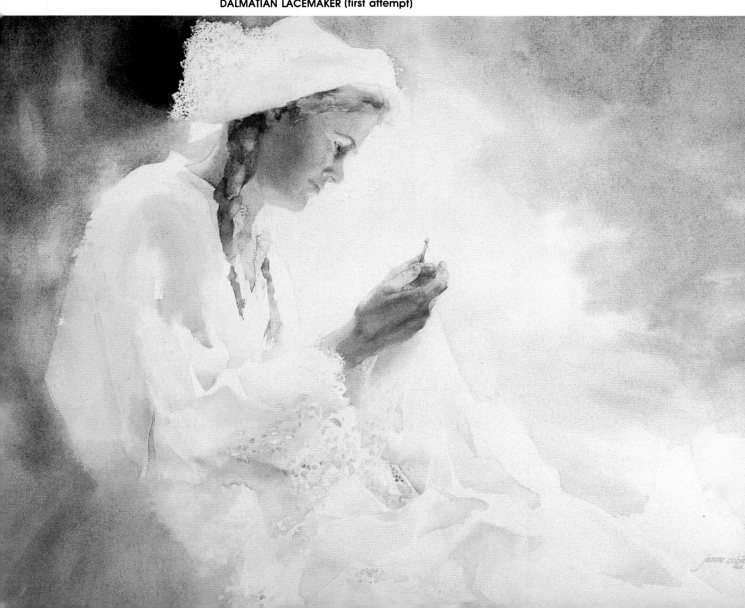

green light. Paint a brushstroke of each in a row across the page. Don't apply the paint too thickly; what you want is a luminous light.

2. *Surround the lights with a dark commercial color.* Go back to the left of each row and paint a square around each color using a black tube pigment. Notice that this creates a very strong contrast—but it is only a contrast. Your goal is to produce a glow.

3. *Now use a complementary dark.* You can get more vibration if you substitute a complementary dark for the unexciting commercial black. Mix a deep purple and use it to accent both yellow lights by painting a square around them. Moving to the next row, make the pink light shine by painting a deep green square around it. Try a rich, dark red or red-purple color to heighten the pale green light. Now a reaction is beginning to develop!

4. *Remix the complement into a warm or cool dark.* Instead of stopping at these complementary darks, let's go a step further to establish a warm-cool relationship. Again, mix your complementary darks, but this time push the color into a cooler mixture or pull it into a warmer, richer color as required. Remember what you learned in Lesson 5, "Push-Pull with Warm and Cool." If your yellow is warm, the best complement to make it sparkle is a cool purple dark. On the other hand, a cool yellow vibrates against a warm, reddish-purple dark. A pink light sings when a cool green dark surrounds it, whereas the cool light green bounces against a warm red-brown. Look back at the first black squares you painted. How dull and ineffective this light-dark contrast is compared to the glows created with color!

5. *Explore mid-value reactions.* Are you ready for yet another step? There may be times when your subject doesn't lend itself to darks, yet you would still like to make your color sing. To do this, you need to avoid any competitive vibrancy in the neighboring color. Once again, mix the complement of your light color, taking care to push it into a cool complement or to pull it into a warm. This time aim for a mid-value color rather than a deep dark. Now mute this mixture by adding a little of its complement. For instance, to the cool purple dark that will accent the warm yellow light, add a little yellow to gray the mixture. Because you have dulled the neighboring mixture, the warm yellow light glows brighter in contrast. The warm red-purple can also be grayed with a yellow complement to make the cool yellow shine. To illuminate the pinkish light, reinforce it with a cool green color that has been subdued with red. Lastly, paint grayed warm brown around the cool green to make it sing.

IT'S ALL IN HOW YOU DO IT

Sometimes, because of the dictates of the subject, you may not be able to use a directly complementary neigh-

boring color. Suppose your yellow is against a brown field or a blue sea. To make the yellow sing, try pushing the brown into a slightly purple brown or the blue into a purplish blue, approaching a complementary relationship. You may even be able to take this a step further—warming or cooling the mixture or muting it to create even more vibration.

Complements can have an impact on your lights even when they are not neighbors. One of my students painted a spontaneous watercolor of a field of golden wildflowers, but was disappointed that the yellows didn't vibrate. There was an unpainted patch in the lower right corner, and I suggested that she place a cool, muted lavender in that spot. The reaction caused the golden flowers at the top of the painting to come alive immediately.

As a final suggestion to help keep your color luminous: paint from light to dark. Then you can always relate other colors to the glowing light and reinforce it. If you work in reverse, from dark to light, you may end up with a contrast but no color reaction.

WHAT WENT WRONG?

A lot can go wrong in mixing glowing color. Use this checklist to see where you might have gone astray.

If a color becomes mud, you may have:

1. mixed two opaque pigments.

2. worse yet, mixed three opaque pigments.

3. used a tertiary pigment in a mixture.

4. mixed more than three pigments to obtain a color.

If a color is too neutral, you may have:

1. used equal amounts of the three primaries for a perfectly dead neutral.

2. selected a pre-mixed tube color of gray, umber, or black instead of mixing the color from pure pigments.

3. combined complementary pigments that cancel each other out.

If a color loses its luminosity, you may have:

1. overpainted with yellow (no matter how transparent) on top of another color.

2. used an opaque pigment over another color.

3. overloaded the brush, with a greater ratio of paint than liquid.

4. chosen a pigment with sediment.

9. WHITE GLOWS
Refining Subtle Blushes of White

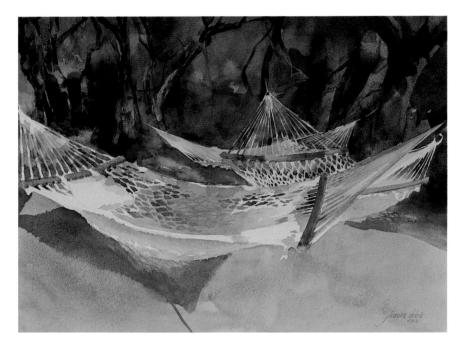

ISLAND EASE
watercolor on Arches
140 lb. cold-pressed
paper, 12" × 16"
(30.5 × 40.6 cm).

Think of your whites as colors, not blank areas. Select a composition, like this one, which features a white interest. Look for subtle warm and cool variations, as well as interactions with other colors, to make the whites glow.

As ARTISTS become more experienced, they seek to refine their work by adding elegant, subtle variations. Although barely discernible, these touches lend distinction to a painting. An Oriental master I knew would change the direction of his hand at a certain point when making a curved stroke. This minute detail, though crucial to the perfection of his work, was scarcely noticed by a viewer. Mixing colors of white is one of these subtle refinements that is almost invisible but can greatly enhance your work. Your whites should be like pearls, containing many beautiful colors and yet remaining white.

The challenge is to make a beautiful, unmolested white glow forth from your watercolor. Simply leaving the white of the paper and placing a dark nearby creates a contrast, but this does not necessarily give you the glowing light you seek. Instead, think of whites as warm or cool, muted or intense.

The subtleties of white colors are endless—the illustration on page 53 should whet your inspiration. It's important here to keep each white shade almost as light as a pure white, to project as a white rather than a halftone. To make my whites glow, I use the pure pigments diluted with lots of water. It may help to think of your white as a "blush." In other words, *one* gentle stroke is all you should use to preserve the virgin glow.

LET THE LIGHT EXPLODE

Since white in a watercolor often describes natural light, the first thing to understand is how we see light. When the setting sun touches the sea, it glows with such intensity that it appears misshapen as it spreads along the horizon. You need to squint to see the pilings silhouetted against it, which are almost consumed by the powerful rays. This is a very clear example of how the light striking an object expands and bleeds into the adjacent area.

To capture this elusive quality of expansion, avoid boxing in your whites. A boxed-in white is one that is hard-edged and looks cut out or pasted on. To eliminate this enclosed effect, give the white a subtle halftone neighbor. Keep in mind that in actuality, if you try to look at an object in bright light, the force is so blinding that you can't see a definite edge. The light tends to engulf the object and eat away at the edges—an effect that I used in creating the hat for *Dalmatian Lacemaker* (page 54).

FOCUS ON HALFTONES

For this exercise, lightly brush some subtle whites on your paper, perhaps as flower shapes (see page 54). Include a yellowish white, a bluish white, and both a cool pinkish white (made with rose madder genuine) and a warm pinkish white (made with cadmium red). Merely blush the colors on the paper so they are barely there. They won't "appear" until later, when the darker values are added around them.

To create a glow, look to your halftones. These are the next lightest values, which can be used either to describe the white form or to provide a transition, blending the whites into the adjacent area. The halftones you want are complementary gray-whites.

ENLARGE YOUR REPERTOIRE OF WHITES

AY + V	CB	CY	RMG + CB	V + CY
FU	AY	FU + AC	CO	V
RMG	V + CB	CR	WB + AY	AC
CO + CB	LR	V + RMG	IR	RMG + AY + CB
AY + CR + V	AY + V + IR	AY + RMG	CR + CO	AY + RMG + V
CR + V	AY + LR + V	AC + WB	CO + V	AC + CB + CO

This chart is just a sampling of the many different blushes of white you can create. For practice, make your own chart, using pure pigments diluted with a lot of water.

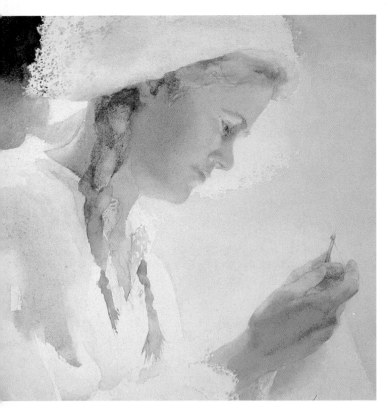

YELLOWISH
WHITE (AY)

DALMATIAN LACEMAKER (detail) *To recreate the feeling of light expanding, soften or drybrush your edges, as I did here (for the full painting, see page 50). To drybrush, let the paint dry on your brush and then paint with a quick stroke. The result is an uneven, ragged edge, as opposed to a clean-cut one.*

BLUISH WHITE (CB)

Wait until the whites are dry before adding the complementary halftones. For the yellowish white, choose a purple-gray tone. Watch the white glow as the halftone is placed next to it. Try using several shades of purple-gray to describe your white form. Next choose a warmish gray halftone to accent the cool blue-white. To complement the pinkish whites, you need green-gray halftones. Remember, however, that one of your pinkish whites is warm and the other cool. Next to the warm pinkish white, place a cool green-gray halftone. Then remix a warm green-gray halftone to complement the cool pinkish white. Don't try to ration your paint by using the same mixture for both because the red pigments are different. A cool green mixture (made with a cool red) cannot be warmed to a fresh, clean color simply by the addition of yellow. Refer to Lesson 4 on greens for advice on selecting the right red pigment to make your mixture warm or cool. Don't let mistakes throw you. Any time you are unhappy with a mixture, wipe it off the palette and start with a fresh batch.

HOW TO KEY A PURE WHITE

When you have mastered the white glows, challenge yourself by taking another step. Leave the pure white paper as your light. Now you may wonder which halftone color will accent it. In fact, any halftone you choose creates a subtle, optical illusion: it tends to push the un-

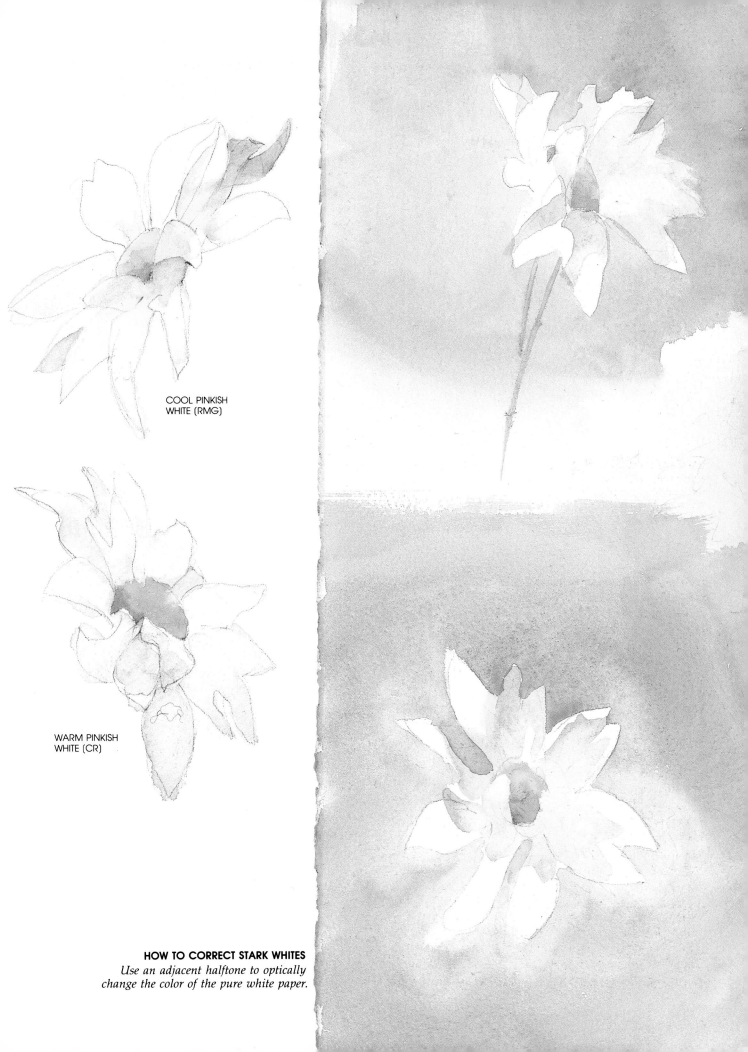

COOL PINKISH
WHITE (RMG)

WARM PINKISH
WHITE (CR)

HOW TO CORRECT STARK WHITES
*Use an adjacent halftone to optically
change the color of the pure white paper.*

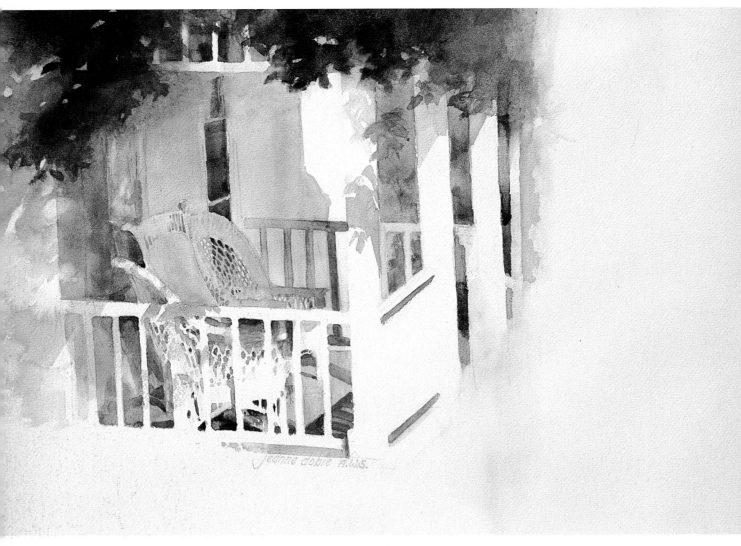

VICTORIAN LADIES
watercolor on Arches 140 lb.
cold-pressed paper, 14″ × 19″
(35.6 × 48.3 cm), collection of
Mr. and Mrs. Theodore A. Hall, Jr.

The actual subject for this painting may seem uninspiring, but my goal was to capture the elusive glow of morning light as it burst upon the scene. Observe where I've keyed the unpainted white paper so that it appears warm. In particular, the cool blue shadow lends the far white wall a mellow orange aura.

WHITE BOATS II BY JOHN MAXWELL, NA, AWS, DF
aqueous acrylic on board, 22" × 30" (55.9 × 76.2 cm), courtesy
of Newman and Saunders Galleries, Wayne, Pennsylvania.

*This prominent artist's interest was in the "pristine glow of the
ubiquitous white boats—silently huddled in their own veiled
whiteness." Notice how the artist painted different hues of white.*

touched paper into appearing as a complement. A blue-gray halftone, for example, gives the plain white paper a subtle, warm orange aura. This optical transformation—called "keying"—is valuable for correcting whites that seem too cold or stark. There is no need to modify the white, which is the usual reaction. If you want to keep the white pristine, simply change the halftone color.

Thinking of white as a color helps you key all the other colors to it as you continue. Before I began painting *Victorian Ladies,* I first considered the plain white paper as a color. Even though I left it untouched, I carefully related the other colors, so that it would become warm in feeling, rather than cold. Notice how the cool shadows react on the unpainted paper to lend the white of the back wall a warm glow. In another, extremely subtle reaction, the purple tones on the wicker chairs by the front railing pull the surrounding whites into a yellowish glow.

Keying your whites can make the difference between a watercolor with an ordinary light-dark contrast and a watercolor that develops a glowing contrast.

10. THE ART OF NOT MIXING
Layering with Glazes

ORCHID IN THE WOODS
BY NADINE PERRY
watercolor on Arches
140 lb. cold-pressed
paper, 12" × 16"
(30.5 × 40.6 cm),
collection of the artist.

Are you accustomed to a set palette or regulated method of using color? The more you can develop your thinking to encompass all possibilities, the more creative you will be. By glazing instead of mixing color, you can give your paintings a unique luminosity. The vibrant glow of this watercolor represents a skilled artist's first attempt at glazing.

EVERY lesson so far has demonstrated how to physically mix one color or another. But you can also "mix" color optically. To do this, you take advantage of one of the inherent qualities of the watercolor medium—its transparency—which allows you to overlay colors for exquisite effects. This is the art of unmixed color or glazing.

Glazing is a process of applying sheer layers of pure pigment, one over the other, to produce a desired color effect. It differs from a regular watercolor wash in that, in glazing, the colors are *not mixed* together but applied separately and allowed to dry thoroughly between applications. The word *glaze* means "glass-like." Glazes should be very transparent so that it is as if the viewer were looking through sheets of colored glass to the layers beneath. The result appears as a color mixed by the eye.

Artists of all levels of experience can benefit from glazing. Beginners will find that glazing provides control over their washes. If, for instance, you have ever lost your whites in a wet-in-wet technique, you will appreciate the glazing method. Or if white paper gives you stage fright, that, too, can be overcome by covering most of the paper easily with a glaze. In addition, working with glazes automatically simplifies a painting into a value pattern for the beginner.

But glazing can also challenge the advanced painter. In the able hands of the more experienced painter, glazing can stimulate creativity. By taking color apart and putting it together again, new ways of thinking about color come into being.

Glazing imparts a luminosity not attained by any other method. This makes it a natural choice for capturing the subtle nuances of an overcast day or a predominantly gray scene. The transluscent grays obtained by glazing can enliven a potentially dull or bland painting.

Turn to my finished painting of an Ohio River barge on page 61. The river was enshrouded with early morning fog as the sun sluggishly tried to burn through. The unusual warm lighting behind the fog could never have been captured with ordinary wet-in-wet effects or gray washes. But the glazing method came to the rescue. By taking the final desired mixture apart and applying the pigments one at a time in glazed layers, I was able to duplicate the sun shining through the fog. Follow along to understand how this was done.

Glazing looks easy and sounds easy, but most artists have trouble when they try it the first time. I always put my classes through the process to check each step along the way and spot any problems. Since I can't be by your side, numerous guides are included to prevent disappointments. My best advice is not to skip ahead but to patiently execute each step.

GLAZING PREPARATION

1. *Choose a dry sheet of watercolor paper that has been stretched taut.* Because the major portion of your painting will be glazed, you want it to be as smooth as possible. Unstretched paper expands when wet and buckles, developing hills and valleys. The paint inevitably runs down and settles in the valleys to become an uneven wash.

2. *Tilt your board* to approximately a 15° angle to give yourself as much control as possible. Now the wash can only flow downward.

3. *Select a wide brush with a fat heel.* The thicker the heel of the brush, the more readily it will store abundant amounts of wash.

4. *Mix the wash.* Use transparent pure pigments to attain the optimum glow. The most effortless way to obtain a good wash is to start with the pigment first and then add water, not vice versa. Pick up a generous amount of fresh pigment on your brush. Place this in the bottom of a paper cup, then add the water. If the mixture seems too strong, adjust it with a little more water. If the mixture seems too weak, simply add more pigment. *Be sure to mix twice as much wash as you think you'll need.* When a painting is dependent on a glaze, the worst disaster is to run short of color. Always be prepared with an ample wash.

5. *Design the white area* to be saved. Whites really sing when surrounded by a glaze.

THE FIRST GLAZE

Now you are ready to begin. Remember, instead of mixing pigments together in a single wash, you are going to apply them separately, one by one, over each other. The final effect should optically approximate the color you want. Look again at the finished painting of *Along the Ohio.* To duplicate the warm effect of the sun burning off the fog, I began with the yellow layer (see page 60). Since yellow is the lightest and most delicate color, it does not cover when used on top of another pigment. Instead, it becomes opaque and loses its luminosity. *If you wish yellow to glow, always place it on the paper first.*

I like to use aureolin yellow because it is so transparent that it is unbeatable for capturing light. Another advantage is that aureolin yellow is not a staining pigment and will lift from the paper, should you accidentally paint through some of your white. If possible, try to avoid selecting staining pigments for use in a glaze. They tend to stain or dye the underlayers and consequently destroy the translucent quality. If it is necessary to use a staining pigment, generously dilute it.

Let's begin now with the first yellow glaze. Dip your brush into the yellow wash and begin a stroke across the top of the paper. Here is where a good wash brush is helpful, as it will constantly feed color until the brush reaches the other side. A thin-heeled brush quickly empties, requiring frequent redipping, and the glazing stroke may not be as smooth.

Notice that a "bead" has formed at the bottom of the stroke as the excess paint flows downward. Return to the edge and begin another stroke, just catching the bead as you move across the paper. *Try not to paint over the bead,* or you'll leave a double yellow stripe. Continue to paint each succeeding stroke, left to right (or, if you are left-handed, right to left), being careful to catch the bead. It helps to pretend you are a house-painter, painting clapboards.

The secret is not to go back over a glazed area or attempt

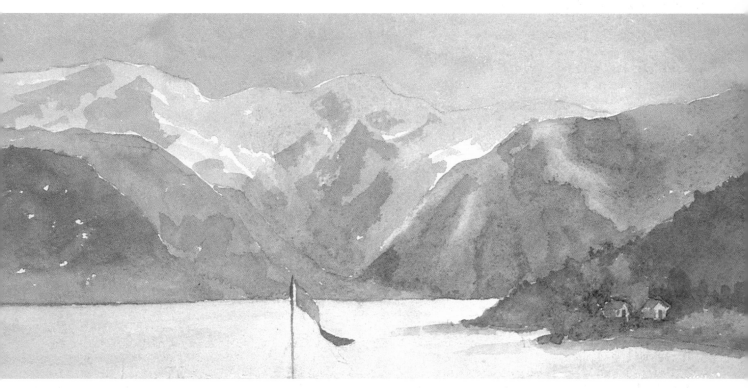

SOGNEFJORD BY HELEN SCHNEEBERGER, watercolor on Arches 140 lb. cold-pressed paper, 10″ × 17″ (25.4 × 43.2 cm), collection of the artist.
Glazing can be used in individual ways to elevate an ordinary subject into a personal vision. This artist, for instance, transcends the usual picture-postcard blue sky to create a special atmosphere with glazes. Try adding mood to your paintings by varying the glazed layers to reflect different atmospheric effects.

GLAZING STEP BY STEP

In this demonstration, done on location for a workshop, I wanted to capture the elusive quality of sun burning through the fog. As you follow the steps, keep in mind how easily the three glazes could be varied to gain any atmospheric effect desired.

1. *Glazes should not be equal. This first glaze of aureolin yellow, which simulates the sunlight, is painted strongly. Notice that I've kept the white shape simple so that I can continue glazing without interruption.*

2. *The second glaze of rose madder genuine is diluted to retain the feeling of sunlight through a morning mist.*

3. *The third glaze of cobalt blue is "barely there" to keep the illusion of sun behind the fog.*

4. *Here I've added an extra layer of the blue glaze to the river area to deepen it. Without waiting for the glaze to dry, I included the reflections and two glints of orange.*

5. *Because the underlying color shines through the layers, this glazed painting is more luminous than one done with the wet-in-wet or gray wash method. Moreover, the glazes suggest the atmospheric layers of mist and convey the mood I intended.*

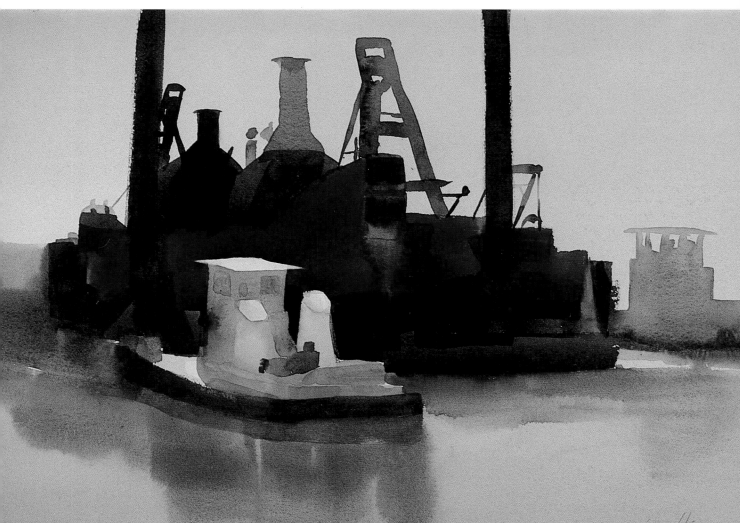

ALONG THE OHIO watercolor on Arches 140 lb. cold-pressed paper, 14½″ × 21″ (36.8 × 53.3 cm), collection of Pat A. Lusk.

AVOID POTENTIAL PROBLEMS

To alleviate pinholing, when the paint won't flow into the valleys of the paper, change the angle of your brush so that it is vertical to the paper.

Remember to collect the bead at the top edge of your white area with a thirsty brush.

Be sure to catch the bead with each successive stroke. Don't paint over it, or you'll leave a stripe.

Try not to go back over a glazed area. Any excess water can spread, leaving unwanted oozles and blossoms.

any repairs. If you do, you will add more water, which must flow or expand somewhere. A few seconds later it will spread and reappear as blossoms, backrings, and oozles (see the illustration on this page).

As you paint, you may encounter a problem with "pinholing"—white paper dots left behind where the paint won't flow into the valleys of the paper (see this page for an example). Alleviate pinholing by simply changing your brush to an upright position, vertical to the paper. This forces more paint downward to fill the pinholes.

When you reach your nicely designed white area, continue to use horizontal strokes, but lift the brush to skip over the white shapes. *Avoid painting "around" your white shape.* Don't worry if the edges are not straight or carefully executed; you can correct them later if you want (remember: aureolin yellow lifts easily). Frankly, I prefer to leave the minute overlays of the glazes. They are usually so light in value as to be barely noticeable. Moreover, they add a little color vibration at an edge that might otherwise be too clean-cut.

After saving your white area, you'll notice that a bead has become trapped at the top edge of your white. *Pick this bead up with a thirsty brush.* A thirsty brush is one that has first been wet, then squeezed between your fingers to remove the excess water. Just touch it to the bead to absorb it instantly.

Before you step back to admire your first layer of glazing, take a tissue and *wipe the edges of the paper.* This simple precaution gets rid of any excess water so that it can't creep back into your painting and create unwanted blossoms, oozles, or textures. Now take a good look and assess your yellow layer as it dries. It should be right on target—check it. Is it too light or too dark, or just about right? If it is too light, wait until it is completely dry, then put on another glaze layer. If it is too dark, again wait until it is thoroughly dry and reglaze, this time with pure water only. Some of the excess color will collect in the bead and be washed off the sheet when the glaze reaches the bottom of the painting.

It's important to *adjust the yellow glaze before continuing.* Unfortunately, you can't correct it later after the other glazes are added. As mentioned before, the yellow pigment becomes opaque when it is applied over other pigments, so that the transparent quality of the glaze would be lost.

Don't despair if your first attempt results in too much color or too little color. Glazing requires several trials to develop an expertise in estimating how much pigment is needed. Eventually, with practice, you will be able to judge how much red, yellow, or blue is required to produce the desired effect.

SUBSEQUENT GLAZES

When your yellow glaze dries, you are ready for the second glaze. This time use the most transparent red—rose madder genuine. Again, mix an overly generous wash in a paper cup. Then, with the same patience, carefully stroke from edge to edge, catching the bead that forms

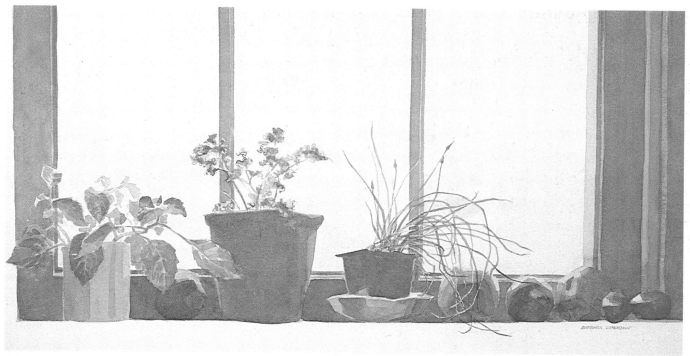

OCTOBER WINDOW BY BARBARA OSTERMAN, AWS, watercolor on Arches 140 lb. cold-pressed paper, 15" × 27" (38.1 × 68.6 cm), private collection. *Don't try to be neat at the edges. This artist has let the overlaps show for subtle color variations.*

with each succeeding stroke. Leave your white shapes and pick up the extra bead on top with the thirsty brush. As you finish, don't forget to wipe the edges of the painting to eliminate excess water and prevent unexpected textures.

Now assess the second glaze. This layer needs to be adjusted only if it is too dark. (To do this, reglaze it when dry with water only.) If it seems too light, you may choose to continue with the next glazing layer, and judge later if an adjustment is necessary. Red and blue glaze layers can be reapplied over one another for a deeper color at any time. It is only the yellow pigment that doesn't work successfully on top of another pigment.

Once the red layer is dry, begin the final layer. Cobalt blue—the most transparent blue—is the best choice for this glaze. Again paint across the paper, controlling the bead as you continue painting stroke by stroke down the paper. All this glazing practice has probably made you an expert at flowing washes by now. Remember to save your white shape, then collect the bead at the top of it, and wipe the excess from the edges of the paper. Your glaze is complete, unless you wish to add another layer of red or blue (or both) to obtain a special effect. For the Ohio River barge painting, I added an extra blue glaze to deepen the water area.

As you finish the last glaze, you can continue with the painting without waiting for the last layer to dry, especially if you want some softly blended edges. In *Along the Ohio,* I immediately added the muddy reflections to blend into the water. At the same time I noticed two glints of color reflected from the smokestacks and intro-

duced them into the water. As you can see, a glaze acts as a perfect foil for such special color effects.

EXTRA HINTS FOR SUCCESS

You can alter the glaze layers to accent any color you choose. *Avoid making all three layers equal*—you'll only produce a dull neutral. A closer look at the glaze in the barge painting reveals a soft, warm glow penetrating through the grayed atmosphere. To achieve this result, I made my yellow layer strong; the red and blue layers were kept weaker so the warmth would dominate. Similarly, if you want a blue-gray sky, simply use a strong blue glaze and fainter glazes of yellow and red. For a purple-gray effect, keep both the red and blue layers strong with the yellow layer weaker.

Don't eliminate a layer. Let's say you decide to drop the red layer because you can't see any red tones in the sky. But then you may be unhappy when your sky turns green. Paint a very pale, "barely there," red glaze to prevent that from happening. Always use three primaries and control the results by strengthening one or two colors.

The time-consuming and careful execution of glazes is well worth the effort. Notice how the white areas glow beautifully against the glazes. The delicate layers are the next value deeper. All that is necessary to complete your painting is to add the middle values and darks to accent your whites and glazes, and make them luminous.

If you're not convinced about the value of glazing, try an experiment. Mix your three colors together in a wash, then compare the result with the same colors layered separately in a glaze. There *is* a difference!

11. ATMOSPHERIC GLAZES
Working with Gradated Glazes

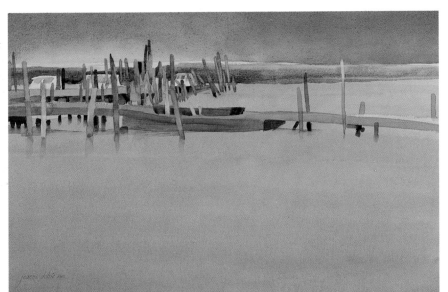

What can you do when your composition has large, potentially uninteresting areas? For an understated emphasis, I used atmospheric glazes to convey both the feeling of water and the silent threat of an impending storm.

AFTER you've become expert at flowing glazes, you may wish to vary the glazes so that they are stronger in some areas of the painting than in others. These gradated glazes allow you to capture not only subtle atmospheric lighting but also an illusion of space. Straightforward glazing (as described in the preceding lesson) is best used when you don't wish the sky to compete with the subject. If, however, your scene seems a bit tame or uninteresting, or if the glazes occupy a large section of the painting, variations in the glazes can add interest. With distinctive glazes, the background can become an important element in a painting.

Using gradated glazes is not difficult, only a step beyond the glazing procedure you have already learned. To begin, simply follow the preparations outlined in the preceding lesson. Select a dry, stretched piece of paper; tilt your board for flow control; pick up a fat-heeled wash brush; and mix a generous batch of pigment in a paper cup. The paper cup allows you to keep the wash close at hand for an uninterrupted supply.

GO FROM STRONG TO LIGHT

We're ready now to start the first glaze. Remember that to attain the glass-like quality of overlayering, you need to select glass-like transparent pigments. Again, my favorite is aureolin yellow. This time *mix a slightly stronger wash than before.* Stroke this deeper wash across the top of your paper. Before you make the next stroke, add a few brushfuls of water to your wash. The second stroke will then be slightly lighter in color. Before beginning the third stroke, add still more water. *Continue diluting the wash with water before each succeeding brushstroke* for

a gradual lightening of color. At the same time remember to carry your bead down the paper, save your whites, collect the bead on top of them, and wipe the edges of the paper when finished. Let this first layer dry thoroughly before beginning another. Stop at this point and assess your yellow color. If necessary, adjust it with another glaze before proceeding.

For the second glaze, mix an ample supply of rose madder genuine, again a little deeper than in the previous lesson. Brush the rich color across the top of your paper. Thin your succeeding wash with some brushfuls of water before the next stroke. Continue diluting and painting in the same manner as you did with the yellow glaze. When finished, allow the glaze to dry completely.

Repeat the same procedure for the third glaze. Start with a lively, transparent cobalt blue and gradually diminish its strength as you paint down the sheet. The result is a gentle transition of the sky color, moving very gradually into the distance. At this point, you can add another gradated glaze of red or blue (or both) to enhance the atmospheric effect.

There's a caution here. If you need more than three or four glazes to create a special atmosphere, take care. Your success or failure depends on keeping the overlays very transparent. The impact is lost without this transparency. Try to arrive at the desired color with only three or four applications. When you are successful in adjusting the three primary colors, there is no advantage in continually applying more. Unnecessarily adding glaze upon glaze eventually cuts down the amount of light penetrating through to the paper and deadens the luminosity. Keep the glazes light, transparent, and minimal in number.

EXPERIMENT UPSIDE DOWN

For still further creativity, turn the painting upside down before beginning one or two of the layers. Then, after you've painted this reversed layer, turn the painting right side up again. The color will then be deeper at the bottom than the top.

I used this method for *Butter and Eggs Road* (see page 67). The yellow glaze was painted right side up, so that it was strongest at the top and gradated toward the bottom. When it was dry, I turned the painting upside down to apply the gradated glaze of rose madder genuine. Thus when the painting was viewed right side up, the glaze of rose madder genuine was more forceful at the bottom. The gradated blue glaze was then painted with the watercolor right side up. The layers in the lower half of the painting mixed optically to lavender, while those at the top produced a warm gray.

You can turn your painting in any direction you want. Some artists have turned their paintings sideways for gradated washes to describe and enliven snow, sand, or wheatfields. Experiment and discover how to put your creativity to work.

HOW TO COMPLETE THE PAINTING

At this point you may be indecisive about how to finish the painting because you fear ruining the beautiful glazes. After all, much time has been expended to adjust them and make them glow. So far, the glazes have helped you cover the paper and retain your white shapes, which are often lost in the wet-in-wet technique. But glazes provide only a halflight value. What about the midtones and darks?

If you are unsure about how deep your midtone should be to bridge the gap between your glazes and darks, pick

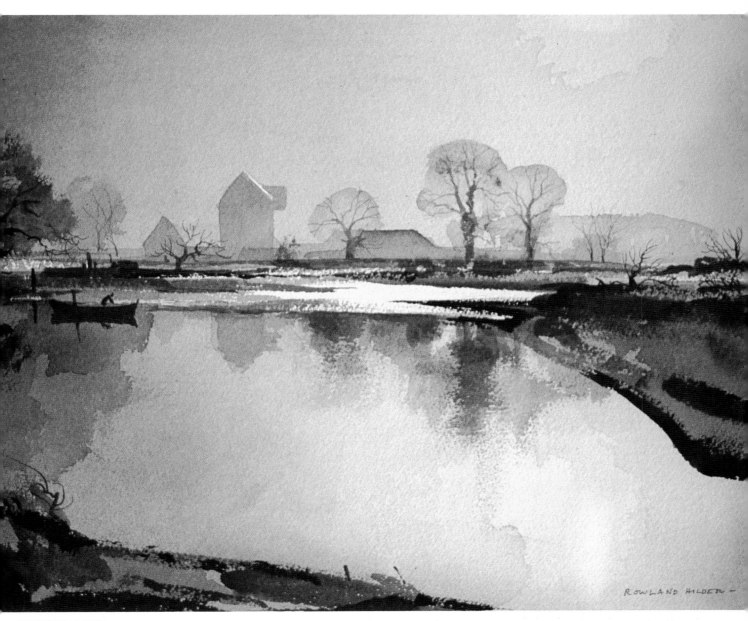

WATERMEADOWS BY ROWLAND HILDER
Royal Institute of Painters in Watercolors, London, Arches 110 lb. paper, 15″ × 22″ (38.1 × 55.9 cm), private collection.
This British artist is a master at using glazes to capture atmospheric nuances. In this painting delicate layers create the unique lighting.

up a brush or some other dark object and hold it up to your painting to discover how light your glaze really is. Now you can see how much deeper you need to make the midtones and dark values to complete the painting. Be sure to save a generous portion of your glazed area, however. Too often, in finishing a painting, artists become overzealous and cover everything, including the glaze, in darker values. They thus wipe out the luminosity.

Look again at *Butter and Eggs Road,* a teaching aid I painted for my students. I planned to leave a large area of the glaze as an important portion of the composition to show that a glaze is only a halflight value. The glazing looked deceptively dark when completed. When the middle-value green was added, however, the students were surprised to find that the fence (the glazed area) was lighter than they originally thought. They were also surprised to find that once the middle value was added, the demonstration was almost complete. Only a few dark areas would be needed to complete it as a painting.

SO MANY ADVANTAGES

One of the advantages of the glazing method is that it organizes a painting strongly into simplified value areas. It also reinforces other good watercolor habits. You learn, for instance, to leave an area alone, so that it doesn't become overworked. You are also pushed into thinking of the whole painting as a unit, instead of getting entangled with the subject alone. In fact, the glazes serve as a frame for the subject. Moreover, there is no room for indecision. You can't leave an area unresolved, to be completed later.

Does glazing have any disadvantages? Yes, one. Glazing leaves crisp edges. It is thus not the best choice for describing subjects with softly blended edges, such as billowing clouds.

Glazing is best suited for capturing delicate atmospheric nuances, making whites truly glow, and creating optical color vibrations not possible in ordinary mixed washes. But the greatest benefit is clean, clear mixtures. When the colors are applied separately, it is impossible for them to contaminate one another.

GRADATED GLAZE DEMONSTRATION

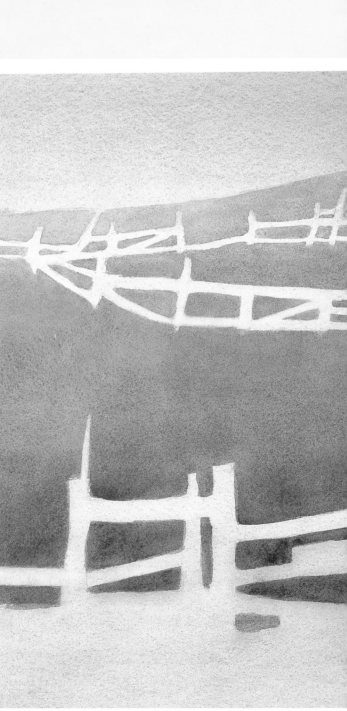

BUTTER AND EGGS ROAD (teaching aid)

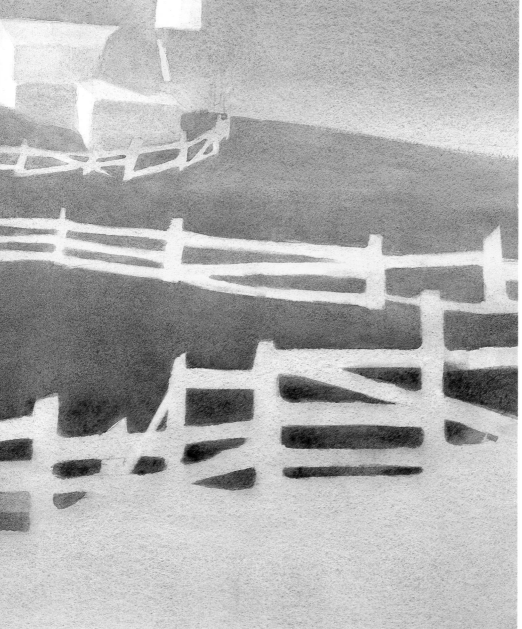

1. *Paint the first stroke of the yellow gradated glaze in a strong color. Then add water to each successive brushstroke to gradually lighten the color. If you have difficulty saving your white shapes as you paint, try labeling them with a large W in erasable pencil before you begin.*

2. *Reversing the painting creates even more variety. Here I turned the painting upside down to flow the red gradated glaze from the bottom to the top.*

3. *For the blue gradated glaze, I turned the painting right side up again. Notice the many color variations obtained from only three glazes. The subtle color blendings would be difficult to duplicate in a single wash.*

4. *Look at the glazed area now, after I've added the middle-value greens. It is actually quite light. All the painting needs are some dark touches.*

12. A MULTILAYERED VISION
Glazing Color Creatively

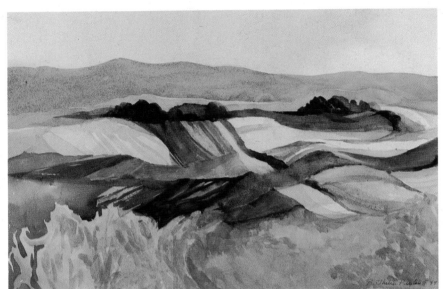

PENNSYLVANIA PATTERNS
BY B. THELIN PRESTON
watercolor on Arches
140 lb. cold-pressed
paper, 11½" × 19"
(29.2 × 48.3 cm),
collection of the artist.

Don't be content with ordinary color. Explore the multiplicity of nuances possible with transparent overlays of color. Selective placement of your glazes can enhance the colors in the rest of the painting. By adding glazes in the foreground and a few well-chosen areas, this artist made the whole painting come alive.

Y OU MAY be familiar with the idea of taking a painting apart in terms of its design. But have you ever thought to do the same with color? Glazing is the perfect method for separating colors and putting them together again in a creative way. Think of the freedom you have to rearrange the overlays in highly individual combinations. You'll find that isolating colors in this way is a pleasant departure from the habits of traditional mixing; it stimulates new approaches to color. To be used creatively, however, the art of not mixing color requires mental exercise before a single stroke is made.

With glazing, you have to think ahead in layers of color. Essentially this multilayered vision forces an overall approach in terms of color. You paint purely in overlays, without modeling, and let the glazed layers produce interchanging colors.

WHERE TO USE GLAZES

Let's try using a multilayered vision to depict an uncomplicated group of farm buildings, following the demonstration on page 70. As you draw the buildings on the paper, plan your white areas to be saved. But it isn't only the white areas you need to plan. Before mixing your first wash of aureolin yellow, you also need to mentally determine the areas where you don't want a yellow glaze.

Suppose, for example, you want one of the roofs to have a warm, rosy cast; another, a lavender color; and others, different colors. The yellow glaze would dull this multicolored effect, so you may choose to eliminate it from the roofs. In this case, leave the roofs as white paper when you apply your yellow glaze. Later you can use the glaze of red or blue, or both, to cover the roofs with the color effect you seek.

Look around—there may be other areas you do not want subdued by the yellow glaze. What about the snow near the buildings? If left cool, it will contrast nicely with the deep, warm mustard of the fields. To keep the snow cool, you certainly don't want any yellow in it. This, then, is another area to leave as plain paper when you glaze. Later it can be covered by the blue glaze.

Once you have determined which areas will be left white and which will become colors without the influence of yellow, you are ready to begin. Prepare your yellow wash and apply it, carefully leaving the roofs and the snow area as unpainted paper.

While waiting for the first glaze to dry, again think ahead. Decide which roofs will receive the pinkish tone of the second glaze and which ones will remain white. The lavendar roof, for instance, requires the red glaze, while the blue roof does not. The snow should also be left untouched. Once your decisions are made, begin the layer of rose madder genuine, saving all the areas planned. Then, while this layer dries, you can plan your next glaze.

One last time, resolve which areas need to be covered with the cobalt blue glaze and which do not. You may want to save a white roof or two. For different colors, save one of the pink roofs, but overlay the other pink roof with blue and watch it turn lavender. You may also choose to make one of the unpainted roofs cool with the blue glaze. And for the snow to be cool, it must be described with the blue glaze too. But do you really want blue glaze added to the rich, warm field? You don't. Then simply end the glaze midway down the painting and leave

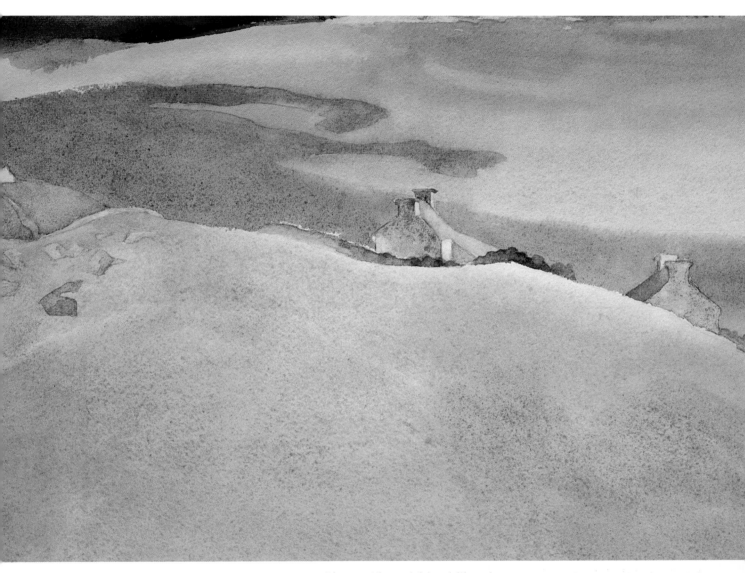

ERIN DRUMHILLS (detail) *If you wish special jewel-like colors to glow, paint them in glazed layers. The cottage depicted in* Erin Drumhills *(see also page 28) was caught in a few lingering rays of light. To capture this effect, I began with the local color of the cottage. When it was dry, I lightly applied a glazed shadow and allowed the underpainting to shine through. The resulting luminosity cannot be obtained by any other method.*

SELECTIVE GLAZING

1. *Before beginning, I decided which areas to leave white and which to save for a special color. These areas didn't receive the yellow glaze.*

2. *As I added the red glaze, I included the pink roof and the roof that would become lavender.*

3. *The blue glaze appears only on those areas I intended to be cool; I thus eliminated it from the warm field. Notice how one pink roof has now become lavender.*

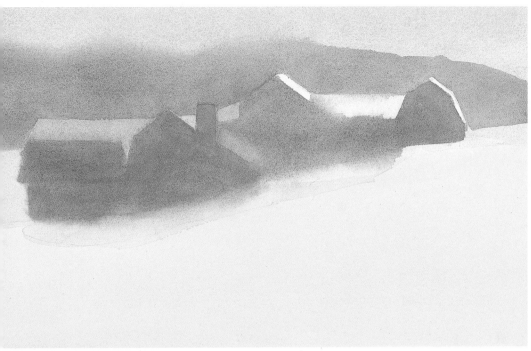

4. *Without waiting for the blue glaze to dry, I continued with the middle values.*

5. *All the careful planning results in a glowing interchange of color. For the greatest luminosity in your paintings, do not mix colors—instead, select and overlap glazes creatively to produce other colors.*

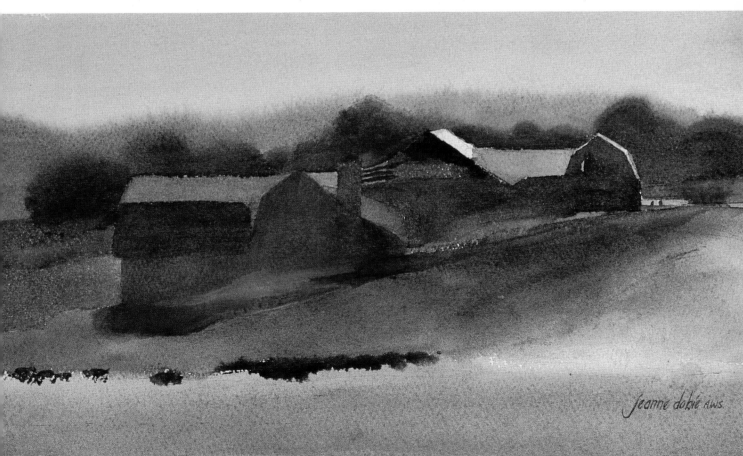

PUDDLEDUCK FARM watercolor on Arches 140 lb. cold-pressed paper, 8″ × 12½″ (20.3 × 31.7 cm), collection of Judy Bolton Jarrett.

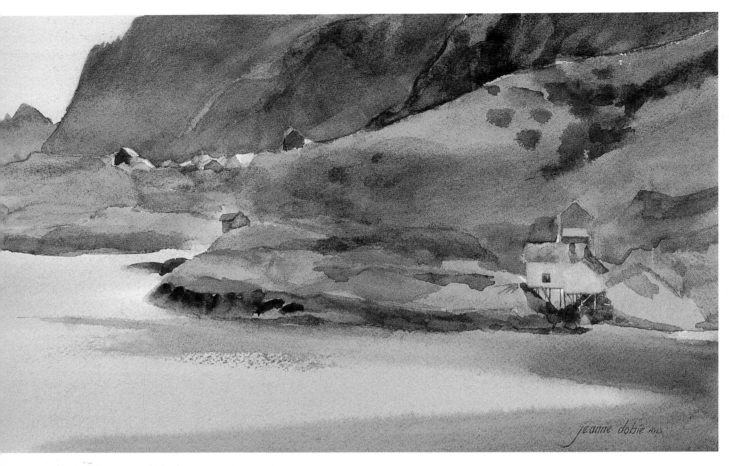

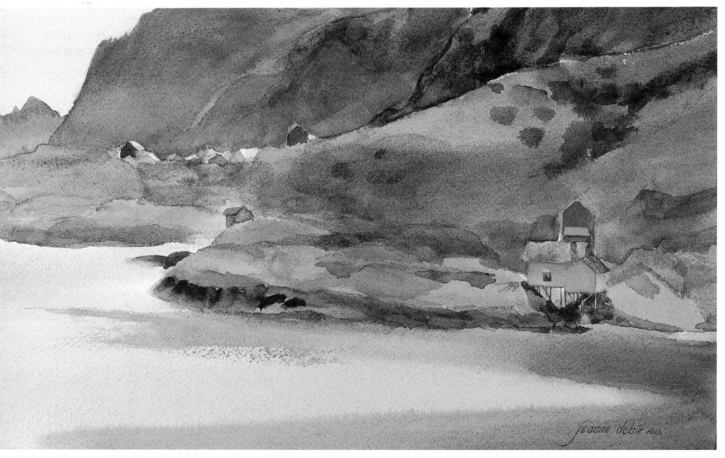

the field unpainted. There is no rule that states you must glaze the whole sheet of paper.

Stop and look at all the variations in color you have created without mixing any pigments. The object of this lesson is to learn to overlap your glazes creatively to produce other colors. Notice how the colors vibrate when the pigments are in their pure form. Now add your midtones and darks to complete the painting.

GLAZING FOR UNUSUAL COLOR

By now you must realize that glazing helps give you personalized, distinctive color not found in a commercial paint tube. It can be essential in capturing a special color effect. While I was teaching in Portugal, for instance, my class became entranced with the light changes on the tile roofs as the sun struck them. The white stucco walls developed a pink glow, against which the orange roofs vibrated. My students wanted to take photographs and hurry on to dinner, but I advised them to make color sketches if they wished to capture that particular lighting condition. When they did so, they were surprised to discover the roofs were not vibrant orange (as they assumed). They arrived at the color only by subtle glazes of yellow-green and red, which enriched the orange and explained the sunlight striking the roofs. Had they relied on photographs, the unique color effect would have been lost. With the glazed sketches to guide them, their paintings took on a distinctive coloring.

MAKE SHADOWS SHINE

Often, when a color is changed to a deeper value, it becomes dead. Here again, glazing is an asset—it makes luminous shadows possible.

To ensure the luminosity of a shadow, first paint through both the light and shadow side of the subject with the natural (local) color. Then glaze a shadow color over the portion in shade. Because the natural color beneath shows through the transparent glaze, your shadow is luminous. It is also related to the light area of the subject. That is, the shadow belongs to the house or field; it doesn't look like a newly introduced shade (which unfortunately often happens when the shadow color is mixed separately). A word of caution: *Be sure to make your local color rich enough to show through the glazed shadow.* You won't have a chance to repeat it!

Many artists find that yellow is the most difficult color to deepen into shadow. Since yellow is a lightweight pigment, trying to mix it into a darker shade rarely works. The resulting mixture is usually brownish or has a greenish cast, but is never a true yellow. But look how easy glazing makes it. To gain a clean shadow, use the procedure described in the previous paragraph and paint a strong yellow through both the light and shadow areas. When dry, lightly glaze it with its complement (purple) and you'll have a rich yellow glowing through the shadow.

A glazed painting has a life of its own; it is much more than a simplistic representation of the subject. As you plan your glazes, you have to go beyond the immediate subject and think about the painting as a whole, taking the view apart and putting it together again in layers of color. Your artistic reactions unconsciously enter the painting in this multilayered vision. In fact, the same subject can be painted in numerous creative ways, with different glazed areas. Enjoy discovering all the artistic possibilities!

i LOFOTEN
watercolor on Arches
140 lb. cold-pressed
paper, 7¾" × 12½" (19.7 × 31.7 cm).
Above the Arctic Circle the colors are remarkably pure and clear. You wouldn't want any muddy shadows there. Notice the difference when I gave the yellow house a shadow that vibrates, thanks to a glaze.

13. E R R O R I N T O A S S E T
Correcting with Glazes

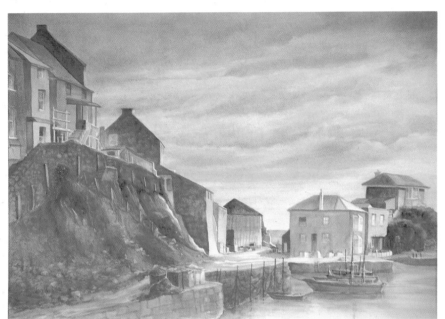

MEVAGISSEY
BY LOIS VAN DYNE, MWS
watercolor on Arches
140 lb. cold-pressed
paper, 21″ × 29″
(53.3 × 73.7 cm),
collection of
Meredith Moore.

Why worry about learning to paint the perfect watercolor? How much more beneficial it is to acquire flexible tools and place in your hands the ability to create. With glazing, this artist had a second chance to pull the colors together in a busy harbor scene. She expertly glazed any details that needed to be made compatible with the overall design.

Is THERE a way to correct color without scrubbing, erasing, darkening, or covering it in desperation? Although it sounds too good to be true, this can be done with glazing.

Rarely does a watercolorist execute a perfect painting. Not until the work is almost finished can the artist accurately assess if all the colors are working in harmony. More often than not, several are too strident or out of tune with the rest. To many artists, correcting those colors means toning them down with black or a darker color. Sadly, the clean color becomes sullied and dull. With glazing, however, you can successfully settle these "loud" colors into the overall color scheme.

HOW TO TAME OVERLY BRIGHT COLOR

Paint a row of vibrant color squares on your paper. Make them as bright as possible. Include a saturated red, a yellow, and two squares of orange. Add a bilious green, two purple squares mixed from rose madder genuine and cobalt blue, and two squares of brilliant blue. Patiently let them dry. While waiting, repeat the squares in another row, adding black or a deeper color to each mixture to kill the brightness. Later you will be able to compare these toned-down versions with the corrections made with glazes (see page 76).

A solid working knowledge of the complements, plus choosing the most transparent pigments, is the key to modifying overly bright colors. When the first row is dry, return to the strident red. Trying to calm your red with a deeper mixture may work, but you will be disap-

pointed with the loss of color. Instead, select the complement of red, which is green. Since viridian is the most transparent green pigment, it is your best glazing choice. When you cover the red with a viridian glaze, it is immediately toned down, but the red color continues to shine through. There is no reason to give up a rich red color in a painting or to compromise the shade by deepening it. Should a bright barn or autumn foliage refuse to be compatible with the rest of the landscape, use this simple correction method.

With the next square of intense yellow, use a glaze of its complement, purple. To keep the glaze as transparent as possible, mix the purple from rose madder genuine and cobalt blue, the most transparent red and blue pigments. In this way, you can subdue the yellow without compromising the hue. As noted in the preceding lesson, this knowledge is indispensable for shadows on yellow objects.

Now two squares of vivid orange confront you. Here you have two glazing choices. You can either use a direct complement or a variation. Let's try both. Over the first square, blush a blue glaze, which is the complement of orange. Notice how the color becomes quieter. If, however, you want to retain a brighter orange, try a glaze of viridian on the second square. Although viridian is seldom used in its pure state in watercolor painting, it is such a beautiful, transparent pigment that it adapts well to glazing. Notice that the orange beneath the viridian glaze is livelier than the one beneath the blue glaze.

Next is the raw green square that sets your teeth on

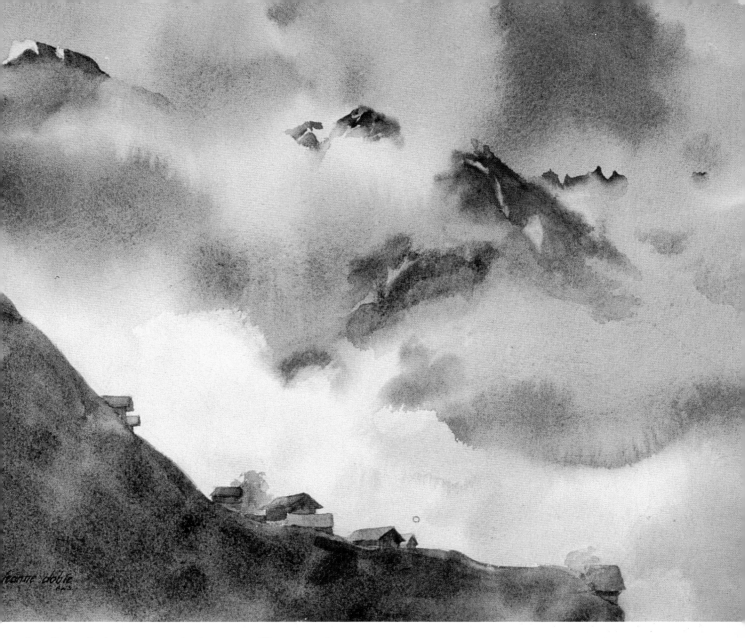

ALPENTOPS
watercolor on Arches 140 lb. cold-pressed
paper, 12" × 16" (30.5 × 40.6 cm).

This brewing storm was such an exhilarating subject, I painted it on the spot, with little chance to plan. (Even so, I didn't make it to shelter in time!) When I analyzed the painting later, I found that the foreground hill and chalets were too bright for the dramatic mood. With the help of glazes, I settled the chalets in and quieted the rich green.

edge. Its complement, a red pigment, will correct that. Whenever possible, choose a glaze of very transparent rose madder genuine to calm a green. Because, however, rose madder genuine is a delicate pigment, it sometimes cannot modify a fully saturated, staining green. In this case, move on to another red pigment. Although the next logical choice may seem to be the transparent alizarin crimson, avoid it! Alizarin crimson is a staining pigment and as such tends to dye the color beneath, destroying the layered effect. Instead, choose cadmium red or Indian red and dilute it. Even though these pigments are opaque and thus diminish the reflected light, they are still preferable to a staining pigment. Of these two, Indian red has tremendous covering power, even when diluted as a glaze. If you ever have a desperate need to correct something by covering it over, remember this quality.

The next square of purple may baffle you. How can you best alter it? If you paint the complement—yellow— over the first square, you'll find it thickly coats the top. (Remember, yellow must be next to the paper to stay transparent.) Again, the versatile viridian is an excellent alternative. Glaze the second square with viridian. Which

correction would you choose? If you find yourself struggling with a violent technicolor purple sky in your painting, simply tame it with a transparent viridian glaze. The result is so distinctive that some of my students plan this "mistake" on purpose!

Finally, we come to the two brilliant blue squares. These give you an opportunity to try another comparison. Orange is the complement of blue, so glaze both squares with orange, but experiment with different oranges. Over the first square paint cadmium orange. This color is very noticeably opaque and sits on top of the blue shade. To glaze the second square, mix the very transparent pigments aureolin yellow and rose madder genuine for a

CORRECT COLORS WITHOUT COMPROMISING

When you subdue an overly bright color with glazing, you don't compromise the hue.

RED SQUARE

GLAZE: VIRIDIAN

YELLOW SQUARE

GLAZE: ROSE MADDER GENUINE
+ COBALT BLUE

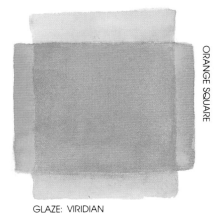

ORANGE SQUARE

GLAZE: COBALT BLUE

ORANGE SQUARE

GLAZE: VIRIDIAN

Deepening the same pigment with black or a dark color won't give you the same luminosity.

transparent orange. The difference is subtle, but a color connoisseur will notice it.

Now compare the muted colors obtained by glazing with the row of mixtures made with black. Surprised? Every little bit of color knowledge helps you create cleaner, clearer color.

BRING DULL DARKS TO LIFE

So far you have learned that nonstaining pigments are the best choice for glazing. Don't, however, completely discard the staining pigments for this purpose, for they come in handy when your darks become lifeless. Because of their enormous staining strength, they can revive dull dark colors. You can correct a grayed dark by glazing with a staining pigment such as Winsor green, Winsor blue, or alizarin crimson. The stain dyes the deadened mixture beneath and revitalizes it, as you can see on page 77.

Knowing what your pigments can and cannot do puts creative knowledge into your hands. You need never be upset about a maverick color; just a little glazing will tame it. Turn an error into an asset!

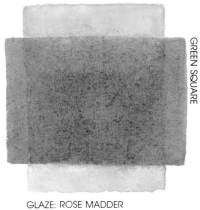
GREEN SQUARE

GLAZE: ROSE MADDER

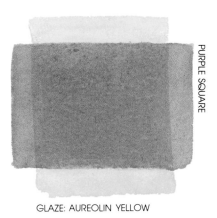
PURPLE SQUARE

GLAZE: AUREOLIN YELLOW

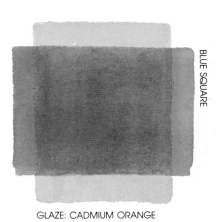
BLUE SQUARE

GLAZE: CADMIUM ORANGE

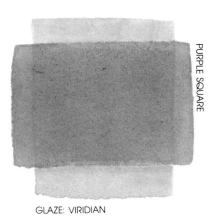
PURPLE SQUARE

GLAZE: VIRIDIAN

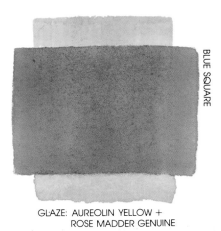
BLUE SQUARE

GLAZE: AUREOLIN YELLOW +
ROSE MADDER GENUINE

REVIVE YOUR DARKS

Use the staining pigments in a glaze to correct a grayed dark.

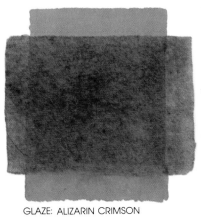

GLAZE: ALIZARIN CRIMSON

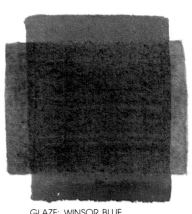

GLAZE: WINSOR BLUE

GLAZE: WINSOR GREEN

14. ORDINARY INTO EXTRAORDINARY
Transforming a Painting with Glazes

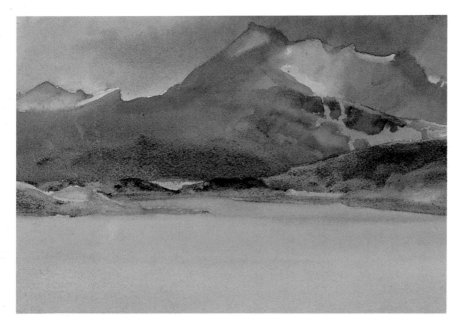

SUN AND SHADOW (detail)
watercolor on Arches 140 lb. cold-pressed paper, 8" × 16" (20.3 × 40.6 cm).

Glazing can be a painting-saver, enabling you to bring a dull watercolor to life. When I first stepped back from this painting, it looked dead. Adding a blue glaze enlivened the gray color of the distant mountain and created a warm-cool interaction.

I N THE previous lesson, we used glazing to turn color errors into assets. There our focus was on specific color mistakes. But glazing can also be used for much broader "corrections," involving the painting as a whole or a special accent.

At some point every artist has the experience of stepping back from a painting at the end, only to find the result disappointing. Perhaps the colors are not working together harmoniously. Or it may be that everything seems ho-hum, not special. With watercolor, you can't simply repaint an area, as you can with oils. Don't despair, however. It's sometimes possible to transform a fragmented or an ordinary painting into something extraordinary with a little glazing knowledge.

If a painting seems too busy and disjointed, it can be tied together easily with glazing. A glaze is transparent enough not to change the value noticeably, yet it can pull disconnected areas together into a unified pattern. A good example is my painting of the morning market in Helsinki (facing page). The subject was fascinating, a kaleidoscope of color, values, and shapes. Unfortunately, though, there was just too much excitement in the final painting. Instead of adjusting many colors and shapes, and perhaps losing the lively color notes, I decided to add a glaze under the awnings. This simple change allowed the eye to unite the myriad colors. Yet nothing was lost. The colors were still vibrant, but they were now seen through a unifying glaze.

In another situation, you may want to use glazing to surround the colors rather than cover them. Try this solution when you have a delicate collection of hues that won't vibrate or glow enough. To set them off from the surrounding area, add a glaze *around* the focus. Fresh flower colors, for example, may suddenly pulsate once the neighboring areas have been calmed with a supportive glaze. Or if you have distracting highlights throughout a painting, as in a group of bottles, try lightly glazing over most of the highlit areas. If you leave only a few highlit bottles, they will be stronger attention-grabbers than if all the bottles vainly vie for honors.

Even a painting that has no life can be rescued. Here you are trying to add a glaze that will revive an area that has become neutral. Select a glaze of either warm or cool color to push or pull the neutral area into a warmer or cooler shade. You might, for instance, try a blue glaze over distant hills or trees to make them recede and thus add space to your painting. With a little thought given to your selection of glaze, your painting will recover.

One of the most creative uses of glazing, I find, occurs paradoxically after the painting is considered finished. Glazing can be a step further, an added dimension, turning an ordinary painting into an extraordinary one.

I usually paint on location. This gives me the freedom to be receptive to changes in mood, weather, atmosphere—anything that will contribute to my painting. Here, glazing is a help-mate; I feel free to change deci-

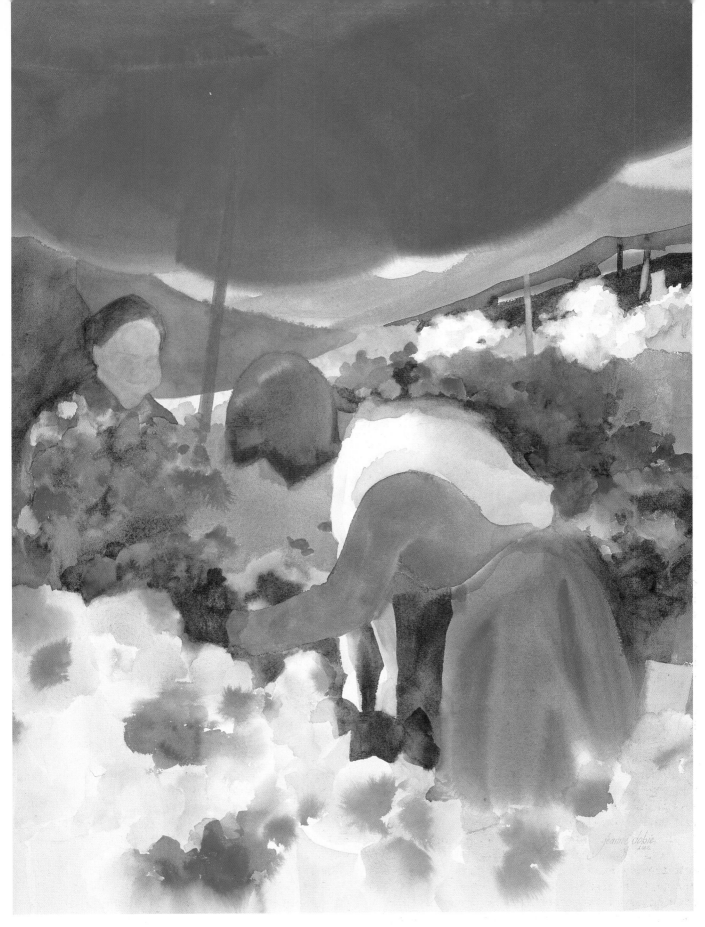

HELSINKI MORNING MARKET
watercolor on Arches 140 lb. cold-pressed paper, 29″ × 21″
(73.7 × 53.3 cm), collection of Dr. and Mrs. Jesse Fisher, Jr.

*Too much color excitement can fragment a painting. By adding a glaze under
the awnings, I brought the lively colors together and yet kept them vibrant.*

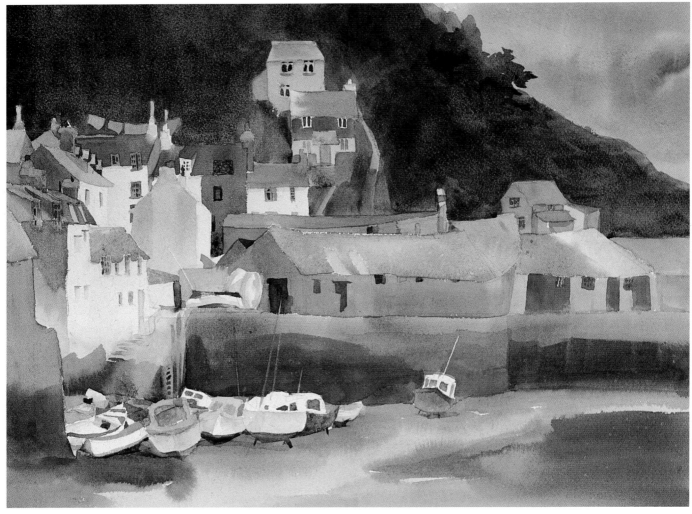

CORNISH SEA VILLAGE (initial version)

sions, knowing that I can adjust with glazes. After all, part of being an artist is the ability to recognize the unusual when it presents itself, and to judge whether it will enhance your painting artistically. Incorporating the unusual can enable you to reach an unexpected creative peak. It may be the way light creeps around a corner, fleetingly illuminating a shadow. Or perhaps a color acquires an odd lavender overtone as the sun changes intensity. Glazing then becomes a tool, allowing you to add or alter colors easily without disturbing the underlying washes. Even one transparent glaze can transform an entire painting.

While teaching in England, I painted a typical watercolor, depicting a tucked-away-from-the-world Cornish fishing village with a fleet of boats at rest in the harbor basin (above). The colors seemed well related and the washes fairly fresh, but I wasn't satisfied. The painting looked just ordinary. Somehow the feeling of this bypassed village, with houses piled one atop another,

climbing up from a bathtub-sized harbor, was not transferred to the painting. Then the sun began to sink and the town emptied, save for the cries of the gulls echoing on the dank, stone cliffs. The lower portion of the scene was thrown into shadow. This shadow suggested the shape I needed to describe the cliff walls, which encircled the tiny town and tucked it in a pocket. If I could design the shadow well, I knew it would spotlight the small fleet. I decided to paint the shadow with a transparent blue glaze. Notice that it didn't harm the previously painted foreground.

This single glazed area changed the painting dramatically. Now the lilliputian fleet was sandwiched into the lower corner for a more exciting composition. Diminishing the white areas made the remaining whites appear even brighter. The feeling of being surrounded by the cliffs was heightened by the shadow flung across the painting. Can you believe this entire transformation was due to a single glaze?

CORNISH SEA VILLAGE
watercolor on Arches 140 lb. cold-pressed
paper, 12″ × 16″ (30.5 × 40.6 cm).

Don't label a painting unsuccessful until you have tried a glaze. At first I felt dissatisfied with this painting—it just didn't convey the feeling I wanted. When I added a glaze to one area—the shadow at the bottom—the whole painting changed dramatically.

15. COLOR BRIDGES
Creating Transitions Between Colors

HEY THERE
BY RANDY PENNER, MWS
watercolor on Arches
300 lb. paper, 21" ×29"
(53.3 × 73.7 cm),
collection of the artist.

There is no right or wrong way to do a painting. Relying on formulas restricts your creativity. A painting can be balanced and adjusted in many ways. Here a bridge of color guides the viewer smoothly through the large pattern of dark cows and integrates them into the painting.

WHAT CAN contribute to your painting and yet never be noticed? A color transition is the answer. This is yet another one of the quiet steps of refinement.

In developing a composition, you design areas of contrast where you wish to place the most emphasis. So far, so good. Too often, though, other contrasts may appear where you don't want emphasis. These can compete with the selected focus.

My painting *Summer Fields* (page 84) provides an example. In translating this scene into paint, I found that the bright sunlit field, because of its extremely light value, was set off by the rich darks of the background trees. Although I didn't intend to make the junction of field and trees so important, that is exactly what happened at first. How could I settle it into the background and still keep the light and dark contrasts?

There was a desperate need for a color transition here. I had to find a color that would permit the viewer's eye to flow smoothly from the field mass to the tree mass. This was difficult because I wanted to achieve an optical union without losing the light and dark value contrast. My solution was to introduce some red into the gold field as it receded toward the trees and gradually change it to a reddish gold tone. When I reached the tree area, I continued to mix the red color into the undersides of the trees for a deep reddish dark. By creating a continuous color, I alleviated the abrupt contrast.

I call this transition a "color bridge." A color bridge, in effect, is a color that visually bridges the gap between areas, thus softening unwanted contrasts. Simply think of a color transition as a bridge of color that joins two unrelated areas.

Once you discover color bridges, I suspect you'll give them quite a workout. As subtle color links, they can be indispensable aids in developing a smooth, flowing composition. A good example occurred when I was teaching a workshop in Ireland. The workshop participants were ecstatic over the dark cliffs, rocks, and intricate sand patterns along the extremely rugged coastline, where the movie *Ryan's Daughter* was filmed. The jagged rock silhouettes were dramatic against the light, sandy beach. But in the paintings, unfortunately, the light sand areas were too delicate to hold the weight of the dominant cliff shapes. Applying their knowledge of color bridges, the workshop participants began to pull the polarized areas together.

To see how this was done, look at my painting on page 85. As the sand area approached the rock cliff, I added some of the cliff color, slightly deepening the sand at the edge. This softened the contrast by uniting the color. I also tempered the heavy cliff by using color bridges. As the rocky mass moved toward the edge of the paper, I reduced the color intensity. And at the cliff edges, I modified the mixture to cooler and grayer darks in order to blend the rocks with the background and sea colors. This shifted the greatest color contrast from the outer edge to a more central place within the painting.

The purpose of a color transition is to deemphasize color contrast. With a continuous color that tempers its neighbors, you can keep adjacent areas insignificant. Save your color excitement for an important place!

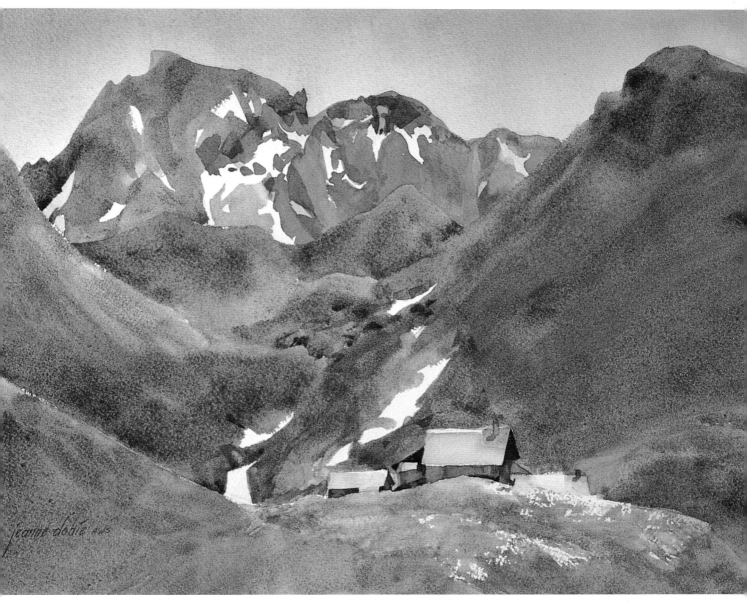

AN ALPINE MEADOW
watercolor on Arches 140 lb. cold-pressed
paper, 11½" × 15½" (29.2 × 39.4 cm).

A color transition is a subtle refinement, not usually noticed. Here the gray mountains at first appeared isolated from the velvety alpine meadows. Floating some of the rich greens into the mountains created a color bridge, alleviating the harsh transition.

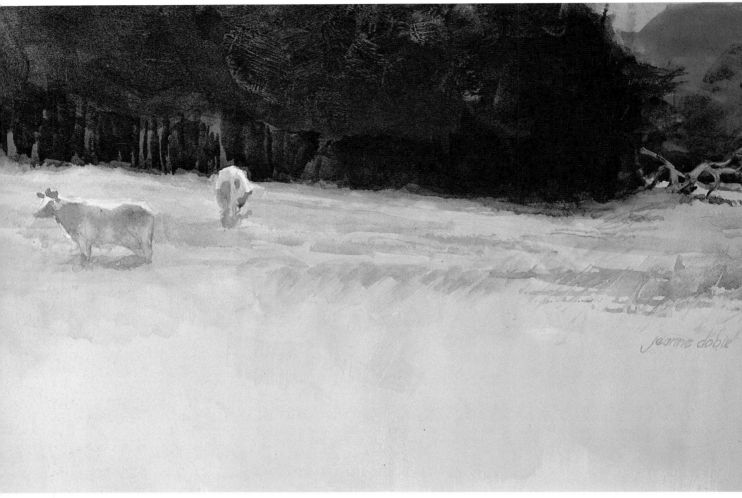

SUMMER FIELDS
watercolor on Arches 140 lb. hot-pressed
paper, 8½" × 14" (21.6 × 35.6 cm), collection
of Drs. Maryann and Gerald Galietta.

*At first the abrupt value changes between the light field and dark
background trees distracted from the focus. By carrying some red
from the fields to the trees, I created a color bridge that lessens
the contrast.*

A WALK BY THE SEA (top right)
watercolor on Arches 140 lb. cold-pressed
paper, 18" × 29" (45.7 × 73.7 cm), courtesy of
Tempo Gallery, Greenville, South Carolina.

*The problem in this painting was to anchor the dark, dramatic
cliffs in the delicately colored sand. To overcome this, I carried
the cliff color into the sand and blended the rocky silhouettes into
the background and sea colors.*

RYAN'S COVE (bottom right)
BY JEAN MACAN VOSMIK
watercolor on Arches 140 lb. rough paper, 11" × 15"
(27.9 × 38.1 cm), collection of the artist.

*This workshop participant ignored all the generally accepted rules
for "safe" composing. The lights are not centralized, and the darks
are positioned on an edge—but what an arresting composition she
has envisioned. To make the painting work, she used color bridges.
Notice how the shadows soften the dark rocks. Also observe how
some of the wet sand color blends into the water to act as a transition.*

16. COLOR CAMOUFLAGE
Disguising with Color Choices

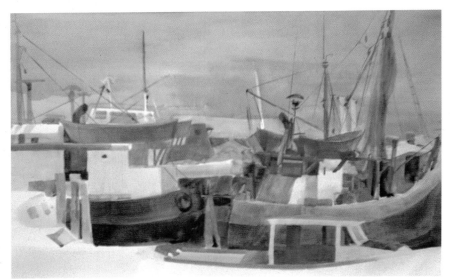

PORTUGUESE FLEET, GLOUCESTER
watercolor on Arches 140 lb. hot-pressed paper, 15" × 21" (38.1 × 53.3 cm), private collection.
You may need to use disguise colors as well as accents to enhance the focus. Here disguise colors were substituted for a bright blue foreground boat in the actual scene. This allows the eye to pass over the foreground into the color arena of boats and masts.

AKING a color appear to be what it is not is the art of creating color illusions. Cleverly used, color can make the eye pass over a shape as well as accent one. Often a smooth visual flow is preferable to seeing every shape distinctly in a composition. To produce a harmonious painting, you need to be an expert in disguising with color as well as in accenting with it.

Have you ever had a lesson in making color disappear? It is easier than you think. By understanding how colors affect each other, you will soon become adept at such color sleights of hand. And becoming a master at making colors disappear as well as appear is indispensable when creating with color.

The important point to remember is that color cannot be judged in isolation, by itself alone. Adjacent color can affect, modify, and even alter the appearance of a color. Placed next to each other, some colors create a contrast, while others blend. Once again, it is the color relationships that count.

COLOR THAT THE EYE IGNORES

At one time or another, we have all left an area undeveloped in a painting. One of my students experienced this problem after capturing a lively dock scene in Maine. The watercolor was vigorously painted in a race against time, as she was inspired by the bustling activity and the crowd of onlookers. In her zeal to record the celebration of a prize fish catch, she didn't have time to plan the composition. Later, happily exhausted, but with a smashing painting, she stepped back for another look. To her utter dismay, she had left a large piling unpainted in dead center. The piling glared back at her; it was a white bull's-eye, too important to ignore. What could

she do? Try to add another person, which meant a great deal of reworking, or try to patch it? Either would ruin the directly painted, spontaneous quality. Instead, I suggested a color disguise. Could she paint the piling in a color that the eye would ignore?

But how do you determine what a disguise color should be? Ask yourself three questions:

1. What color is the largest area adjoining the unpainted shape? In the dock painting, the figure standing by the piling was wearing a green skirt. Therefore, a green shade was the correct color choice.

2. What is the predominant value adjacent to the area? In the Maine scene, the neighboring colors were a middle value. To disguise the color, then, the artist needed a midtone.

3. Can the color be dulled or grayed? If the disguised color is less intense than the adjacent shade, the impact is reduced. Since my student didn't want the piling to be the same color as the skirt, but merely wanted it to blend, she chose a gray-green for the piling.

When the corrected painting was displayed before the class at the critique, none of the artists was conscious of the piling. Evidently it was a successful disguise!

ALTERING A NEIGHBORING COLOR

Although artists generally concentrate on making colors sing, disguising has its merits too. Suppose, for example, you have painted a red barn accented by white snow patterns and black cow silhouettes. You've taken pains to make your reds rich, saturated colors. So much so that they almost jump off the paper, especially when you wash

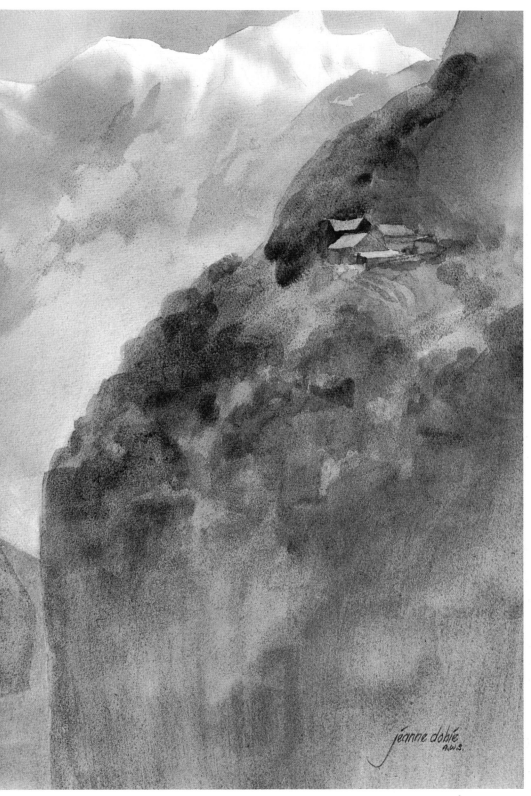

HOYFELLSAETER
watercolor on Arches 140 lb.
cold-pressed paper,
15½″ × 11″ (39.4 × 27.9 cm).

It's not always wise to paint the color you see in nature. In the painting above, the dark mountain pulled the viewer's eye into the corner. Instead, I selected a color camouflage.

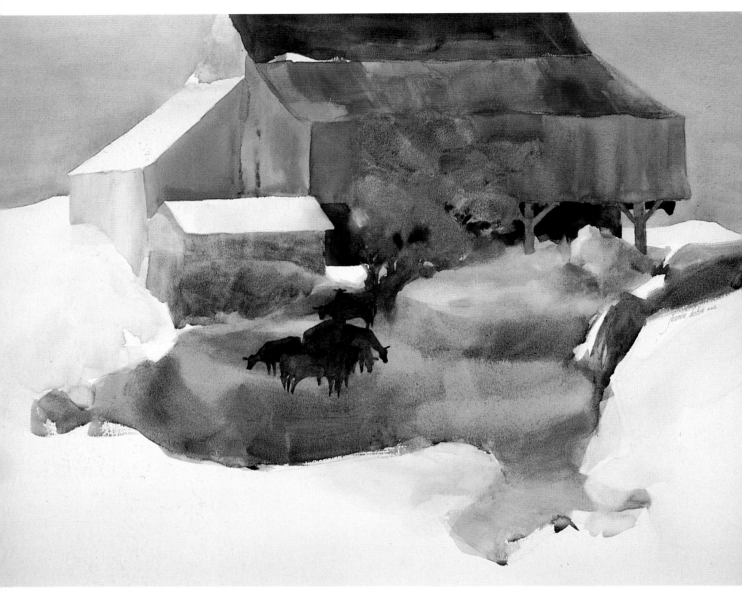

VALLEY FORGE BARN
watercolor on Arches 140 lb. cold-pressed
paper, 21" × 29" (53.3 × 73.7 cm), collection
of Smith, Kline, and French Laboratories.

*Instead of compromising the rich reds in this barn, I selected disguise
colors for the neighboring areas. As I painted, I modified the green
field into a warm brown and altered the blue sky to a warm gray.
With these changes, the barn settled into the painting without any
loss of color.*

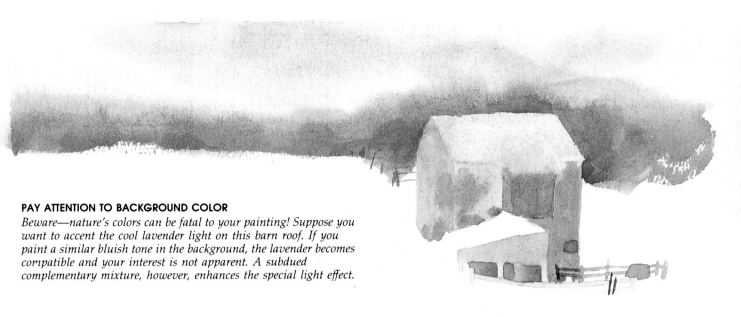

PAY ATTENTION TO BACKGROUND COLOR

Beware—nature's colors can be fatal to your painting! Suppose you want to accent the cool lavender light on this barn roof. If you paint a similar bluish tone in the background, the lavender becomes compatible and your interest is not apparent. A subdued complementary mixture, however, enhances the special light effect.

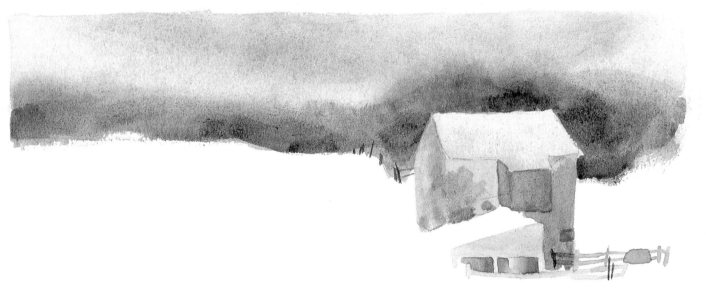

in a blue-gray sky behind the barn. Now how can you quietly blend the barn into the painting without destroying the freshly painted color? The answer is to select a neighboring color that blends, rather than contrasts, with the red barn. Your choice should *not* be a complement. Simply changing the color of the sky to a warm gray helps, as you can see in the painting on page 88. A warm brown foreground further melds the far-from-boring reds into the painting. Because the surrounding colors have a common denominator of red, there is no distracting color excitement.

Of course, you could correct an overly bright red by glazing it with a complement (see Lesson 13). But a color disguise lets you keep the red barn as rich as possible yet settle it into the painting. If the barn is to remain untouched, then adjust the neighboring color to become compatible with the barn. By eliminating a color contrast, you wed the barn to the painting without compromising its brilliance.

THE POWER OF BACKGROUND COLOR

Even when a color is not a direct neighbor, it can accent or disguise another color. Don't overlook the important role a background color can play. The illustrations above show the same scene with two different color choices for the background. Suppose your goal is to accent the lavender light of a winter day. The first painting depicts the usual reaction: a cool, bluish-gray color for the stand of trees. The bluish tone, however, reinforces the warm stone colors in the barn, thereby showcasing the barn and not the unique atmosphere. In the second painting, the color of the background trees was altered to a warm brown. This change causes a different reaction. Now the odd lavender light on the rooftop is accented. The warm stone barn is no longer an important color but has become compatible with the background.

A color placed next to another influences it for better or worse. Only by gaining color knowledge can you make the best choice.

17. PAINT PASSAGES
Weaving Color Through Space

HAWAIIAN WATERS
BY ELEANOR BRODSKY
watercolor on Arches
300 lb. paper, 21" × 26½"
(53.3 × 67.3 cm),
collection of the artist.

The thinking process is more important than the painting process. It is the most exciting area in which you can grow as an artist, and the most neglected. By concentrating on a concept—in this case, seeking a color that travels throughout the composition—this artist developed a striking color pattern.

Have you ever orchestrated a color so that it travels rhythmically throughout a scene? Can you move it forward, then float it into the distance, make it disappear and then reappear again, perhaps as a lilting note here or there? If you haven't tried this, you are about to discover a new approach to thinking in paint passages. Simply put, a paint passage is a color that weaves throughout your scene, leading and delighting the eye in its different variations—warmer or cooler, muted or intense, lighter or darker.

This lesson is designed to push you beyond the habit of using color straight from the paint tube. Too often, once an artist dips into a color—let's say, yellow—the temptation is to paint every yellow area in the scene with the same brushful. Yet no two colors in nature are alike. Every color is modified by light, distance, the cloud cover, the time of day, the season, and so on. In actuality, there are so many influences it is rare to find two shades exactly alike. For every color, there are minute deviations.

Look at the painting of *Butterfly Catchers* by Theodore Wendel, a contemporary of Monet (page 91). The color that intrigued the artist was obviously purple. Note that the most vibrant variation is used on the figure. You see it first because the cool purple tone sings in contrast to the predominant warm yellow field surrounding it (see Lesson 18). The distant field, although brilliant, is a warm purple, which is compatible and blends with the neighboring warm shades. It thus settles nicely into the middle ground. The distant mountain echoes the color passage

but this time with a purple that has been muted with another color—in this instance, orange. Even the dark tree silhouettes are deep purples. The one on the left has green added to bring it forward, but the silhouette on the right is kept a cool bluish purple to push it visually into the background.

In Fremont Ellis's painting (page 92), blue is the predominant color used for the paint passage. The foreground blue is toned to allow the eye to pass over it and continue on into the painting. As the blue moves into the distance, it becomes muted by the addition of green. The muted tones, however, build up again to a bright light blue toward the mountain peaks, which the artist obviously chose to accent.

TRY A PAINT PASSAGE

We tend to select landscapes for light-dark contrast, a strong value distribution, or other reasons. Maybe you have never thought to look for a paint passage. Yet color can evoke a powerful emotional response in the viewer of your painting.

For a landscape painting, select a color that intrigues you. It need not be the dominant color or in the center of interest or even important. Just select a color that you respond to and wish to develop into further variations as it travels through the landscape. Concentrating on one specific color will help you see subtle differences. Later, as your eye becomes more acute, you will begin to notice minute changes in many other colors too. But for now,

THE BUTTERFLY CATCHERS
BY THEODORE WENDEL
oil on canvas, 1906, 26″ × 36″
(66. × 91.4 cm), courtesy of
Vose Galleries of Boston.

Trace the purple color as it moves through this painting and note the variations from intense to muted, warm to cool, light to dark.

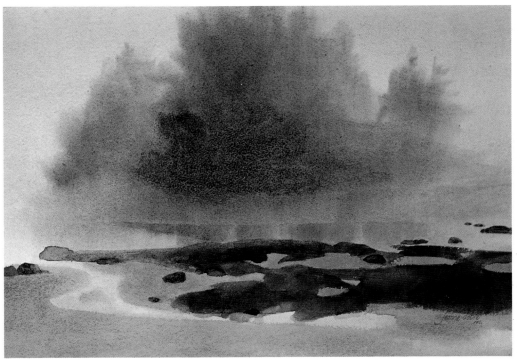

BLUEBERRY POINT
watercolor on Arches 140 lb.
cold-pressed paper,
13¼″ × 20″ (33.7 × 50.8 cm).

A paint passage makes you aware of the numerous variations possible with one color. Here purple is used for jewel-like accents on the wet pebbles, as a glaze over the foreground sand, and as a mouse color in the background fog.

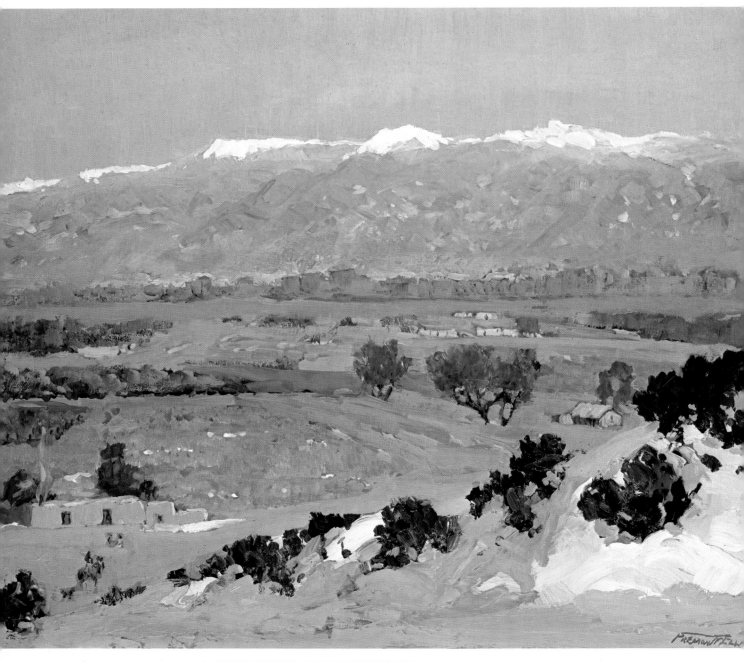

WINTER EVENING—RIO GRANDE VALLEY
BY FREMONT ELLIS
oil on canvas, 27" × 33" (68.6 × 83.8 cm),
collection of Nelda C. Stark.

*Here the blue paint passage moves from muted accents in the
foreground to modified green-blues in the middle ground to a climax
of icy light blues in the background peaks.*

let's keep it uncomplicated and single out one color.

Once you've decided on a color, observe how it moves through your scene. The object is to use this color to lead the viewer's eye through your painting, along a path of color. By observing subtle color variations, you can enhance the feeling of space or accent your interest.

First decide which area should be the brightest. In *Blueberry Point* (page 91), for instance, I chose the wet pebbles and stones, which glow in unreal purplish tones. Once you've decided on your richest colors, don't let the others compete. Vary the remaining areas within your paint passage, making some warmer and some cooler.

Perhaps the color in the distance should be grayer or muted. Notice in *Blueberry Point* how the silhouettes of the pine trees change to a cool purple-gray in the fog.

You can also make the foreground a muted shade so that the eye will pass over it and find the place of interest. This problem confronted me when painting *Blueberry Point.* The yellow sand seemed to take precedence over the soft, purple atmospheric quality I was trying to achieve. I decided to correct the color with a glaze (see Lesson 13). The yellow sand received a purple glaze to mute it and yet echo the purple passages.

When finished, your passage of color should move rhythmically throughout the painting with some high points, some supportive areas, and a few subtle echoes. When a paint passage isn't used and the color is painted without variation, the resulting sameness traps everything on a flat plane. Don't miss out on the opportunity to weave color spatially back and forth in your paintings.

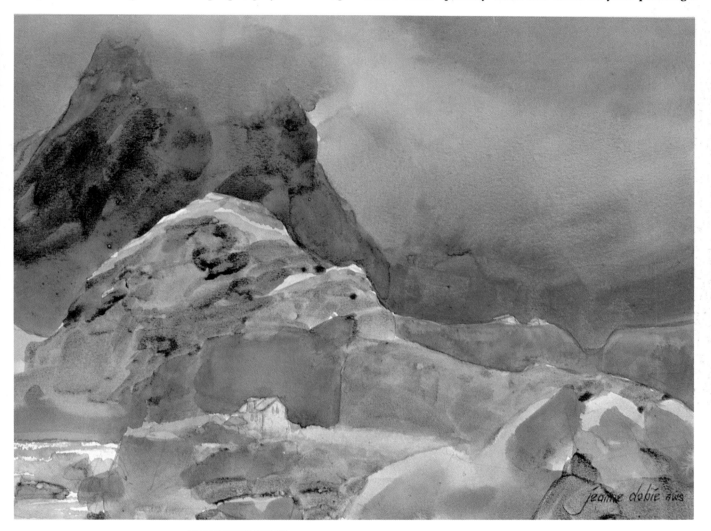

QUICKSILVER MOOD
watercolor in sketchbook,
8½" × 11½" (21.6 × 29.2 cm).

Basically, this painting is composed of two paint passages: green and purple. The two colors appear as unobtrusive grayed hues in the foreground, become richer as they move into the composition, and achieve their brightest note on the light-struck hill. The background mountain offers an echo of the green and purple, refined into cool tones and deeper values.

18. COLOR VIBRATIONS
Invoking Visual Tension

ICARUS-SAFFRON
BY BETTY BOWES, ANA, AWS
acrylic on Masonite,
9⅞" × 12¾" (25.1 × 32.4 cm),
collection of the artist.

Think of color as a tool that you can use to create excitement in your painting. Here the artist has matched two colorful areas equally so that the viewer's eye dances back and forth between them in a lively interchange.

WHAT do you do with color besides carefully duplicating the scene before you? Have you ever considered using color, not to render, but to develop a vibrating reaction? Vibration occurs when two colors interact to add visual tension and enliven an otherwise uninteresting area.

To what extent can one color alter another? Let's consider some color interactions. A yellow field, for instance, vibrates against purple trees, but not against green trees. A red barn vibrates against green trees, but not against brown ones. And the red barn appears less red and vibrates less against reddish-brown trees that immediately surround it. A blue rooftop, however, vibrates against reddish-brown trees. Going a step further, that same blue rooftop vibrates even more against orange-brown trees.

THE POWER OF COMPLEMENTS

Obviously, complements do much to alter the appearance of neighboring colors. To demonstrate this remarkable ability, I've painted a fence across page 95. The color is a neutral gray, without variation, neither warm nor cool. (Let's hope the color reproduction is accurate here.) Notice that the center section of the fence does not have a background color. This is crucial to prove that the background field color alone can turn the neutral gray fence optically toward the complement of the field color.

Look at each side separately. On the left side, I've painted a cool green field behind the fence. This green field forces the gray fence into a red tone, which is the

complement. In other words, the gray fence adopts a warm, slightly rosy gray appearance against the cool grass. Moving to the right, notice the reaction that the warm mustard field creates on the gray fencing. The fence now appears lavender-gray because purple is the complement of yellow. This purple, though, feels cool, due to its reaction with the warm, mellow field color.

VIBRATIONS ARE THE NEXT CHALLENGE

If a complement can affect a neutral color so strongly, what happens when the two complements are placed side by side? Some stunning vibrations can be generated, that's what! But these vibrations are not automatic—there are additional considerations. For a vibration to result, *both colors must be totally equal in carrying power.* Moreover, a vibration is not complete until the eye is forced to pulsate between the two colors, so that it cannot come to rest on one over the other. *Both colors must be seen simultaneously.*

Creating a vibration therefore involves a delicate balancing act with the two complementary colors.

1. Both colors should be exactly the same value. (This step is the easiest part.)

2. Both colors should be matched to the same intensity. (This is a bit more difficult.) If you make one color more appealing than the other, you've lost the reaction you seek. A vibration will not occur if one color is dull and the other vivid. Both need to be perfectly matched, with

both colors bright or both colors dull or both delicate.

3. To generate the greatest vibration, one color should be cool and the other warm. And here comes the hard part: both need to garner the same amount of attention. If you could use a thermometer to measure the temperature, the warm color would be a certain number of degrees warmer than normal and the cool color would be the same number of degrees cooler than normal. Your task is to match the warmth and coolness to the exact degree. Only your eye will tell you when you have succeeded.

Once you've learned how to create vibrations, this exciting reaction can be applied to your painting wherever you need some life. Perhaps a quiet center of interest without intriguing shapes can be activated by the interplay. My favorite use of vibration is in a foreground area that has become dull. Two muted colors that dazzle the eye a bit is all that may be needed, without resorting to an abundance of color that doesn't contribute.

MORE VIBRATION CHALLENGES

The above three steps will get you started, but optically matching colors for a vibration is not always a simple matter of using equal amounts of color. Some colors have more force than others. Size and allocation also affect the relationship.

You have learned that blue recedes, right? Therefore a blue moon should move back into the distance in the sky, you believe. One of my students, however, painted a boat scene with a dominant orange sky. Ironically when he placed a blue moon in the orange sky, the moon didn't recede at all. Instead, it popped forward. Why?

This is what happened. The discriminating eye ferrets

MY BLIND BEAUTY (detail)
watercolor on Whatman paper,
21½" × 31" (54.6 × 78.7 cm).
To make the eyes stand out as the focus of this painting, I kept them cool and surrounded them by warm complements, all carefully balanced for a scintillating effect. Notice also how I made the whites in the dress glow with subtle halflight transitions (see Lesson 9).

HOW COMPLEMENTS ALTER COLOR
To see the power of complements, study each side of this illustration separately. On the left, the green field pushes the gray fence toward a rosy color, as red is the complement of green. On the right, the yellow field gives the fence a lavender cast (again, the complement at work).

VIRIDIAN

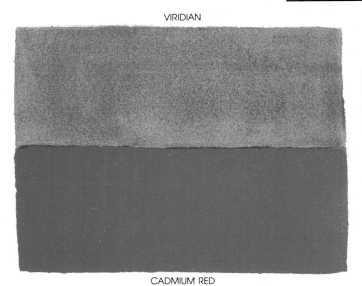

CADMIUM RED

V

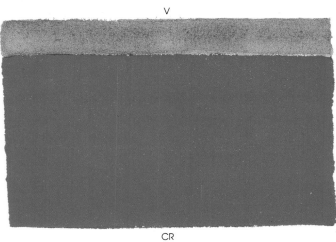

CR

Match two complements—red and green—in value, intensity, warmth or coolness, and size. You'll find, however, that the red is inevitably more forceful than the green.

Give the green a special emphasis by making the two color areas unequal in size. Surprisingly, the smaller area of green increases in strength.

V

CR

V +
AY -
LR

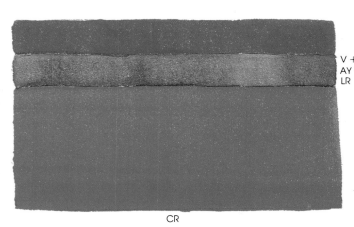

CR

Place the green within the red. Now the power of the two colors is equal.

Try dulling one color. Immediately, the vibration disappears.

V

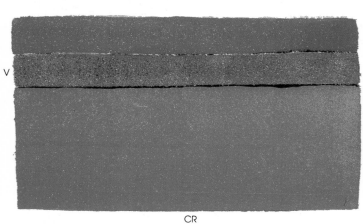

CR

V

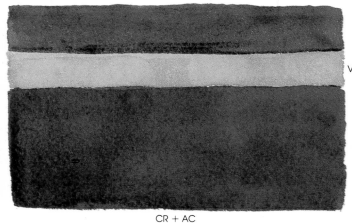

CR + AC

Now vary the values. Although there is a contrast, the pulsation is gone.

out jewel-like color. Although the orange color my student chose was beautiful, it covered a vast area so that it was no longer unique but mundane. By providing relief, the cool blue moon paradoxically superseded the overwhelmingly bright, warm orange. As you can see, the amount of color chosen can tip the balance of the scale.

Another consideration that makes the balancing act a thoughtful operation is the different carrying power of each color. To clarify these differences, try the following experiment (see page 96):

1. Paint red and green equally, side by side. Match them for value, intensity, degree of warmth or coolness, and size. Notice that the red tends to dominate because it is more powerful. Under these conditions, no matter how bright you make the green, it can never match the force of red.

2. Try enlarging the red area and reducing the green to a thin bar. The two are unequal in size, yet the green is beginning to develop greater intensity because you are creating a special jewel-like color.

3. Give the green a bold placement within the red area. Now it matches the intensity of the red and results in the vibration you seek.

4. Dull one color or the other. Notice that with the slightest color change, one color "sings" over the other. The vibration is immediately lost.

5. Change the value of one color to either a lighter or darker shade. Again, with even a slight value change, one color predominates, nullifying the vibration.

ENLIVEN NONCOMPLEMENTS

Two colors that are not complements can also be enhanced with a little vibration. Just an infinitesimal adjustment in one color or the other can invoke a scintillating reaction. Try some of the subtle changes shown in the color samples below. First paint a brushstroke of neutral viridian, then one of neutral cobalt blue abutting it. Since the colors are compatible, there is no reaction. Instead of vibrating, they tend to blend.

Now paint the same colors, but this time vitalize the green in an unusual manner: add a touch of the complement of the *neighboring* color. By using the complement of blue (which is orange) to adjust the green, you generate more vibration.

As a final step, enrich the blue color by adding a little of the complement of the neighboring green—some red. Notice how the reaction is increased by just a slight modification of the mixture. Your colors are still green and blue, but now there is a lively difference.

REACTIONS WITH NONCOMPLEMENTS

CB　　　　　　　　V

These two colors are compatible, without any reaction.

CB　　　　　V + AY + LR

By adding just a small amount of the complement of blue to the green, you can introduce a vibration.

CB + RMG　　　V + AY + LR

When you add the complement of the adjoining color to both colors, there is even more vibration. Keep this in mind as a way of enlivening your paintings.

19. COLOR AS ABSTRACT PATTERN
Designing with Vibrating Color

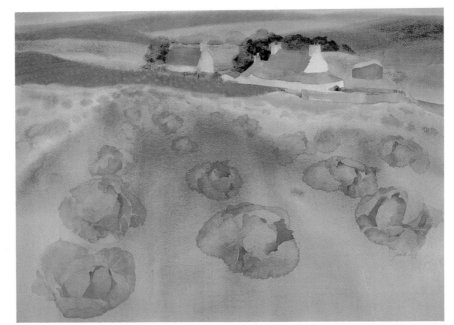

CABBAGE FIELDS
watercolor on Arches
140 lb. cold-pressed
paper, 20" × 29"
(50.8 × 73.7 cm).

Take the idea of a color vibration one step further and use it as the basis for your painting's color design. The excitement of the painting shown here comes from careful planning of the main color interaction, as you can see on the facing page.

ALTHOUGH a color vibration is a good way to enliven an area without compromising its value or overworking it, don't wait around for a chance to use it. Go ahead and plan a vibration, if for no other reason than for pure color excitement.

Let's take the previous lesson on color vibrations one step further into developing an abstract color pattern. You may have tried to design a painting with a strong, underlying compositional pattern, but have you ever thought to design a painting with an exciting *color* pattern? Although imperceptible to the viewer, an underlying abstract color pattern can set up a lively vibration.

Using the diagrams on page 99, follow the way I developed the color vibration that underlies my painting *Cabbage Fields*. To initiate a vibration, I chose two complements—red and green—and tried to balance them to produce a reaction. The beginning step of matching values was easy. In this instance, I made both colors luminous halflights. To equalize both colors in intensity, I chose an Indian red pigment rather than a forceful red. For the green, I used viridian. To balance the muted quality of the pink with the same degree of grayness in the green,

I added a tinge of rose madder genuine to the viridian.

As we learned in the previous lesson, to counteract the strength of the red, I had to make the weaker green a special accent. Initially, I used equal pink and green squares to match the color. Now, however, I changed the green squares to bull's-eye shapes and decreased their size (see the second diagram). This was done to emphasize the silvery green color.

In the next step I changed the green shapes to add variety and to conform to the landscape (see the third diagram). Note, however, that I was careful not to diminish or compromise the vibration between red and green in any of the changes.

The top priority throughout this process was to maintain the pulsating color reaction. What resulted was a vibrating color abstract, which added an extra dimension to my painting. Look again at the third diagram and compare it to my painting *Cabbage Fields*. You'll discover that the color abstract is identical to the underlying color pattern in my painting. Now try this process on your own. Develop a color abstract and incorporate it in your next landscape for an exciting vibration.

As a first step, I set up a color vibration between two complements—Indian red and viridian.

To balance the power of the red and give the green more importance, I changed the green squares to bull's-eye shapes.

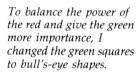

With an eye to my landscape subject, I altered the green shapes further, increasing their variety. Throughout these changes I was careful not to dilute the underlying color vibration.

20. COLOR COMPOSITION
Planning the Color Design

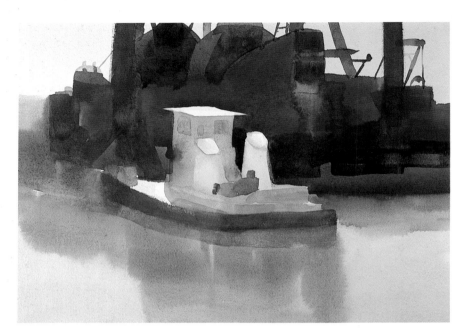

Color should be an equal partner with composition when you design. You can use color, for instance, to balance a heavy weight. Here the orange accents keep the dark background shape from overpowering the painting.

A RE YOU ready to design with color as well as with shape? Color is a powerful tool that is often overlooked in creating a composition. All the lessons have been building to this point, preparing you for composing with color.

In an effective color composition, every color works together. This doesn't mean, however, that everything is equal—that would be boring. Instead, think of the diverse colors as members of a team, all striving toward the same goal. One color may dominate, but all the other colors work to enhance it. The idea is to use color to orchestrate the focus, without striking a discordant note.

REDIRECT THE VIEWER'S EYE
Through color interactions, you can "tell" the viewer where to look. You may remember, for instance, that a small, jewel-like color supersedes a larger, more dominant color. It can be added to steal the eye away from an unrelieved or awkward area by its unexpected sparkle. Look at the detail above from my barge painting *Along the Ohio* (for the full painting, see page 61). Here two bright glints of orange flash in the muddy water reflection. Simply cover the special color in the painting with your hand to see what happens without this forceful color accent. The jewel-like color acts as a counterbalance to an overpowering shape.

You can also use color to move the viewer's eye past intricate and potentially intriguing patterns so that it comes to rest on your center of interest. To do this, place your special colors at the focus. In the watercolor *Vacillating Reflections* (page 101), for instance, I was intrigued with the changing, almost abstract patterns of the reflections rather than the usual picturesque subject matter of the pier and boat. Composing with color became essential to accent the reflections over the lively scene.

BE SELECTIVE
Methodically duplicating colors as they appear in a landscape is rarely satisfying. Moreover, unfortunately for the artist, sometimes nature's colors "disguise" the center of interest. In dealing with this, even a small color decision change can make a great difference, as one Pennsylvania workshop participant found out.

It was a glorious autumn day, filled with color—the perfect time to present a color lesson. The overwhelming brilliance of the landscape challenged the most skillful. One artist's interest was in bright berry accents, half-buried in fall leaves. As she excitedly sketched, she captured the lovely rust tones in the berries *and* the lovely rust tones in the leaves! Later, when she analyzed the sketch, she realized nothing interesting was happening with the color. There was no reaction. But when she applied the day's lesson in her final painting, she developed a color interplay that improved her original composition (see page 102).

If you have a special color you wish to accent in a painting, repeating that color everywhere defeats your efforts. Workshop participants have heard me preach about how beautiful a diamond can look displayed on a cloth of black velvet. As it shimmers and catches light from all directions, the viewer can readily appreciate its uniqueness. But if two dozen diamonds were placed

around it, would you be able to admire the original as much as before? Would you even be able to find the original?

Similarly, if there is too much variety of color, the viewer will be confused about which one you favor. I remember a well-executed painting of a waterfall brought to one of my critiques. The artist had captured a sunny blue sky, brilliant fields of wildflowers, rich darks in the river bank, unintimidated greens in the trees—the painting was alive with color. He explained, however, that the waterfall was his interest and lamented that no one seemed to notice it.

Being unaware of how colors interact can be detrimental to your painting. In a case like this, "tame" the wild colors that bedazzle the eye, hang on an edge, or compete with your center of interest. To do this, you might correct the overly bright color with a glaze (see Lesson 13) or create a color disguise to add harmony (see Lesson 16).

Accenting color to its fullest requires restraint rather than a lavish use of color. For the greatest impact, ration your bright color. Try painting an orchard in springtime without using a true pink until the very end. I guarantee it will be a challenge. Then toward the finish, drop in the pinks. When you do, observe how the pink color sings, more so than if you had painted your subject predominantly in that shade. For an example of color restraint, look at my painting of a fishing hamlet on page 103. Only one of the reds here is vibrant; the others are muted—yet the whole sings.

VACILLATING REFLECTIONS
watercolor on Arches 140 lb. cold-pressed paper,
21" × 29" (53.3 × 73.7 cm), private collection.
Try locating your strongest color at the focus to direct the viewer through a maze of other, potentially distracting interests. Notice how the color in this painting tells you what is important.

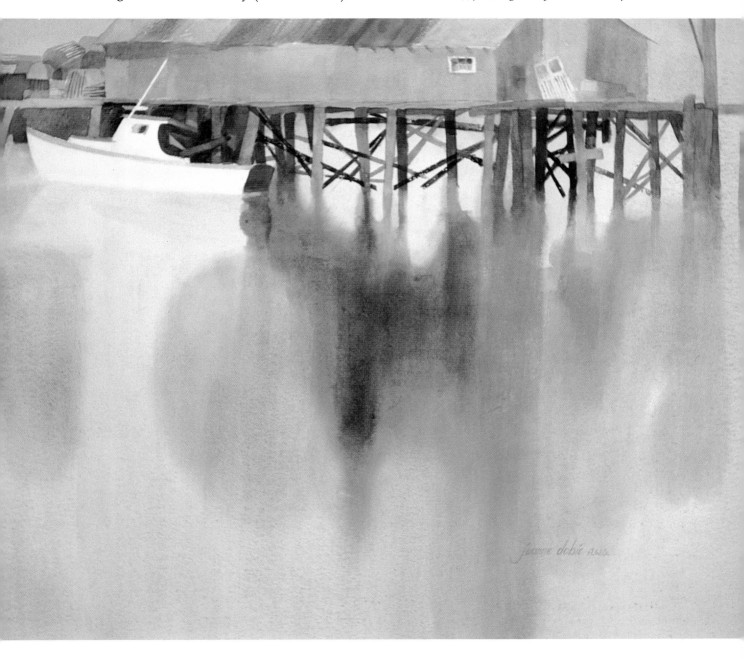

BERRY BRANCHES
BY KAREN FOGARTY
watercolor on Arches 140 lb. cold-pressed
paper, 14″ × 10½″ (35.6 × 26.7 cm),
collection of the artist.

Keep a color unique if that is your interest. To make the rust color of the berries stand out, this workshop participant introduced some knowledgeable color changes in moving from her sketch to her final painting. Using one of my teaching suggestions, she cut out red circles (for the berries) and tried different placements. To her astonishment, only a few drops of color were needed for the jewel-like impact she wanted.

ORCHID SERIES—EPIDENDRUM
BY JOY SHOTT, NWS
watercolor on Arches 300 lb.
paper, 21" × 29" (53.3 × 73.7 cm),
collection of the artist.

Always keep the total painting in mind. Learn to paint with colors that relate to each other, that don't jump or pop off the paper. In this painting most of the colors are kept subdued to echo, rather than compete with, the colors at the center of interest.

FISHING HAMLET OF Å
watercolor on Arches 140 lb.
cold-pressed paper,
14" × 21" (35.6 × 53.3 cm).

Notice the restrained treatment of reds in this painting. If all the reds had been equally intense, the repetition would have been boring. Muting all but one red created a color crescendo.

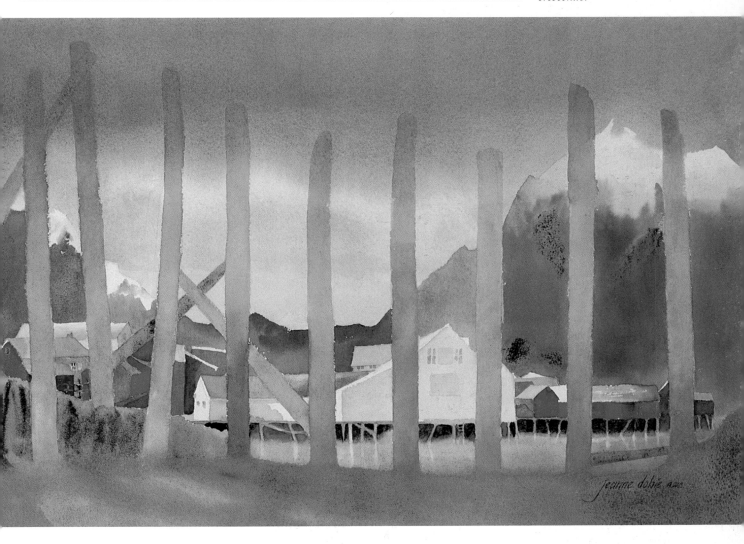

21. TWELVE SHAPES
Thinking "Shape"

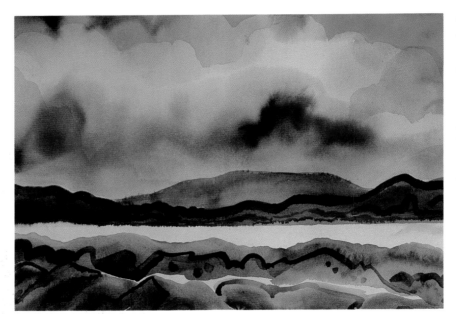

A RIVER REMEMBERED
BY TEE NASH HERRINGTON
watercolor on Arches
140 lb. rough paper,
20″ × 26″ (50.8 × 66 cm),
private collection.

The most important ingredient you can add to a painting is yourself. Instead of aspiring to paint like other watercolorists, involve yourself and start developing your own "painter's eye." This painting is a perfect example of how the twelve shapes lesson can be personalized by the artist. Its simplicity and directness make it powerful, and the colors are rich.

A PAINTING is composed solidly by structure, not technique. The structure is the very essence of your statement. To achieve distinctive work that reflects your own expression, you need to develop a thorough working knowledge of how to build a painting.

The challenge and excitement are not in the subject, but in the arrangement of shapes made by the subject. We are told to design better shapes, but how? We are told to have a center of interest, but where? We are told to leave a nice white shape, but again the how and where have been left up to the baffled student.

A more concrete approach is needed. Most artists have a substantial knowledge of composition, so that is not a problem. But *how to apply* the knowledge presents a difficulty. As a result, I conceived the "twelve shapes" lesson. This lesson actually forces you to compose, think, and work through a complete design concept.

First of all, a composition is composed of shapes. Translating the subject matter or scene into shapes may not be easy for you if you are accustomed to making line drawings. Look at the line drawing on top of page 105. This is *not* how you should see your composition. Although such line drawings are commonly referred to as "compositions," they are incomplete. Perhaps when you were in grade school and prepared a preliminary sketch, your teacher remarked, "That is a good composition, now go ahead and paint it." But as you painted, the good composition suddenly went downhill—what happened?

A line drawing is only an initial step; it is only one part of the composition. I teach that *composition is the sum total of many parts*. In order to explain, I'll discuss each part separately, one by one, beginning with the line drawing.

Dividing your scene by lines can mislead you into thinking about boundaries. Do the following anxieties sound familiar? "Is the horizon line in the center?" "Is the tree edge running into the roof line?" After checking and rechecking the edges, the artist begins to paint with a false sense of security, which often turns to disappointment when value and color are added. Remember, composition is the sum total of *many* parts.

Now look at the second illustration on page 105. This is how you should "see" your composition. Move beyond a concern about where the edges of your drawing meet or intersect, and think about shapes. Each shape is a volume and has form or space. When you think in terms of shapes, you are working with these volumes; you consider the total mass of the hillside against the entire expanse of the sky, the whole weight of a tree against the bulky form of a house. You concentrate on masses that are solid. And you paint with whole shapes abutting other whole shapes, instead of filling in areas between lines for a feeble, colored-in look. (Incidentally, these shapes are natural forms derived from your landscape and should not simply be geometric cubes, triangles, and rectangles.)

EXTRACT THE TWELVE MAJOR SHAPES

When you can see in terms of shapes and are able to translate the components of a scene into shapes, try this exercise. Select a scene you wish to paint. Confronting you are many unimportant shapes, distracting details, varied color effects—all vying for attention. Attempt to

*This line drawing
is incomplete
as a composition.*

*Try, instead, to conceive
your composition
in simple shapes.*

*If you tend to paint the details
of a scene before the solid shapes,
you are starting at the wrong
end. Look for the twelve major
shapes in your composition, and
then reshape them into your own
personal painting.*

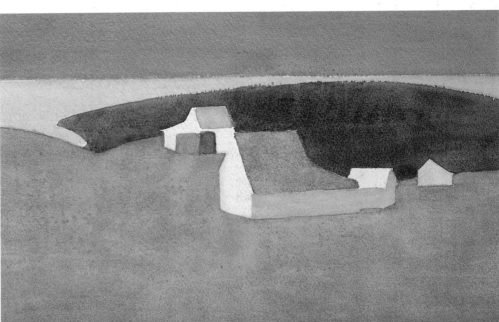

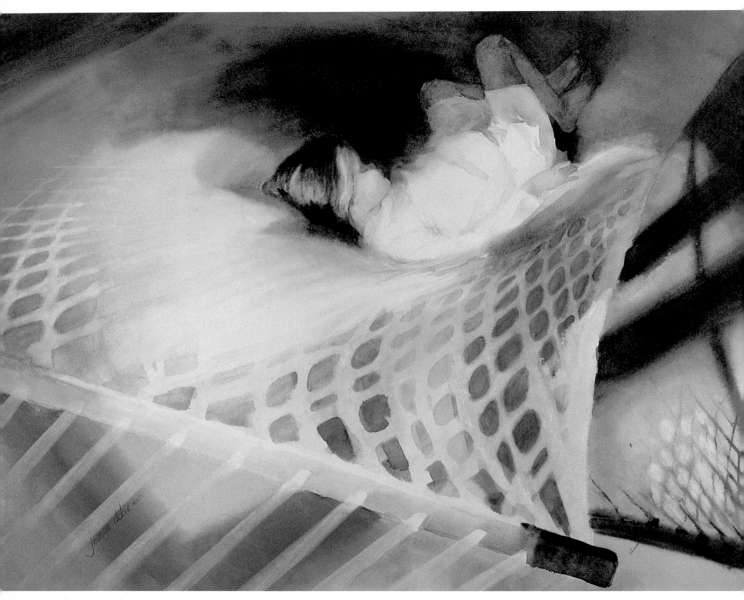

GODCHILD
watercolor on Arches 140 lb. cold-pressed
paper, 20″ × 28″ (50.8 × 71.1 cm),
collection of Monique Klaus.

*In painting a figure, think of it as a shape in your overall
composition. Concentrate on designing a painting, of which the
figure is a part, rather than on the subject per se.*

CORNISH COVE
BY MEL FETTEROLF
watercolor on Arches 140 lb. cold-pressed paper,
11½″ × 15½″ (29.2 × 39.4 cm), collection of the artist.

*Pushing shapes around assures the best possible design. Having
resolved the twelve shapes exercise, this artist has an excellent
blueprint for a later painting.*

extract from the scene before you twelve major shapes, no more, to form the foundation of your painting. I advocate cutting out your twelve shapes from scrap paper to give you the optimum opportunity to reorganize them expressively. Years ago, when one of my classes had trouble extracting the twelve shapes, I suggested that they cut them out like a puzzle, reshape and improve them, and fit them back together. This helped them to see the major components better. They became so adept they were soon able to design compositions with fewer than twelve shapes.

Having the shapes before you is where the fun comes in. You can adjust, reposition, relocate, enlarge, eliminate, modify, or do anything you wish. Remolding these shapes into your own individual painting—that's creativity!

Begin to consider your shapes in relation to each other. If they seem much the same, can you vary their size? Can some be enlarged, others reduced? Some may need to be redesigned slightly. Try extending others, perhaps raising or dropping still others. Try to keep the shapes varied in volume, if possible, to avoid a monotonous composition. The idea is to develop wonderful new shapes from old.

These twelve shapes are the very foundation of your composition, so don't skimp on time in designing them. For variation, make some with eye-catching contours.

These may be used at your center of interest. It would be utter chaos, however, if every shape were agitated and competed for attention. Some shapes need to be less interesting, especially in less important areas. They can support quietly.

EXPLORE ALL YOU CAN DO WITH SHAPES

Shapes are more pliable than you think. Many artists are not aware of how plastic they can be—how they can be molded, stretched, altered, recontoured, manipulated, almost like working with clay. Here are some pointers:

1. Remember: small doesn't mean unimportant. An exciting road shape can steal the show from a majestic mountain shape.

2. Be aware (not beware!) of pointed shapes. Since a pointed shape attracts the eye, you must decide if you want the eye to go there or not. This should be your criterion, not whether to avoid points. If you don't want attention riveted there, change the point to a gentle curve.

3. Note that shapes placed in corners can become static. Vary them slightly so they don't begin and end at the same distance from the corner.

4. Avoid the pocket that develops when several shapes funnel into a channel. This situation is descriptively

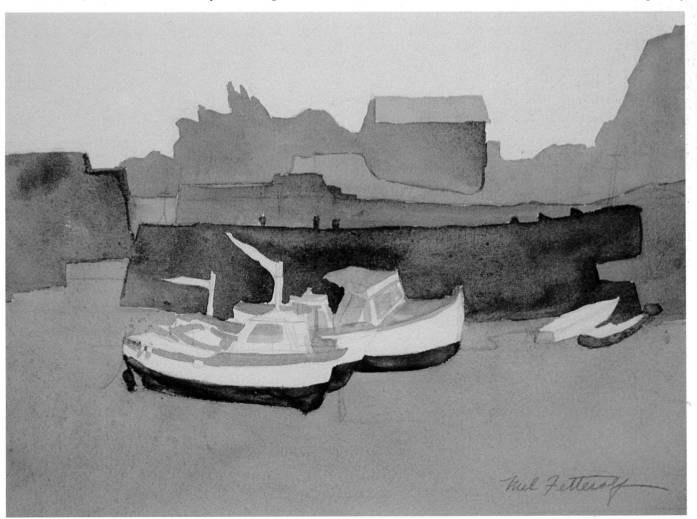

RETHINK YOUR SHAPES IN DIFFERENT WAYS

The challenge is not in the subject, but in the arrangement of shapes. Here a master oil painter, Antonio Martino, NA, AWS, uses the same location and subject—sailboats—to achieve varied arrangements of shapes, values, and colors. Obviously, it is the mind of the artist that contributes the excitement.

HOLIDAY REGATTA collection of the artist.

BETWEEN REGATTAS collection of Mr. and Mrs. Alexander Manos.

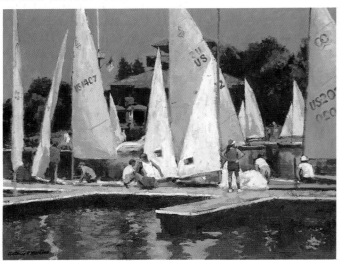

SUMMER REGATTA collection of Mr. and Mrs. Daniel Kraus.

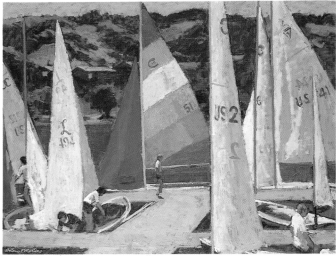

HARVEST REGATTA collection of the artist.

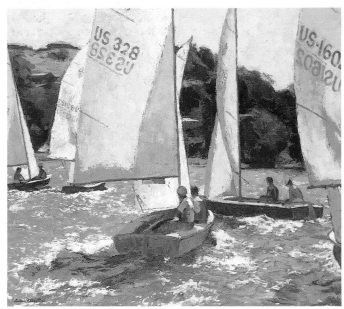

THE REGATTA collection of Dr. and Mrs. Edward Sutter.

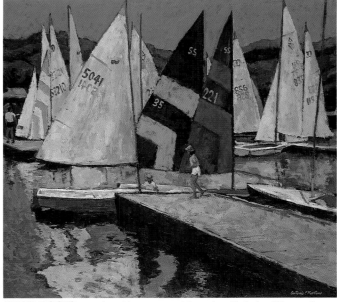

AT THE DOCKS courtesy Newman and Saunders Galleries, Wayne, Penn.

called, "All roads lead to Rome." Fortunately, the cure is easy. Simply overlap one or two shapes.

(You are now beginning to think in shapes, I hope. *Stop thinking of a boat floating on the water. It is a shape floating on another shape!*)

5. Don't let trees stymie you. My suggestion is to look for the sky spaces within the foliage. Select a few sky shapes and vary them in size. Once these areas are planned and designed, the rest of the tree surrounds them. Now you have a tree that contributes to the design, not one with a thousand sky holes haphazardly spaced. Also, trees don't sit on the ground; they grow *in* the ground. Plan your foreground to support them.

6. Get rid of your anxieties about foregrounds. The foreground can be simplified into a definite shape rather than becoming a nebulous array of indecisive brushings and color. Tuck it around houses and trees to integrate them.

7. Remember that shadows are shapes too! A beautifully shaped shadow can be dramatic and stronger than numerous strokings of the brush. Similarly, reflections are shapes, not an unresolved area. Actually, every area, even if it is not hard-edged or definite, is still a shape or a part of the whole.

8. Design skies as part of the painting. If you have a strong painting, your sky shape should equal the strength. Don't leave any voids.

9. When two shapes come together but don't meet exactly, look at the space left in between. Is it a good shape also? Often this space is a distinct shape, which you may not have previously considered part of the composition. Check, for instance, the spaces between tree trunks or where a tree and rock come together.

BACKGROUND AREAS ARE SHAPES TOO

Don't neglect the shapes that are in the distance and perhaps less obvious. When these areas are painted on the paper, they become shapes, too, not merely leftover paper. Be aware that on a flat piece of paper, a distant shape may be right next to a foreground shape, side by side on the same plane. Distant shapes should thus be designed to contribute equally with neighboring shapes. Every shape should uphold its place strongly as part of the composition. Again, remember that composition is the sum total of *all* the parts, and that includes the background.

Sometimes background areas are merely stroked in. To paint them nebulously, without designing them as shapes,

spaces, or forms, leaves them unresolved, as if you had totally ignored them. *Every* shape is important.

The background of the painting should act as a frame for the subject. Too often painters concentrate on the subject first, then paint "around" it. Dark thrusts in the background or foreground to fill voids do not substitute for constructed areas. The areas surrounding the subject should be thought of as volumes of value and color; they deserve as much consideration as the subject. Space is not a void, but a shape or component of the painting.

The actual subject doesn't matter. What is important is that it have an interesting shape. Once you've determined its shape, compose that shape in harmony with neighboring shapes that accent or complement it; don't relegate the surroundings to meaningless brushstrokes. This approach is especially important if your subject is an exciting figure. It is an injustice to leave a beautiful figure shape dangling and barely supported by a few flimsy strokes.

If you are having difficulty seeing the figure as a part of the painting, do the surrounding shapes first. The leftover shape will be your figure. You'll discover that the neighboring shapes can help you draw your figure accurately. Always consider your figure as a shape that fits into the total composition, much as a tree or field does. For an example, look at the painting *Godchild* (page 106).

PUTTING IT TOGETHER YOUR WAY

Where is the center of interest, you ask? Decide your own. It may be where you put your greatest contrast, or your most exciting shape, sharpest edges, special color. With an uncluttered, strongly designed composition, the viewer's eye will find the most beautiful or most exciting shape. There is no need to resort to clichés like diagonal strokes, roads that lead in, or obvious shadows that direct the eye to the center of interest. Be aware that roads or shadows that lead in, also lead out!

Putting whole shapes together is another way of drawing. There are many ways to draw other than with pencil. When his eyesight began to fail, Matisse did not stop "drawing." He used scissors to cut out and arrange shapes for some of his most handsome work, claiming the bite of the scissors gave the shape a decisiveness. In fact, drawing with shapes leaves no room for indecision. You must make a definite commitment.

The benefit derived from pushing shapes is the best possible design. Think of the twelve shapes lesson as taking a painting apart and putting it together again. But you have the opportunity to put it together better than before and in a more individual, creative way—*your* way.

22. SHAPES PLUS VALUE PLUS COLOR
Taking an All-Encompassing Approach

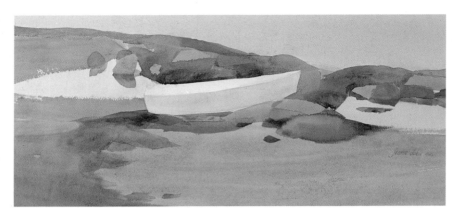

EVENING TIDE
watercolor on Arches
140 lb. cold-pressed
paper, 10" × 22"
(25.4 × 55.9 cm)
The underlying simplicity of this watercolor derives from the twelve shapes lesson. Additional strength is gained from the value distribution, and an emotional response is triggered by the color.

Although you may have completed designing your shapes, you haven't finished yet! Composition is the sum total of many parts, remember? A stronger underlying value foundation is the next goal. The values you allocate to your shapes will make the difference between an effective or ineffective composition.

Let's return to your composition and begin to assign values to the twelve shapes. The easiest guide to use is a five-value scale (see below). On the left side is value 1, which is white or the lightest value. On the right is value 5, the darkest value. The middle (value 3) is of course the middle tone; value 2 is mid-light; and value 4 is mid-dark. Inbetween values can be made from 1 to 25 or more if you wish, but using the simplified five-step sequence gives you strong, distinct gradations.

LAYING THE VALUE FOUNDATION

Begin with 1, the white or lightest value. Because this is the most prominent value, it is usually placed in an area of importance, in or near the center of interest. Although it can be positioned at the edges of a composition, this requires greater knowledge to achieve balance. (See Lesson 28 for in-depth instruction on designing with white areas.)

For now, select a shape that you would like the viewer to notice, perhaps a farmhouse or boat, and make it white or the lightest value. Because the lightest value is the most dominant, no paths are needed to direct the viewer's eye to it. It is the element the viewer will see automatically.

Next turn your attention to the darkest value (5). If you position the darkest value strategically near the lightest shape, a reaction develops causing the white to glow more strongly by contrast. Yet when light and dark values are placed side by side, they often produce a contrast that is too obvious. Locating the darkest value in the immediate vicinity of the white area is sufficient to obtain the reaction.

So far your concern has been the effective placement of the lightest and darkest values to create an emphasis or center of interest. The remainder of the painting falls into the great amalgam of midtones. Lesson 27 deals specifically with ways to organize and plan midtones. For now, allocate tones of mid-light, mid-value, and mid-dark to the remaining shapes. Since these values are in the middle range, they won't compete or distract from your center of interest, which has the greatest light-dark contrast. With your basic values distributed wisely, other less important and minuscule details can be applied to the solid foundation. Scattered calligraphy—that is, expressive brushstrokes used for accenting—will not "float" if there is already a strong value structure holding the painting together.

The simplicity resulting from the twelve shapes lesson increases the power of a composition. More strength can be added by the skillful manner in which values are distributed. And still more emotional impact can be achieved by your color selection, which is the next step in developing your composition.

ALLOCATING COLOR

Just as you have been painstaking in planning each shape and coordinating your values, take time to strive for distinctive color. Choose some colors as accents in your scene, but keep the others supportive. Obviously, this third part of composing entails a great deal of restraint.

EXPERIMENT WITH THUMBNAIL SKETCHES

INTENSIFY THE MOOD WITH COLOR

This is a realistic value interpretation of the scene. The houses, however, are too equal in size, and the river and the hill repeat the same contour.

Here I varied the houses. Don't stop at the subject, however. Check all your shapes. If you look again, you'll notice that the humpbacked hill is a distraction.

Although this is still the same scene, the hill shape has been modified and the values placed effectively for contrast. Even a small change can make a big difference in the composition.

Since color sends a message to the viewer, interpret the same scene in different color schemes. Certain colors, for instance, will accent the stillness of a warm, lazy day; others may complement a lonely mood. Let your personal reaction to a scene dictate the color scheme you select.

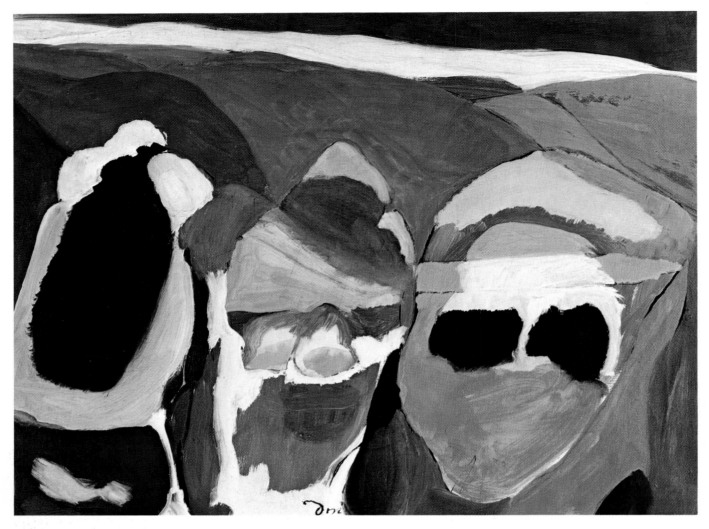

CARS IN SLEET STORM
BY ARTHUR DOVE
oil on canvas, 15" × 21" (38.1 × 53.3 cm), collection
of Memorial Art Gallery, University of Rochester, New York,
Marion Stratton Gould Fund.

*Although Arthur Dove used nature for his inspiration, he elevated
an ordinary subject into a masterpiece through his personal
arrangement of shapes, values, and color. To develop your own
creativity, spend fifteen minutes a day doing a twelve shapes lesson.
With practice, you'll be able to quickly analyze a scene before you
and discern the best compositional possibilities.*

Give your special color or colors a place of honor in the painting. These will be your lightest or brightest or most unique colors. The other colors in the painting should not compete, but help these sing or glow (refer to Lessons 2 and 8).

Too often in an attempt to create liveliness, myriad bright colors are tossed together throughout a composition. This is painting with color but without color reaction. In fact, too many ill-chosen discordant colors quickly disintegrate an otherwise solid composition. The effect is jarring, with no center of interest as far as color is concerned. If you want your colors to appear lively and bright, then you must prudently select the shades to support the special glows in your center of interest.

It is not only the selection of colors, but also the placement of color in a composition that is critical. Extra-bright colors are more effective within the painting than hanging on an edge. As an example, suppose a vivid red boat is situated so that it merges with the edge of your paper. If you paint it as intensely as it appears in your scene, it will be a distracting element, pulling the viewer's eye away from the central focus and out of the painting. To integrate the offending red shape, move the boat within the painting and reduce the vibrancy to allow the original center of interest to be seen.

Using color to compose your painting forces you to describe color excitement in a sophisticated manner. As a consequence, you move to a new, creative level of thinking, one that dislodges you from a reliance on tired clichés. Learn, for instance, to depict the early sunrise through observed color nuances instead of with stereotyped sun rays pointing to the center of interest. The viewer's eye will find and appreciate the special glow that you have created through color knowledge alone. There is no need for directional signals.

THE SUM TOTAL OF MANY PARTS

An all-encompassing approach to composition depends on the sum total of major components rather than a foreground/middle-ground/background format. It needs no roads or shadows leading in or out. Instead, it is a distinctive division of shapes, value, and color coming together to form an integrated composition. Every area works and contributes. The viewer's eye will settle on the most pleasing shape, the most luminous light, or the most exquisite color as the center of interest. You can finish the painting realistically or abstractly in any individual style or way you wish. These compositional lessons do not infringe upon your creativity; they give it a stronger foundation.

Saved until last, as a succinct example of an all-encompassing approach to composition, is the painting by Arthur Dove on page 112. Dove was an abstract artist, who extracted from nature for his inspiration. He then creatively elevated ordinary subjects into an exquisite arrangement of shapes, values, and colors. Take a long look at Dove's painting and try to determine its subject or inspiration. Truthfully, it doesn't matter, for the composition is an arresting combination of intriguing shapes, strong values, and rich colors. After a few guesses you might want to look at Dove's beginning sketch to discover three cars in the snow! This supports one of my basic concepts, that any subject can become a masterpiece. The secret lies in the mind of the creator. The emphasis is no longer on how well you paint, but how well you see, think, and arrange the shapes, values, and colors from the inspiration before you.

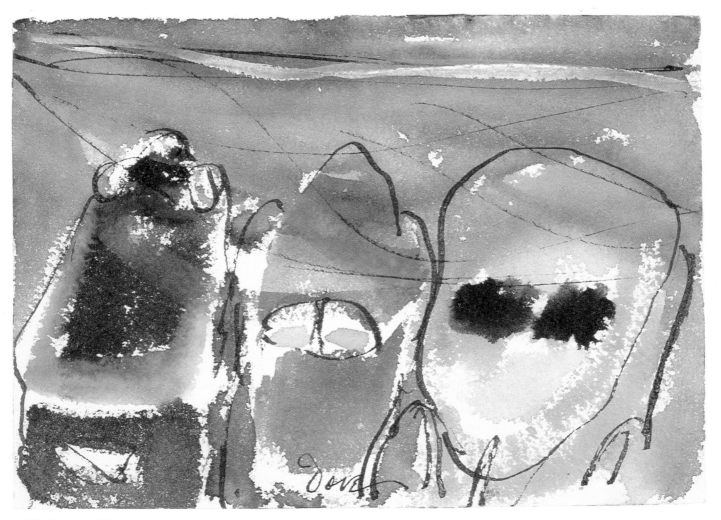

CARS IN SLEET STORM (sketch)
BY ARTHUR DOVE
watercolor on paper, 5″ × 7″ (12.7 × 17.8 cm),
collection of Herbert F. Johnson Museum of Art,
Cornell University, Ithaca, New York.

23. UNPAINTED SHAPES
Using the White Paper

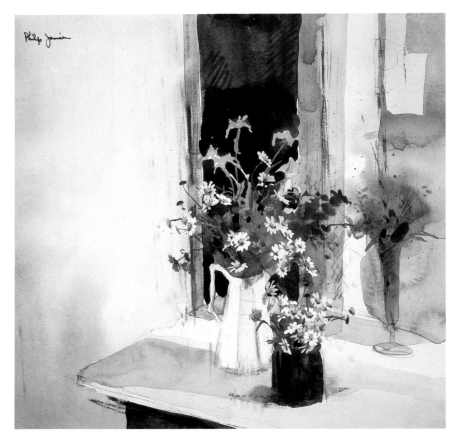

THREE VASES OF FLOWERS BY PHILIP JAMISON, NA, AWS, DF watercolor on Arches 110 lb. hot-pressed paper, 11½″ × 12¼″ (29.2 × 31.1 cm), collection of the artist.

How much and what is selected to be painted is the artist's choice, and this decision can make the difference between a good painting and a mediocre one. Here paper and paint are exquisitely balanced in strength. The white areas are solid forms in the foreground, subject, and background.

STOP at this point and consider the importance of unpainted shapes. As you study your painting, you may discover the areas you do *not* paint are as vital to the composition as the areas you do paint.

When I ask students, "What is the strongest element in a painting?" the usual responses are: spontaneity, technical control, a strong dark design. While these are desirable qualities, my students seldom think of the simplest element of all—leaving white paper *white*. A little investigation on their part, however, reveals that the eye quickly picks out beautifully designed shapes of plain white paper.

In watercolor these white shapes are enhanced by the transparent quality of the medium, which allows light to pass through pigments, reach the paper, and then reflect back. Areas left untouched or thinly covered reflect or "glow" more than heavily painted areas, which obstruct the passage of light. As a result, the eye of the viewer goes first to these "glowing" light areas.

Because of its luminous quality, white paper generates the same power as a heavy dark. To appreciate the effectiveness of an area left as unpainted paper, try this experiment. Paint a black circle in a white square (see page 115). Next to it, paint another square, this time reversing the circle to white (unpainted paper) within a black or dark square. It is important to keep both circles the same size in order to compare them fairly. Optically, the white circle appears to expand. Also notice how your eye favors the white circle over the dark one. Remember this experiment every time you are tempted to cover the surface of your paper with paint!

EVERY SHAPE COUNTS

Making what is not painted a vital part of the composition may be a new concept for you. From the very beginning, you should work with every shape—the painted ones and the unpainted ones. Notice I said unpainted *shapes,* not paper left as an afterthought. Merely leaving white paper is not the answer. The white area is a shape, form, or space. It must function as part of the painting. For a strong painting, I concentrate on making my unpainted shapes as powerful as my painted shapes.

For a visual explanation, look at the barn painting on page 115. Here, only half the paper is painted, leaving large areas of luminous, untouched paper. My challenge was to make the unpainted shapes stronger than the

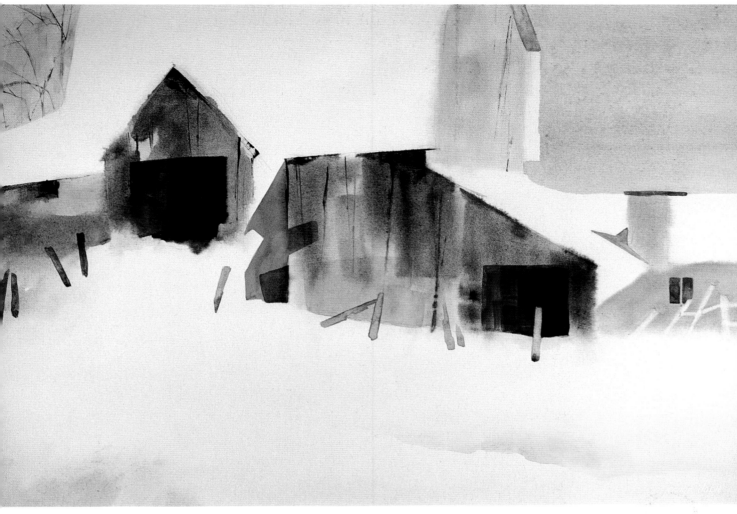

UNDER COVER
watercolor on Arches 140 lb. hot-pressed
paper, 21″ × 29″ (53.3 × 73.7 cm),
collection of Drs. Maryann and Gerald Galietta.

*Unpainted areas can be just as powerful as painted areas. Here
the untouched paper actually supports the painted barn shapes.
Remember to design the unpainted paper as a shape, space, or form
so that it functions as part of the painting.*

CIRCLE EXPERIMENT
*Which circle appears larger? Which contrast seems brighter? And
which circle advances? This experiment should help you remember
the power of white paper.*

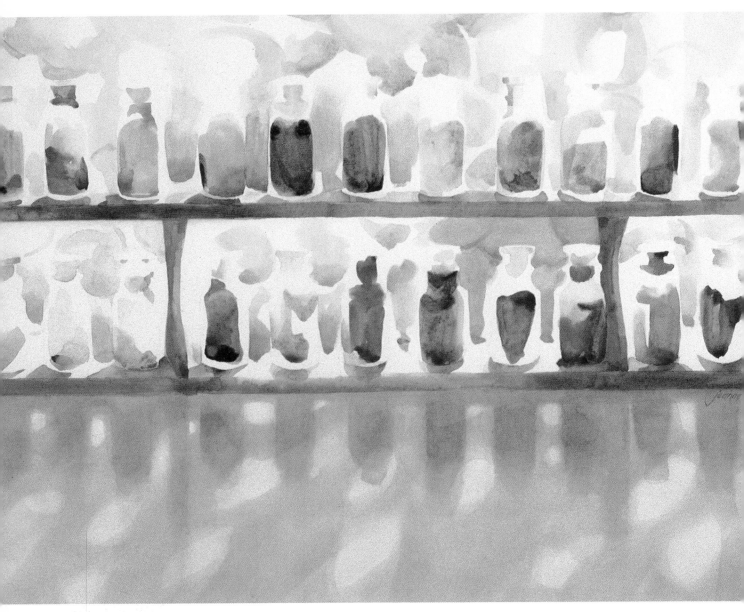

PARSLEY, SAGE, ROSEMARY AND THYME
watercolor on Arches 140 lb. cold-pressed paper,
21" × 29" (53.3 × 73.7 cm), collection of Betty Garver Nagy.

Even your subject can be left unpainted. Here the bottles are defined by the painted spaces between them, as well as their contents. The white paper makes the bottles appear all the more translucent.

painted shapes, which normally would dominate. In this watercolor the large shapes of untouched paper actually *support* the heavy weight of the painted barn shapes.

The power of unpainted paper shapes can also be seen in the watercolor *Parsley, Sage, Rosemary and Thyme* above. Notice that the bottles, which are the subject, are *not* painted. Instead, they are suggested by the painted areas around and within them. By giving the bottles the advantage of unpainted paper, I intensified the dazzling brilliance of the sunlight streaming through them. Remember the experiment with the white circle that seemed to expand?

DESIGN THE UNPAINTED SHAPES

It would help every watercolorist immensely if it were possible to ration paint to only half the amount needed to cover a sheet of paper. Then we would be forced to use it judiciously to describe the remaining unpainted forms! With this thought tucked in your mind, you are going to design a painting that is half unpainted shapes

HALF AND HALF EXERCISE

Determining the positive and negative areas can lead to confusion. Instead, try a different concept—use half painted and half unpainted shapes, which can be in the subject or *the background. Try using black pigment to paint the unpainted areas so that you can visualize them, as in the top sketch here. This should help you redesign these areas to balance the strength of the painted shapes (see the bottom sketch).*

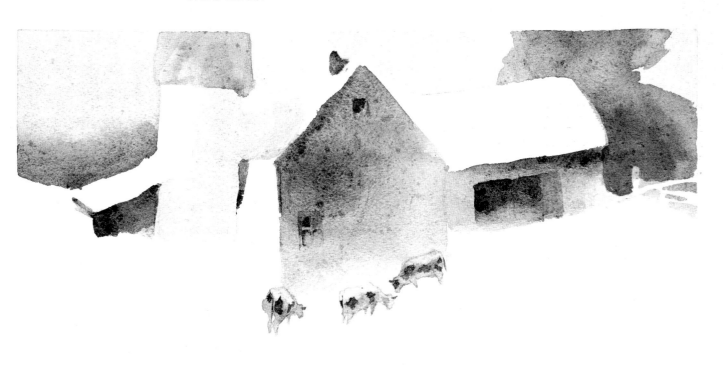

and half painted ones. The idea is to become preoccupied with the unpainted shapes.

First plan the composition in your usual manner in your sketchbook. Include unpainted areas. Now, to help you develop the unpainted areas into shapes that contribute to the strength of the painting, do another sketch next to the original one. In the second sketch, paint with *black* pigment every area you intend to leave unpainted, all the way to the edges of your sketch. You are reversing the white shapes to black so that you can think about and design the unpainted areas as solid parts of your composition. In this way you can easily see where an area may be unbalanced or undecided. You have a visual x-ray of the strength of your unpainted paper (refer to the illustrations below).

Looking at the black shapes you have painted should help you realize that the space around the painted areas is not a void but actually another shape, a component of the painting. Once you have designed this space to contribute to your composition, you are ready to move on to the actual painting. As you paint, use the painted areas to define the unpainted areas.

When you're finished, step back and critique your unpainted areas. Ask yourself: Are they decisive shapes? Do they work to reinforce the focus? Remember: a shape left as paper should never be an afterthought.

DON'T LEAVE WHITES AS AFTERTHOUGHTS
Try painting your white shapes in black in small sketches to see how they work in your composition.

POORLY POSITIONED

LEFTOVER PAPER

EFFECTIVELY DESIGNED

EFFECTIVELY DESIGNED

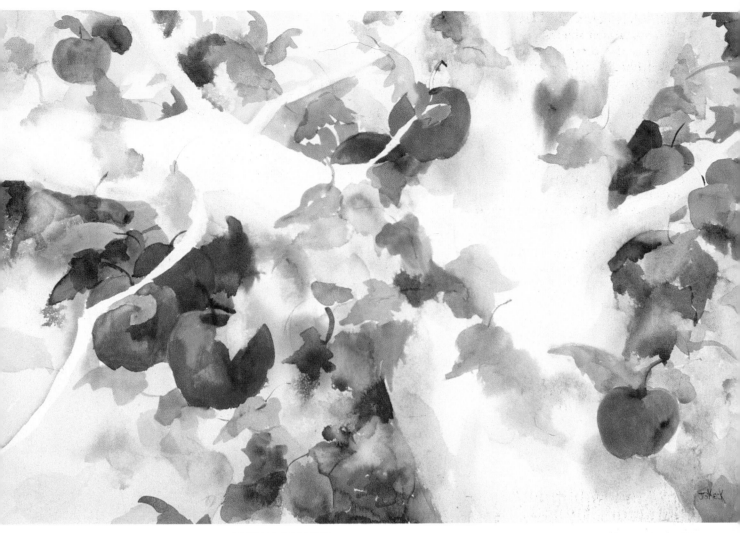

ORCHARD MEMORY
BY JEAN KECK
watercolor on Arches 140 lb. paper,
21″ × 29″ (53.3 × 73.7 cm),
collection of Koppers Company.

*Using paper as part of the painting led this artist
to an exciting conception of a realistic subject.*

24. BEYOND THE SUBJECT
Looking for a Relationship

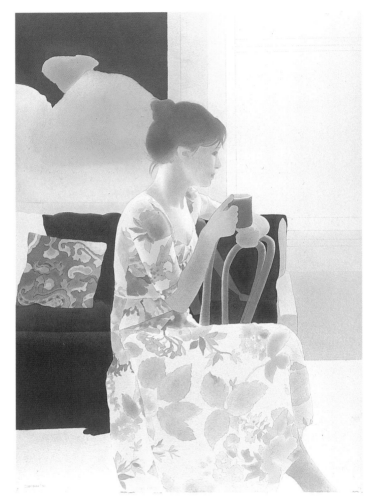

NAVA WITH GREEN CUP
BY ELIZABETH OSBORNE
watercolor on Arches
paper, 50½" × 37½"
(128.3 × 95.3 cm),
courtesy of Fischbach
Gallery, New York City.

Both the subject and the areas around the subject create the exciting shapes in this painting. Although a figure usually dominates a painting, this outstanding artist has brought all the areas up to the same level of power. Every shape contributes to the solidly constructed composition.

Whan usually captures your eye as you search the countryside for painting inspiration? Is it always a subject? Or is it a relationship? Don't stop short and merely depict a subject. Even though you may lavish all your expertise on it, a subject will remain just a subject. What lends excitement to a painting is the interaction of the subject with other areas. So look around, and find a shape or shapes that will complement your interest and showcase it to best advantage.

Seeking an exciting relationship helps you avoid two tendencies that lead to weak compositions. One is indiscriminately transferring everything viewed in the scene to the painting; the other is focusing exclusively on the subject and ignoring (or poorly designing) everything else. Seeking out two areas that interact with each other counteracts these tendencies.

SIMPLIFY A COMPLICATED SCENE

With my midnight sun workshop, the participants' first view of Norway was the eleventh-century seaport of Bergen with its colorful Merchants Quay. There was a profu-

sion of orange-canopied stalls, carts, boats laden with flowers, step-gabled warehouses, and tiled rooftops climbing the mountainside, culminating in breathtaking snow-capped peaks. Where do you begin when confronted with such a bewildering array of subject matter?

Developing a relationship between the subject and a complementary area helps simplify even a complicated scene. Take a look at my sketches of Bergen on pages 121–123. You may wish to trace them and push them around to help you decide on an effective composition. Although you are inspired, don't be tempted to shove the whole panorama into one painting. You need to choose one aspect. Let's say you are intrigued with the boats in the harbor and decide to accent the glistening white shapes as your subject. Will you automatically paint the town behind them, which is in actual view? Look at the scene on page 121. You don't need three or four subjects in the same painting, so don't include things simply because they are there. Pause here and think about finding a complementary shape (or shapes). The step-gabled rooftops and lively window patterns are extremely

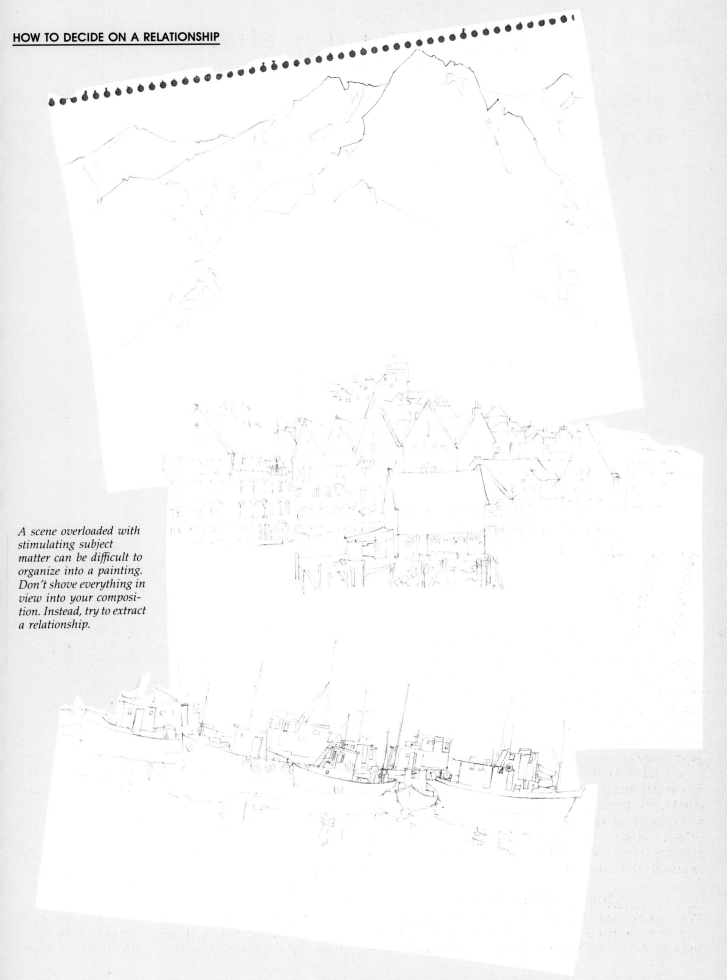

A scene overloaded with stimulating subject matter can be difficult to organize into a painting. Don't shove everything in view into your composition. Instead, try to extract a relationship.

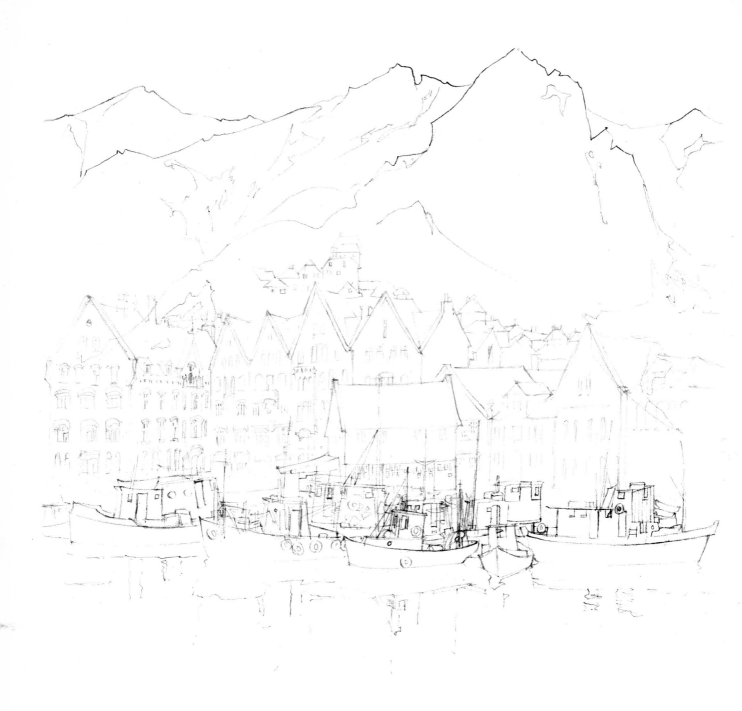

Move the tracings around or do several different sketches to compare various possible interactions.

Now select and reject. Here the town has been eliminated, and the background shape clearly complements the subject.

picturesque, but do they enhance or detract from the boat shapes? Move the Bergen boat tracing around to compare the interaction with other areas and select the most exciting relationship.

Good, you've changed your mind and decided that the quiet, towering mountains better complement your active subject. Now, develop a relationship between the two, with the background acting as a "frame" for the subject. When you sketch your composition on the paper, you can deemphasize the town (see the facing page), or you can eliminate it completely (above).

Another interest in the scene, such as the rooftops, could be chosen for your subject. They climb in a fascinating pattern up the hillside and could be complemented

by mountain shapes or the interplay of boat masts. But again, select one relationship, not both, to create a complementary reaction. Should you depict everything equally—boats, town, mountains—the viewer won't know where to look and the reaction will be lost.

COUNTERACT HALF A RELATIONSHIP

A reaction is also lost when only half of the relationship is depicted—when the artist focuses exclusively on the subject. If the shapes surrounding the subject are ignored, the composition remains weak and incomplete. A creative placement of your subject can prevent this.

Now that you have learned to design a variety of shapes, direct your attention to their placement on the

THE KING OF LOVE MY SHEPHERD IS
BY ELIZABETH OWEN
watercolor on Arches 140 lb. cold-pressed paper,
15½" × 19½" (39.4 × 49.5 cm), collection of the artist.

Whenever you are disappointed with a mundane composition, experiment with the placement of the subject. This artist chose an unusual arrangement and carefully designed all the elements to make the painting work as a whole.

paper. When you add a treasure to your home, you place it with great thought, within surroundings that enhance it. In other words, it relates or becomes part of the scene. You should do the same with your subject in a painting.

The sketches of *Pond Necklace* (page 124) show how an ordinary subject like rocks can become dramatic through placement alone. The original composition depicts a routine view of the subject. The rocks are designed with variety in volume and shape and given a prominent position in the painting, yet the composition is unimaginative. Visually, the rocks "float" because they are overwhelmed by too much surrounding space. To make matters worse, that space is evenly distributed between the rocks and outside edges and becomes static. To achieve an unusual composition, you must design the areas *around* the subject as well as the subject itself.

Vary the placement (see the broken line). Notice that the composition is immediately made more interesting. Push your subject to the right or left, up or down, or try it larger or smaller. In effect, what you are doing is creating different size areas *between* the subject and the edge of the paper. As these areas become more varied, your composition will improve!

Try one more placement suggested by the dotted line. Now look at the variety in the complementary shapes. They are as exciting as the subject shapes! Only when every area is contributing to the overall composition does the painting become strong. Let me point out that the subject has remained the same. It is the placement that is different. An ordinary box arrangement has become elegant.

Look at the unusual watercolor above—the result when this lesson was taught in a Pennsylvania workshop. It is a good example of a daring placement. The unorthodox treatment could have been a disaster if the field had been nebulous or indecisive. The artist, however, designed not only the sheep, but also the field and complementary shapes to support them.

Whenever you are disappointed with a conventional scene, try relocating the subject elsewhere on your paper. This forces you to design the mundane areas of the painting. You'll discover that as these surrounding complementary shapes become more interesting, the subject does too.

25. DISTINCTIVE DIVISIONS
Making Shapes Dynamic

SAN GIMIGNANO
BY SALLY W. PORTER
watercolor on Arches
140 lb. cold-pressed
paper, 21" × 29"
(53.3 × 73.7 cm),
collection of the artist.

Do you approach all paintings in the same way? Challenged by an unusual concept, this artist designed the shapes to travel around a lightly blushed center. The final composition thrives on the daring divisions of the paper.

Don't throw away an inspired painting just because it hasn't turned out well. If the original idea is good, you may only need exciting divisions.

In Lesson 21 we learned to compose with twelve varied and well-designed shapes. But you may still yearn for greater mastery in composing. Do you want a barn to be a bit more exciting, a mountain to soar even higher, or a waterfall to be eye-catching? Continue, then, into the next step of refining the twelve shapes into twelve unequal divisions within the edges of the paper.

When jurying an exhibition, judges often comment, "I like the simplified division of shapes," as they accept a painting. There is little doubt that distinctive divisions can make a painting stand out. Indeed, an expertise in dividing areas of the paper is the reason a painting excels, more than relying on a dramatic subject. Common scenes can be transformed by an uncommon division of shapes.

DESIGN BOLD DIVISIONS

For this exercise, I again advocate cutting paper to force you into designing bold, unequal divisions. This time, work in a single color with different shades of colored construction paper. My illustrations (pages 128–129) are done in a light blue, a middle turquoise blue, a mid-dark blue, and a dark blue. Use white paper for the lightest value. Notice that the colored paper provides an extra bonus: the different shades help to simplify and organize your values.

As you learned in the twelve shapes lesson, begin with the white or lightest and most important shape. First cut the white paper to represent your light shape and adjust it until it satisfies you. Then put your scissors to work on the darkest paper. Trim and shape it to complement the light shape. Next, add the middle value, followed by the mid-light and mid-dark papers, to create value variations.

Once all the major shapes are cut and placed on your paper, you're ready to assess them. Now comes the fun of turning your shapes into large, bold divisions. Each time you compose, you break up the paper into areas. The fewer divisions or areas you have, the more forceful your painting becomes. To make these areas exciting, you want to create unequal or unusual divisions within the four edges of your paper.

The shapes you have extracted from your landscape will help to suggest these divisions. You might, for instance, push a shape of mid-dark blue paper over to become part of a larger mid-dark blue paper area. With the colored paper, you can quickly identify shapes of the same value, which might be pooled into a single, more dramatic division. Moreover, because the pieces are only colored paper, and not indelibly painted, you are free to experiment bravely with building very unusual divisions. With your scissors, you can make quick adjustments and modifications. Extra pieces can be annexed to form the shapes into stronger major components.

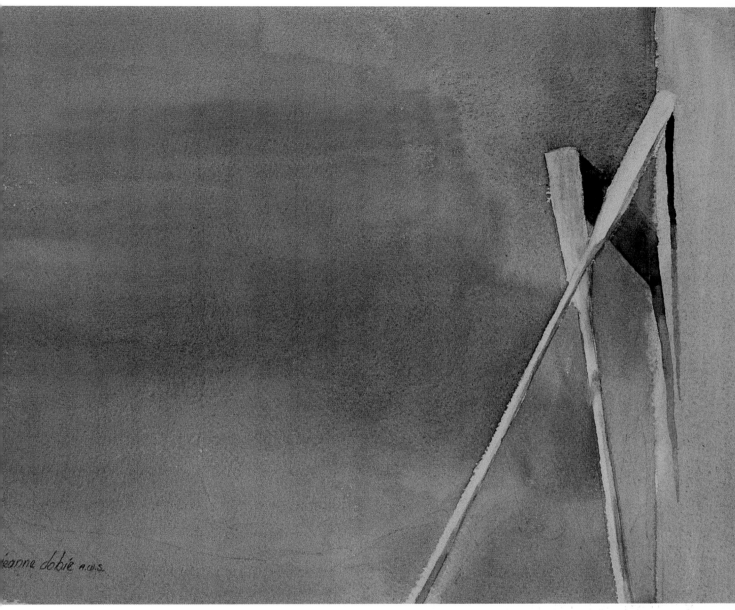

OFF SEASON
watercolor on Arches 140 lb. cold-pressed
paper, 11″ × 15″ (27.9 × 38.1 cm),
collection of Beverly Trevathan Williams.

Explore different possibilities. Push a shape over as far as you dare.
And stretch equal or "predictable" divisions into unequal shapes
and sizes.

EXPERIMENT WITH DIVISIONS

The bite of scissors cutting paper forces you into large, bold divisions.

This exercise should help you visually accept unequal divisions and reject a mild, complacent composition. Here are some suggestions to encourage you to venture into more daring divisions and consequently more exciting compositions. As you cut your shapes, can you exaggerate a shape? Can you push another shape over as far as you dare? Or make your size differences more extreme? Now try moving your subject to the top or bottom of the composition, anywhere but the usual, most comfortable place. The less balanced your composition is, the more exciting it will be.

Next, turn your exercise upside down. This is an excellent way to test your painting divisions. If they work well upside down, you have a good composition. When I reversed the illustrated exercise, the reflections of the mountains dominated rather than the mountain itself—an unusual viewpoint (see page 129). But note that the divisions are unequally proportioned either way the exercise is turned.

*Play around with the divisions
to transform ordinary scenes
into extraordinary ones.*

*To step back from the scene and
test your painting divisions,
turn your exercise upside down.
Here the reflections of the
mountains are featured, but the
divisions are equally pleasing
either way.*

129

AVOID MONOTONOUS SHAPES

In addition to the problem of falling into safe but undistinguished compositions, it is easy to inadvertently acquire monotonous shapes in your paintings. Here again, the previous exercise aids you in identifying any similarities, even if they are disguised by color and value in the scene.

The illustrations below depict a scene with uncomplicated mountain shapes and reflections. In the first attempt, the mountains are repetitive. This can be boring, especially if they are emphasized again in reflections. The second illustration shows how the composition was improved. This time I expanded one of the mountains beyond the top of the paper, elongated another, and reduced the size of the third. Now all three mountains have differ-

ent angles and different volumes. Notice that the smallest adjustment can make a big difference. To "unbalance" the reflections, I made them slightly shorter or longer or off-center. They need not be exact. In fact, they will contribute a greater liveliness if they are slightly different.

Pause here and consider that if you had taken a photograph, you would be locked into reality—three mountains, all the same size, with the reflections as an identical repeat. Now wouldn't it be a waste of time to sit in front of the scene and spend the afternoon faithfully painting the poor composition that a camera is stuck with? As an artist, you have the opportunity to improve the scene. Alter monotonous shapes. Change ho-hum compositions into distinguished divisions. And watch ordinary scenes become extraordinary.

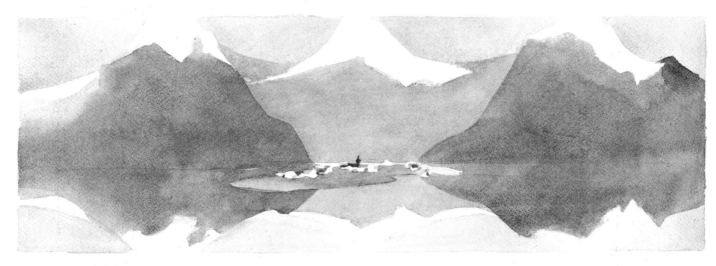

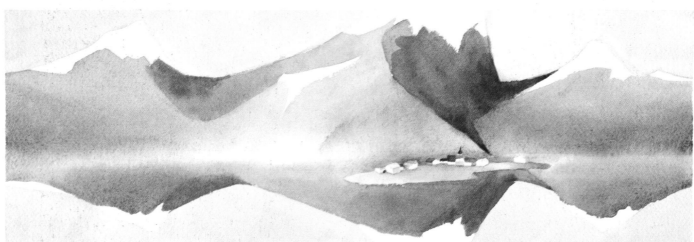

OVERCOME BORING REPETITION

If you just paint what you see, without thinking and designing, you may end up with repetitive shapes, as in the first sketch of the Arctic Circle here. Use the division lesson to identify similarities and to make noticeable size variations before it is too late.

"AN TOILEÃNACH" SEALS (right)
BY MARIA SIMONDS-GOODING
etching on Bockingford paper, 11½" × 8"
(29.2 × 20.3 cm), collection of Jeanne Dobie.

Limit the number of divisions for the greatest impact. This skillful artist dared to evenly divide her composition and still made it dramatic—a difficult achievement. With the direct division, she emphasized the thrust of the cliff walls pushing against a narrow sliver of space positioned in the center. This straightforward approach builds a quiet strength.

GJENSKINN
BY JAMES D. MICHAEL, MWS
watercolor on Arches
300 lb. cold-pressed
paper, 14″ × 21″
(35.6 × 53.3 cm),
collection of the artist.

*When you organize a
composition into solid
shapes and values and
then top it off with
distinctive color, the
result is unbeatable.*

A RE YOU puzzled by the difference between a solid value structure and a superficial one? Your value plan is important, as it can change a good "twelve shapes" composition for better or worse. The actual procedure is a simple, step-by-step exercise. Now where could anyone go wrong? you may wonder. Ironically, the best way to describe how to organize a solid foundation is to explain how *not* to (see the illustrations on page 133). Here are five common pitfalls:

1. Shifting a value within a plane.

2. Adding accents, texture, and details prematurely, without an underlying value.

3. Wedging against a weak edge.

4. Failing to resolve an indecisive or incomplete value plan.

5. Dissecting forms and planes with an arbitrary light path.

AVOID THE PITFALLS

Let's examine these problems one by one to see how each can be prevented.

1. *The Shifting Value.* Vacillating about the value, changing your mind en route from the left to the right side of a house, barn, roof, tree or whatever will not keep shapes solid. Instead, you have a "neither-here-nor-there" value, which constantly alternates and seems indecisive to the viewer. As you paint you may want some variations, but the general tone should never waiver greatly between a lighter and darker value. Keep the value solid to keep the shape solid!

2. *Details and Accents That Float.* The second pitfall is usually the product of overzealous enthusiasm, that uncontrollable urge to dive into the details and texture before the painting is structured. It is a little like putting icing and decorations on a cake before you bake it. And it is equally disastrous. No amount of brushwork can

ESTABLISH A SOLID VALUE STRUCTURE

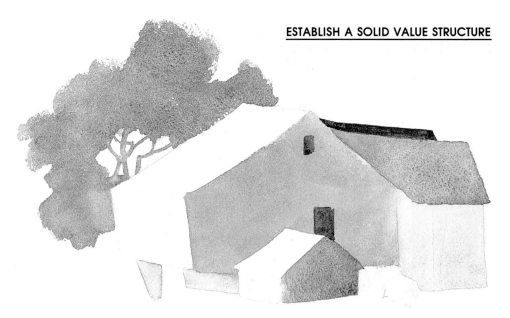

Every shape here has been given a value, and each value works in relation to the other values. Details and other variations should be included only after you have given the composition a solid value foundation to anchor the extra touches.

DON'T MAKE THESE COMMON MISTAKES

Shifting values cause the viewer's mind to shift, too, and the shape's solidity disintegrates.

Adding details and fancy calligraphy before the underlying value foundation is established only gives you technical practice.

Ironically, wedging pinpoints a weak area.

Solidity is weakened when a fabricated shaft of light dissects the forms.

133

DOORWAY PACENTRO
BY HELEN SCHNEEBERGER
pentel-sepia and water sketch on cork,
9" × 5½" (22.9 × 14 cm), collection of the artist.

This exquisitely conceived value sketch has become a work of art. The drawing is on a piece of cork, fashioned into a sketchbook by Italian villagers. The artist carefully considered the cork sheet as part of her value sketch, much as you should consider the white paper.

camouflage an impoverished value plan. Unless they have a solid value structure to support them, the bedazzling details and accents will float, producing a weak painting. Before you begin, take time to decide the values of all your major areas. Then, adding the extra touches becomes a joy and enhances each area. Note that details and texture integrate better if they are fairly close to the value of the underlying shapes. Also give some thought to whether the accent is serving a purpose. Unfortunately, accenting can become a habitual way of painting. Too often accents are misused for the sake of lively effects. Since accents tend to entertain the eye, they can distract the viewer from your original focus. Use them selectively. (Accents are discussed further in Lesson 29.)

3. *Wedging.* Wedging means pushing more value against an edge of a shape to repair or reinforce a weak spot. It never succeeds in developing a stronger shape; instead, ironically, it targets the weak area. When you have the urge to wedge a darker value into the side of a house, barn, or porch, it is a signal that the value structure is not working successfully. Go back and reexamine the values. More than likely, two adjoining shapes have the same value and one needs to be darker or lighter. Readjusting the values is a better solution.

4. *An Unfinished Plan, an Unfinished Painting.* At times when you are anxious to get started or feel you'll lose your spontaneity, you may be tempted to leave the value areas indecisive or plan only some of the values with others to be resolved later. Don't delude yourself into thinking that you'll know what to do when you reach that section. Creativity is blocked by having that concern foremost in your mind. The solution is to plan your values speedily with thumbnail sketches.

5. *Dissecting Planes with Arbitrary Light.* Still another weakness develops when an arbitrary light is introduced. Knowing that a light value glows and dominates a painting often convinces students to leave a contrived white area. Instead of being powerful, a contrived light has no form and no function. Consider, for instance, the effect of a beam from the heavens, pouring through buildings without regard to changes of planes. The result fractures rather than strengthens the buildings and any other areas it encounters. Remember that your light value is the strongest value. As such, it can be used to give validity by describing the form it falls upon and explaining a change of plane. Even when the light value is left unpainted, be sure to observe and describe its shape and function in the painting (see Lessons 23 and 28).

PLAN YOUR VALUES

As you have probably surmised, the way to overcome all the problems mentioned is the same: develop a solid value plan. How? Here are three basic steps:

1. Begin by allocating only one value to a shape.

2. Plan each value to be distinct from its neighbor.

3. Don't leave any value unresolved.

The objective is to distribute your values *throughout* the composition. Read that sentence again if you are an artist who tends to be enamoured with the subject alone and places all the values in that area. Sadly, I see many subjects lovingly painted with the entire gamut of values: lights, darks, and every value in between. But when a complete range is contained in one object rather than distributed throughout the painting, your value contrast is weakened. You have nothing left to effectively show your subject to its best advantage. Any value painted next to your subject merely blends with its "twin value" in the subject and tends to dilute the impact. *Consider the whole painting and not the parts* when planning your value foundation. Remember your subject is only a "part" of the composition. (Review Lesson 22 for a full discussion of this point.)

USE THUMBNAIL SKETCHES

A quick method of immediately seeing your value organization is to make thumbnail sketches, approximately 2 × 2 inches. The advantage of this size is that it is too small to allow you to become sidetracked into details or areas that are not major components of your composition. My favorite tool to extract the large major areas is a half-inch carpenter's pencil. The wide, thick lead allows me to gain value shapes with a stroke or two. I am not concerned with drawing at this stage but merely with organizing the values. I make at least five thumbnail sketches—no fewer. This gives me five different variations or choices. Inevitably one distribution of values is better than the others. In effect you are training your mind and eye to recognize a good value plan by comparison. Doing ten thumbnail sketches is even better and even more training!

The reward of investing a little time in value sketches is an immediate analysis of the underlying value foundation of your scene. Sometimes a landscape can appear to be a good composition and actually fool you. As you explore the shapes and values underlying the surface distractions, you may find the scene doesn't lend itself to an exciting arrangement at all. A few thumbnail sketches can warn you and save you the heartbreak of painting a dud. I remember, for example, how a white-washed Portuguese village with orange-tiled rooftops attracted the eyes of my students like a magnet. Yet the scene was deceiving. Investigating beyond the surface attraction, my students discovered that it was necessary to readjust the values of the dazzling orange roof shapes. Don't underestimate the importance of taking the time to do a seemingly insignificant thumbnail sketch. The result is a strong value foundation for your painting.

BANYAN TREES
BY BEVERLY FETTIG
sketchbook page, 7" × 10" (17.8 × 25.4 cm).

Thumbnail sketches like these help you to immediately see your value organization. By making several, you can compare them. And the practice will train your eye.

27. A SUBTLE TOUCH
Handling a Mass of Midtones

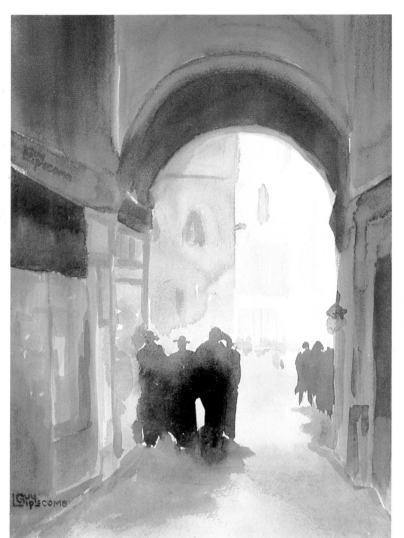

VENICE GATE
BY GUY LIPSCOMB
watercolor on Arches
140 lb. cold-pressed
paper, 15" × 11"
(38.1 × 27.9 cm), col-
lection of Georgia Cheek.

The greatest foe of artists is seeing too much, to the detriment of their paintings. This artist chose to accent how the orange lights illuminated the evening scene. To achieve this effect, he had to keep the remaining values closely related, without distracting contrasts or details. Notice that each value anticipates the next, creating a flow that does not compete with the focus.

HAVE YOU ever wondered what gives a painting that elusive museum quality? Often it is because subtle refinements, such as midtones, have been considered. In studying museum paintings, you'll find that many are executed in a full value range, offering more than a simple light-dark contrast. By learning to use a distinguished arrangement of mid-values, you'll advance another step beyond a good value sketch.

Your light value does not always need to be in the sky. Nor should the dark value be invariably applied to trees silhouetted against the horizon, especially if you wish to accent something else. Employ the middle values. The sky could be a mid-light; the trees, if unimportant, could be close to the same value as the sky to avoid a contrast. Don't fall into the trap of painting every scene in the same manner. That same scene can look many different ways depending on how you arrange your middle values.

MAKE MIDTONES FLOW

Tack your five-step value scale from Lesson 22 to your board for reference, especially if you have experienced difficulties with values in the past. Now you are ready to begin. First plan your light area. Then determine the placement of the darkest value to magnify the light. Now you can confront the great amalgam of midtones and decide how to distribute them.

Sadly, in many paintings the values take on the appearance of "steps" as the artist attempts a clear definition between areas and shapes. The many changes cause the eye to bump into, trip over, and bounce from value to value throughout the composition. The rhythm is disrupted. This is most noticeable when values alternate, a common disease among landscape painters. Alternating values, with their continual changes from light to dark, have a "seesaw" effect spatially and undermine solidity.

Ideally, the midtones should flow, carrying your eye

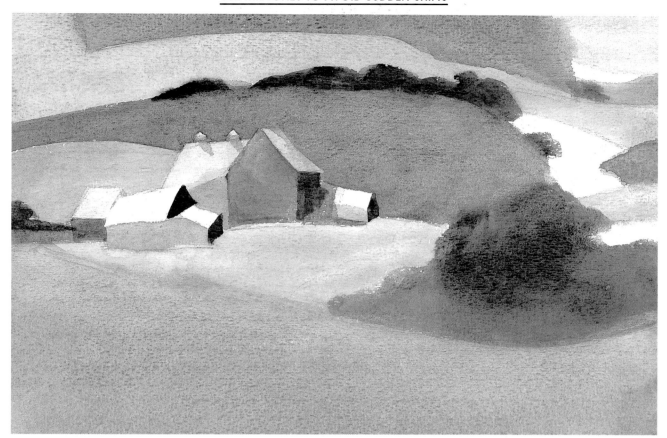

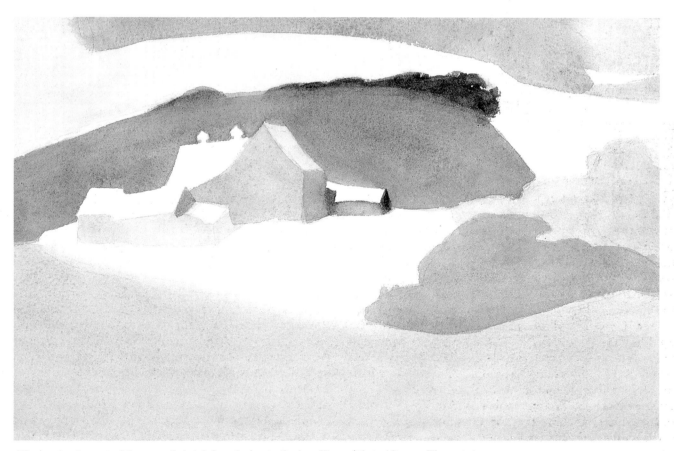

The greater impact of the second sketch here is due to the handling of the midtones. The secret is to develop a flow without interruptions, where each value anticipates the next.

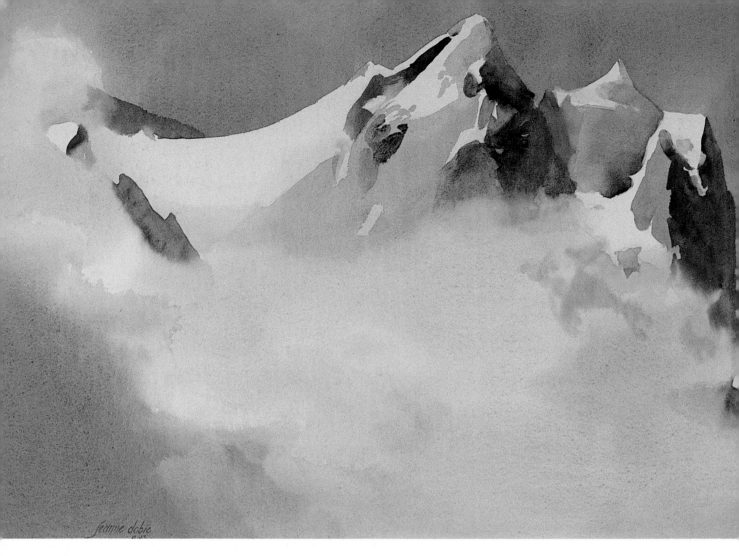

smoothly through the painting, without abrupt interruptions. By adjusting the mid-values for a smooth passage, you strengthen your interest by leading viewers directly to it. The viewers, of course, are completely unaware that this is what helps them enjoy the painting.

To prevent alternating values and instead develop credible volumes, study the before and after illustrations on page 137. Then look again at your own painting. See if you can change your values slightly so that each anticipates the next value. To accomplish this, change the value only one step wherever you can. Save the dramatic changes for areas where you want to arrest the viewer's eye. Try to allocate values that blend with their neighbors and continue to closely relate them as long as possible to keep the rhythm flowing. The result should carry the eye to the focal point in a smooth movement, without a struggle.

The idea is not to confuse the viewer. Avoid fragmenting a form with myriad values and changes. It will be stronger if described simply and beautifully. Notice, in the illustrations on page 137, that very few changes were made from the first sketch to the second. Also, notice that in most instances the changes were minor. The value was modified by going only one step lighter or darker. But what a difference these *small* changes make in the final composition. The majority of the changes were made *within* the middle values.

ADJUST MIDTONES FOR STRENGTH

Never underestimate the importance of a good mid-value plan. Occasionally I've heard students lament that they can't paint because there isn't any sun. Alas, they have relied solely on sunlight and shadow for their value changes. But values can be determined without sunlight and shadow to build a painting with a highly individual impact. As the artist, you can direct your viewers to see exactly what you wish them to see with a straightforward arrangement of mid-values.

At times it may be necessary to push a shape a bit lighter than it appears, to effect a greater range of value or to continue the value flow. Or if you have a powerful subject, your foreground may need to be a stronger value to support it. Simply change it from a light ethereal value to a gutsy, solid midtone.

Suppose, for example, that a barn is massive and strongly painted, but the sunlit foreground field appears feeble and refuses to support the barn. Your intuition tells you that the painting needs "something" in that area. The usual reaction is to look around and find an object to place in the field, such as a hayrake, puddle, or fence. That object might enhance the composition, but more often it only clutters the painting. Supplying an object is not always the best solution. Consider, instead, allocating a weightier value to the field to give it the needed strength.

ARE YOU READY FOR A MIND-BENDER?

The following is an intensely challenging project that I assign my master class. I'll warn you in advance that it may not produce a painting that satisfies you, but it serves as a valuable exercise in developing middle-value refinements.

The project is to paint a scene without any light and dark values. The entire scene should be constructed of close mid-values: mid-light, middle, and mid-dark. Staying within this limited value range will force you to employ the subtleties of minute value differences to gain a distinction between areas.

As a guide, look at my painting *"Up-Along" Lane* (be-low). This watercolor was painted on location in England to show my master class how a painting evolves without strong lights and darks. Areas that are similar in value can be expressed with slight nuances of color. These can be distinguished from one another through color reactions, vibrations, complements, warm-cool contrasts, and muted versus intense variations. Your newly acquired color knowledge is put to the test. Without the advantage of a dramatic light-dark contrast to carry your painting, you are prodded into drawing on your own inner resources. More creative paintings will be the ultimate outcome. Since you are the creator, learn to develop your own excitement.

CHALET VIEW (left)
watercolor on Arches
140 lb. cold-pressed paper,
15" × 21" (38.1 × 53.3 cm).

In a composition without a dramatic light-dark pattern, mid-values become crucial. To gain more force, arrange the mid-values to gradate from the light areas to the darks in a gentle progression.

"UP-ALONG" LANE (right)
watercolor on Arches
140 lb. cold-pressed paper,
15½" × 11½" (39.4 × 29.2 cm).

The challenge here was to make this scene interesting without using a strong light-dark contrast. Notice how I employed minute value and color differences to distinguish various areas. In particular, look for the interplay of warm and cool and the reaction of complements. The outcome of these color choices was a personal painting.

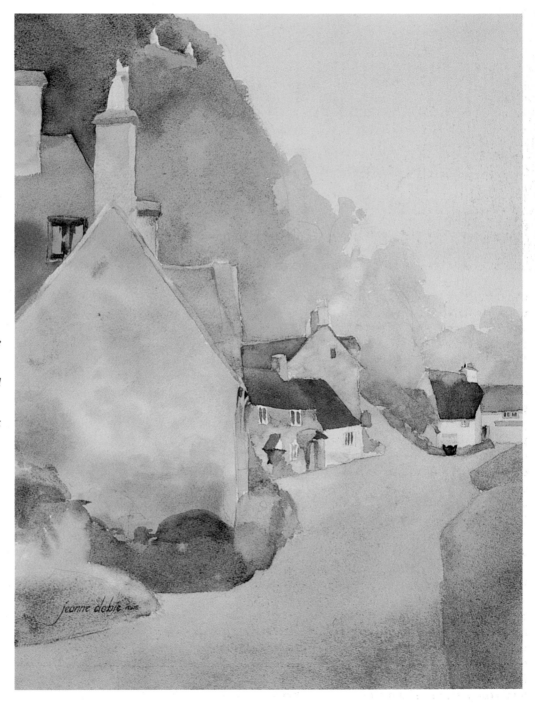

28. THE IMPACT OF WHITE
Planning the White Pattern

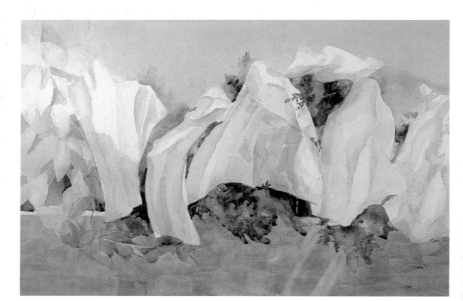

BARBERRY CLOTHESLINE
BY GERY PULEY
Canadian Society of
Painters in Watercolor,
watercolor on Arches
140 lb. paper, 14½" × 21½"
(36.8 × 54.6 cm),
collection of Mr. and
Mrs. Simon Tunley.

*Before you paint,
spend some time
quietly absorbing your
surroundings. Give
your feelings and
reactions time to
respond. This artist
chose a group of
cleaning cloths laid on
top of bushes to dry.
But she looked beyond
this ordinary subject
to reap a lively abstract
white pattern.*

I
N LESSON 23 we saw how quickly an unpainted white
shape attracts the viewer's eye. If the viewer's eye
is drawn first to the light areas of a painting, shouldn't
the artist develop the white shapes into something dis-
tinctive? Let's take another step and focus on how white
shapes can be developed into a powerful pattern.

For the untouched white paper to be the strongest ele-
ment in a painting, I stress the idea of working with
unpainted shapes from the beginning. Seeking the light
pattern as a first priority is often a new approach for
artists who use other mediums, such as oil, in which lights
are applied during the painting process or overlaid on
previously painted areas. It's all too easy to forget to
save the white paper as you become mesmerized with
effects while creating a watercolor. Too late, you find
that you have completely covered the paper.

LOOK FOR ALL THE WHITES

To counteract these tendencies, I have devised a simple
exercise using torn paper to foster a respect for the white
of the paper. In this exercise you isolate light areas from
the rest of the composition so they can be analyzed, ad-
justed, and arranged into the best possible pattern before
you begin to paint.

An interesting light pattern begins with the shapes that
will eventually form the pattern. To develop a clear idea
of the light areas in your composition, first tear or cut
shapes from white paper that correspond to the light areas
in your scene and place them on a piece of neutral gray
cardboard (see the illustration on page 141). Include all
the white, half-white, and generally light shapes you see.

Unfortunately, beginners sometimes miss out on potential
patterns by failing to see all the light shapes they could
put in a composition. If, for example, the composition
includes a bouquet of white flowers in a vase, they readily
see the obvious area and tear out only one white shape—
the flowers themselves. And that is the extent of the
pattern. Obviously, that's not enough.

At this point I introduce a three-dimensional "light"
box to help show students light shapes in surrounding
areas, shapes that may complement the subject. The light
box is an ordinary open box (about 6 × 6 inches), turned
on its side, with a "window" cut out from the rear (see
the illustration on page 142). In it, I position a painting
of a vase of flowers. When the "window" of the box is
held up against a light source, the direct rays of light
are interrupted by the inside flowers, causing a variety
of light shapes to appear on the surfaces around the flow-
ers and vase. Tilting or turning the box produces new
light patterns on the walls, windowsill, and the fore-
ground, as the direction of the light rays changes. Seeing
shapes of light that supplement the primary subject shape
is the goal.

In addition to revealing shapes created by natural light,
the box enables me to show how other whites can be
placed in a composition to complete a pattern. I position
a cut-out fallen flower in my boxed still life to demon-
strate this. Moving the unattached flower around conve-
niently illustrates how it is possible to continue or add
a pattern of light areas.

Using the box complements the torn paper exercise
by increasing an awareness of the many light choices

DEVELOP THE LIGHT PATTERN

If white areas gain more attention than darks, shouldn't they be planned to create a strong pattern? Use cutout paper shapes to explore different arrangements.

Now plan your dark shapes to complement the light pattern.

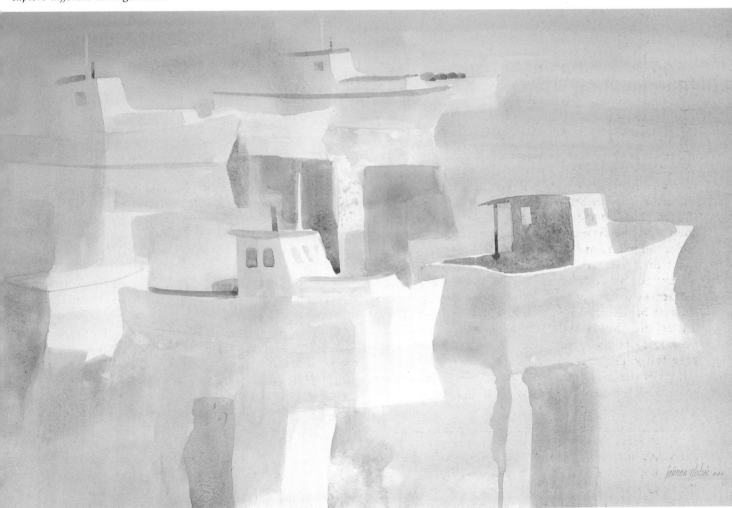

FLEETING
watercolor on Arches 140 lb. hot-pressed paper, 20" × 29"
(50.8 × 73.7 cm), collection of Mr. and Mrs. Wade Camlin.

Always remember that your medium is paper and paint. To incorporate the paper into your painting, try leaving the whites untouched as you paint. Then, when the painting is completed, tone down any overly stark whites with a gentle wash. To take the exercise that led to this painting one step further, try tearing white paper shapes and moving them around on an unsuccessful painting to see how it can be improved.

available. A second look at your landscape or still life will reveal light areas throughout the composition, not just in the subject.

DESIGN THOSE WHITES!

Return now to your composition and search for all the light shapes possible, as these will give you the tools to build an exciting pattern. Tearing paper facsimiles allows you to divorce the shapes from other influences in the composition and push them into patterns. The torn shapes can be combined, made to flow, or blocked into a solid group. As you examine the boats in a harbor scene, for example, you may decide they make a distinctive light shape if two or more are merged. Combining several torn shapes in this manner often produces a silhouette with more angles and variety than would be found in just one shape.

But what if you become overwhelmed by too many torn pieces scattered across your board? Even these random shapes can be easily organized. In fact, this is often an opportunity to utilize the natural lighting in your landscape to suggest a flowing pattern. You might, for instance, gather the strewn shapes and make them echo the light crossing over a field, traveling up the side of a house, reappearing on a tree trunk, and coming to rest on a picket fence. This arrangement encourages the eye to move smoothly around the composition, following the light areas, instead of jumping abruptly from one scattered piece of light to another.

Or you might develop a forceful pattern by tying white shapes into a solid group. Try joining one light shape to another, and yet another, for as long as you can continue, to build a dominant mass. Since the sheer size of this mass commands attention, be sure to maneuver the pieces to make the final shape attractive. (For more on building a dominant pattern, see the final lesson.)

Working with torn paper allows you to explore the many adjustments possible. You can move the paper shapes to the right or left, up or down; you can even retear pieces, combine them, or eliminate one here or there. Best of all, you can experiment with different placements within the composition until a well-designed relationship is achieved.

When you are satisfied with the shapes and their arrangement, draw or transfer them to your paper. Remember, for the greatest impact, these areas must be left untouched as you paint. Don't, under any circumstances, submit to the temptation to cover them, for you will lose their brilliance. Adjusting white areas should be done after the painting is completed, and then only with a gentle wash or tone to calm an overly blatant white.

ACCENT YOUR WHITES WITH DARKS

If you like the result obtained by this process, repeat the torn paper exercise to learn about distributing dark shapes. But this time, place the dark areas so that they complement the light pattern (see the illustration on page 141). Like magic, the darker additions further heighten the light shapes. As you add the remaining midtones, the strength of the white paper increases. Finally the painting is completed, and the light pattern "emerges" as a beautifully designed target.

With this exercise, there's little chance of arbitrarily leaving areas of white paper or ending with a ho-hum, nondescript light pattern. And how flexible the light shapes are when working with torn paper! Imagine the difficulty you would encounter adjusting a light pattern as you paint or attempting to reclaim white paper after the painting is completed. That's why it's important to plan your light pattern from the start.

MAKE A "LIGHT" BOX
This three-dimensional "light" box helps you to discover light shapes beyond the subject— throughout the composition. It can be rotated or tilted to create even more light shapes.

29. THE DARK PARTNER
Designing a Dark Pattern

MONHEGAN COAST BY ANTONIO MARTINO, NA, AWS watercolor, 21″ × 29″ (53.3 × 73.7 cm).

Let the dark pattern transform an ordinary scene into pure drama. To design a predominantly dark painting, you must carefully plan the white focus. Look at the exquisite one in this painting, which captures and holds the eye.

I F A large dark is placed in the center of a composition, are you attracted to the painting as much as when a glowing light is placed there? Probably not. Darks appear to contract in size, while lights tend to expand. (Remember the circle experiment in Lesson 23?) Actually, the role of darks in the composition is that of a partner, supporting the light. As you design your darks, you have an opportunity to showcase the brilliance of your light.

Don't add a dark just because it is in your scene. Thinking of darks as a setting for light will suggest their placement in the painting. Your choice should be an intellectual, artistic one; it should not be influenced by the actual position of the darks before you. A quick way to visualize where darks will function best is to turn your painting upside down. This enables you to view the painting in compositional terms rather than as a landscape. Most important, you can concentrate on a *painting* of the scene, not a duplication.

INTERLOCK DARKS WITH LIGHTS

If you need to use a large dark in dead center, then exciting white shapes are essential to detour the eye and help it travel around the dark area. Try interlocking these shapes—wedding a dark pattern to a white pattern, or a white one to a dark, to create an interplay. A sense of excitement can be lost when darks are painted insensitively all over the paper. But when both patterns are interwoven, they create an entirely new dimension, more intriguing than what each pattern alone could offer.

To give you a visual explanation, each morning I pass a farm with two horses—one white, the other chestnut brown. Often they stand together, pointed in opposite directions. I'm always taken with how perfectly they complement each other, the pure white horse accenting the rich brown, and vice versa. Neither one would be as striking alone. But together, interlocked, they create an elegant picture.

SELECT, REJECT, AND VARY

Always design your darks to heighten your light pattern, but don't overpower it! Remember, try not to be misled by the visual appearance of darks in the scene. Avoid hinging heavy, dark shapes to the edge of your paper or locating them somewhere else where they pull the eye away from your interest. If they do not contribute to the light pattern, don't select them for an interlocking pattern. Instead, you can make them less noticeable as half-darks. Study your lights and determine which darks in the vicinity complement them best.

Look at the sketch I made for my painting *Pawley's Gray Lady* (page 145). The summer house had many darks that could have been used. But when the sketch was turned upside down, it was obvious that most would interrupt the rhythm of the composition. I simply rejected any darks that disrupted the composition and selected others that helped.

Once you've selected your darks, there's another consideration. We have such fun capturing all the nuances and variations we see in lights, yet we completely forget about variations in darks. Generally, a large batch of dark color is mixed and applied liberally throughout the painting for the "finishing touches." Not only is the dark predominantly the same color, but alas, also the same value. Often, the dark mixture is used everywhere, indiscriminately—for objects in the distance, foreground, and middle ground. All illusion of space is destroyed.

CHOOSE DARKS THAT WORK

Don't add a dark just because it is in your scene. It's all too easy to let darks take over as you add more shadows and accents. Instead, consider darks as a setting for lights. A good way to judge the dark pattern in compositional terms is to turn your painting upside down. Try that with this sketch. Analyze which darks complement the light pattern and which interfere. Then look at the changes I made in the final painting.

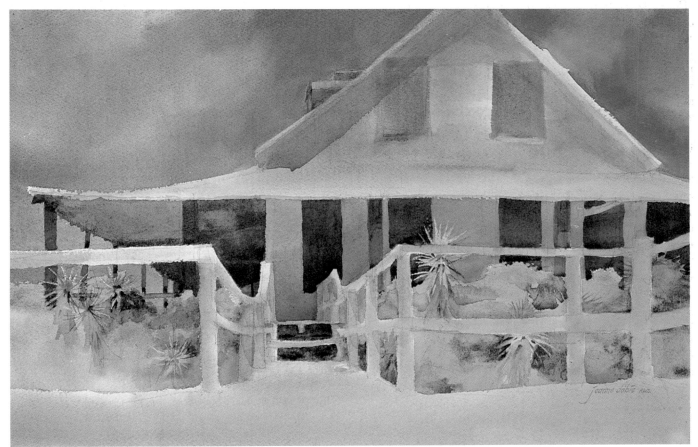

PAWLEY'S GRAY LADY watercolor on Arches 140 lb. cold-pressed paper, 15″ × 21″ (38.1 × 53.3 cm).

In the final painting many bits and pieces of darks that punctured the light pattern were removed or changed to mid-values. The dominant shadow under the roof was modified to a lighter value (and one side was barely painted to further diminish the powerful thrust). The stronger side of the roof was blended into the sky with a color bridge. Now the simplified dark pattern complements the regained light pattern.

Every dark can't be the center of attention. Some are less important than others, and the value of these should be restrained. None should be as rich and potent as your important ones. Large areas of unrelieved darks are not needed to make a composition strong. A few well-chosen darks, used judiciously, will highlight your lights. Remember that it becomes difficult to keep a watercolor lively if most of the values drop into deep tones.

USE DARK FORMS NOT DARK STROKES

Your dark pattern should be composed of forms not strokes. Accents and brushstrokes are not planes; they are merely slashes that float in space. As such, they contribute nothing to the main structure of the composition; they are, as their name implies, just accents. When accents are exploited throughout a painting, the viewer's eye is forced to tap-dance over the surface. Unfortunately, a dark pattern created by brushstrokes rather than vital components can change a painting into a technical exercise. A solid composition begins with solid forms.

CHURCHGOERS
watercolor on Arches 140 lb. cold-pressed
paper, 21″ × 28″ (53.3 × 71.1 cm), collection
of Dr. and Mrs. Charles D. Farmer.
In my preliminary sketches I explored different ways of interlocking the light and dark patterns. In the painting itself the dark and light areas became partners. Notice that the darks are not applied as one value. Strive for variations in your darks as well as in your lights. To capture the dusty shades of the old hats, I rocked the paper back and forth, forcing the paint to settle in the valleys of the paper. Going one step further, I contrasted the weathered hats with a transparent, octanic color in the shadows.

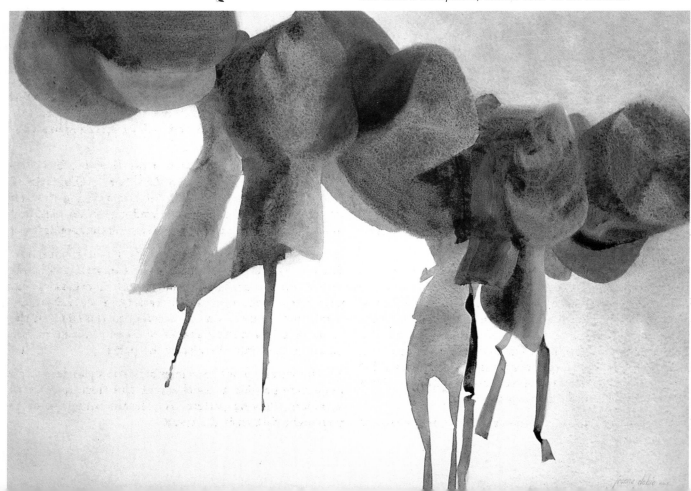

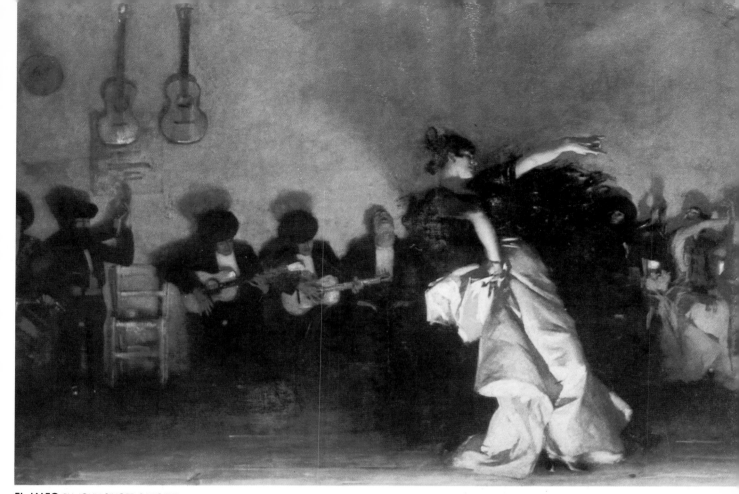

EL JALEO BY JOHN SINGER SARGENT
1882, oil on canvas, 93″ × 138″ (236.2 × 350.5 cm), Isabella Stewart Gardner Museum, Boston.

The simple, powerful dark pattern interlocks beautifully with the whites in this masterpiece. Imagine the whites barely supported by numerous, small dark accents. Or picture the dancer merely described as a subject. Notice how Sargent has, instead, woven the dark pattern into the figure and interlaced some whites into the dark shape.

If you wish to kick the habit of accenting, try reversing the dark and light values in your sketchbook. You'll discover it is almost impossible to reverse accents or create an outstanding pattern with them. You'll be forced to find solid areas to support your focus. With practice, you may soon be able to design both patterns, lights and darks, to be equal in strength for a stronger interlocked unit.

SOME FINAL SECRETS

The darks from pure pigments are powerful, highly saturated, and transparent. What more could you want to gain strong darks? Actually, there are a few secrets you can use in applying your paints to increase the octanic effect and gain the optimum vibrancy.

1. When the dark area is large, the painted result can be nonluminous. To counteract this, paint the area as a half-dark. Then, before the wash dries, drop additional undiluted pigment into a corner or section. This procedure creates variation and an illusion of depth in an area that would otherwise be a flat, static dark. An additional plus is that if the area is a large opening in a barn or something similar, it will have a bit of air breathed into it. Darks need variations as much as lights.

2. If you paint with a wet-in-wet technique, be sure to include all the darks before the paper surface dries. Apply these darks as richly as possible. The chances of making them deeper later by repainting are not good due to the uniqueness of the wet-in-wet method. The surface quality of paint flowing off the hills and settling into the valleys of the paper is lost when repainted. A wash applied later covers the hills and valleys, resulting in a cutout or pasted-on look.

3. For rich, octanic darks, use a brush with a bite. My favorite is the aquarelle brush. The short, stubby bristles are perfect for parting the paint and pushing through to the paper for intense darks. Load it with pigment and use a minimum of water for a fully saturated application.

4. Suppose you've painted your dark pattern but now discover you are in trouble—there's a dark that tends to leap off the paper. Since your dark is necessary and must remain, you need to counteract the action by tying it into the composition. To accomplish this, deepen the value of a few nearby shapes to form a transition and meld the dark into the rest of the painting.

The important point to remember is that darks can do more than provide a visual accent. Put them to work in a smooth, flowing pattern. A pleasant counterpoint to your light pattern is the result.

30. A PERSONALIZED LIGHT
Changing the Light Pattern

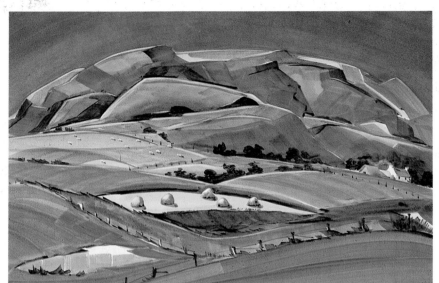

IRISH HIGHLIGHTS
BY JAMES D. MICHAEL, MWS
watercolor on Strathmore
300 lb. hot-pressed
paper, 13¾" × 20¾"
(34.9 × 52.7 cm),
collection of the artist.

Art is freedom to create a world of your own, as you see it. This Irish landscape was not at its best on an overcast day, and the painting might have been dull had the artist faithfully recorded what he saw. Instead, he changed the light pattern to help the eye travel around the composition.

ONE GOOD lesson leads to another! You have learned to extract an interesting light pattern from the scene before you. But as a serious artist, you may want to move beyond a status quo composition toward a far-from-ordinary painting. If you question whether you have overlooked the potential of an untapped light pattern, one that could produce a unique work, then this lesson is written for you.

Actually, I teach students how to change the light pattern in an unconventional manner. The lesson is given *after* they have completed a painting. Have faith. My method has been "field-tested" (literally) by participants in a decade of workshops. In the morning I set the artists free to paint a scene with the goal of incorporating all that they have learned about the light pattern to date. At noontime we gather and the next concept is given. If you wish to try this new approach, then do the same as my class—first go out in the morning and paint a watercolor using all that you have learned so far. Now you are ready for my lesson.

ADD A NEW LIGHT PATTERN

Return to the same location where you painted in the morning. You are going to paint the scene again, but this time with a different light pattern. The objective is to search for *another,* less obvious light pattern. (Naturally, you'll be helped by the altered direction of the afternoon light, which may suggest alternative patterns to you.)

You are seeking a totally new light pattern; you are *not* reversing values. I cannot stress this too strongly.

Reversing values seldom works because what you have is the same pattern as a mirror image. Only select a reversal if the values actually work, not merely to change them.

Spend some time looking at your scene. Put your mind into gear and see if you can find another light pattern traveling through the scene. This exercise is excellent training for seeing beyond the usual composition. It also eliminates a dependence on sunlight and shadow for your patterns. When you create your own lighting excitement, the result is often a more sophisticated composition than the pattern that sunlight and shadow just happen to make. And there's no need to wait for a sunny day or limit your outlook.

Discovering alternate light sources is a challenge. Let your eye search for an interesting shape. Perhaps an irregular road design is more arresting than the ordinary white house chosen for your morning effort. Observe if a distant hill collects the light and acquires a golden yellow glow. Find some areas around your center of interest that accent it. Or be creative and design some!

YELLOW AND BLUE EXERCISE

To explore different light patterns, I ask my students to make three value sketches of their landscape (approximately 5 × 6 inches). Executing these in the usual black and gray tones is not very helpful, I have found. With smudged grays, it may be difficult to channel your thoughts into lights. Instead, I suggest using two colors: yellow and blue. Use the yellow (either aureolin yellow or cadmium yellow) to depict the lighter values because it is easy to identify with light. The blue pigment (French

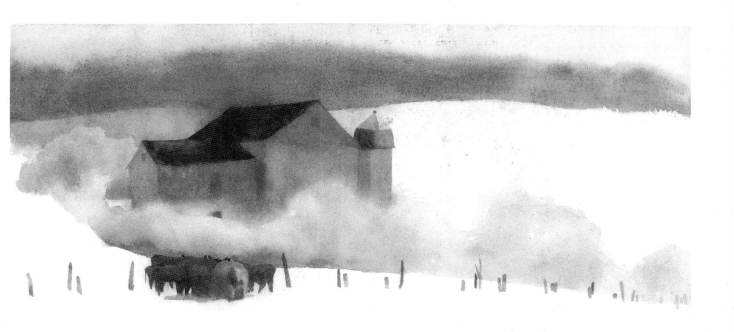

DON'T LET THE SCENE DICTATE TO YOU
My preliminary sketch shows a gray, overcast day without any inspiring sunlight or shadow patterns.

PENNSYLVANIA COUNTRYSIDE
watercolor on Arches 140 lb. cold-pressed paper,
10½″ × 21″ (26.7 × 53.3 cm), collection of Lois Van Dyne.

You can develop a pattern without relying on the actual light and shadow. Here I was intrigued by the silhouette of the cows and the way it balanced the weight of the barn hovering above. I made the cow shapes more aggressive by placing a narrow strip of light between them and the barn. Other light areas were introduced, but I reduced their contrast with neighboring values so as not to dilute the interest in the cow pattern.

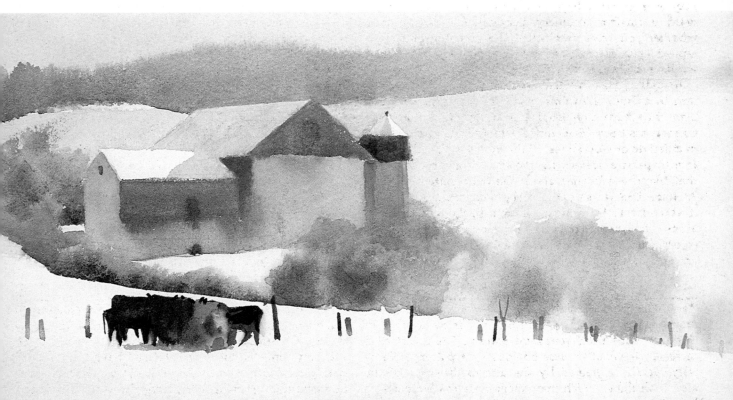

TRY THE YELLOW-BLUE APPROACH

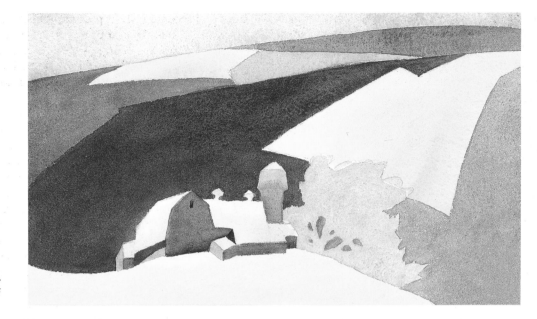

This view is a realistic one, suggested by the actual scene. Observe how the light travels through the composition.

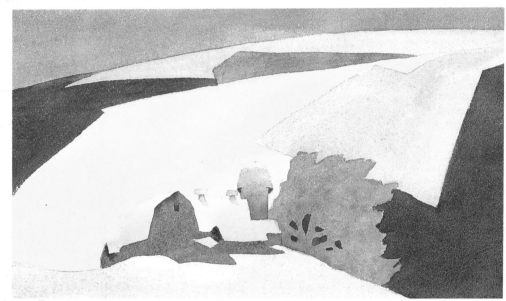

Here the light shapes have been joined to create an enlarged pattern. The composition promotes a feeling of expansion.

In another interpretation, the light pattern accents the fields and ignores the original subject. Note how easily changes can be made with the yellow-blue approach. When I decided not to continue the light pattern into the foreground field, I simply changed it with a blue wash—producing a compatible green, which left the light pattern clear and distinct.

ultramarine or cobalt blue) can then be used for the remaining values, from middle to dark tones.

The yellow-blue approach is fun! Students claim that the visually pleasing color departure from the tired gray sketch improves their designs. After all, yellow is a warm pigment associated with light, and it is the pigment with the lightest value. In fact, it is so light, you can't produce darker values with it! As a result, your light pattern is kept clear and distinct. Since the blue is a cool pigment, it is ideal for describing the non-lights, the rest of the values. And should the two colors overlap anywhere while you are painting the progression of values, they will blend into a compatible middle-value green.

Now that you have been introduced to the concept, try sketching (with yellow pigment) three different light patterns. Be sure the patterns are varied. And if you see more light pattern possibilities, by all means, do more than three sketches. Then paint the rest of the values in blue (see the sketches on page 150).

With the yellow-blue approach, there is no way to lose your light pattern, which can happen in a gray value sketch. In addition, you are guiding your thoughts visually into a composition with color. Even your warm and cool placements are being decided at the same time. Isn't it amazing what a little color association can do to activate our minds!

At this point, you have three or more exciting light pattern choices. Select one to be your second painting. No matter which one you choose (although I hope it is the best), it will invariably be a more sophisticated pattern than the obvious light pattern of your first painting. Even though my classes struggle a bit with this lesson, they are always surprised at the critique. The majority of watercolors painted in the afternoon supersede the mundane morning efforts. Some become highly individual.

Searching for another light pattern forces you to open your mind and discover other creative avenues. Twelve artists painting the same scene will not have look-a-like paintings. Each will have a personal statement, depending on the light pattern chosen.

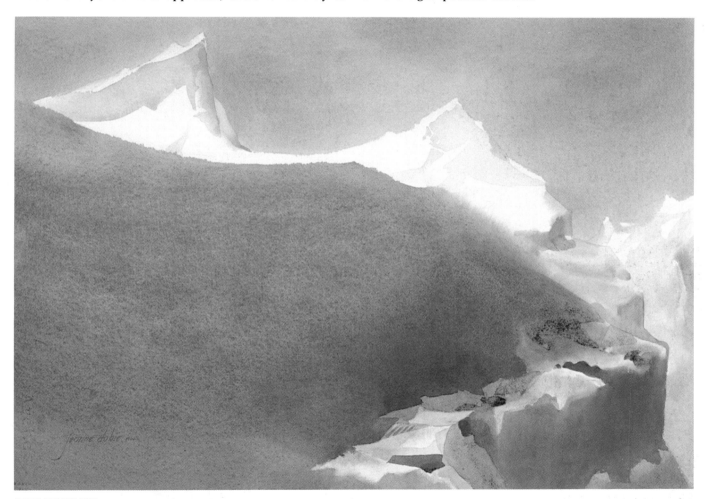

GLETSCHERBLICK watercolor on Arches 140 lb. cold-pressed paper, 15" × 21" (38.1 × 53.3 cm).
Changing the light pattern initiated this unusual composition. My eye was attracted to the irregular field shapes, clinging precariously to the mountainside. Using the yellow-blue exercise, I selected the sketch that best accented my interest.

31. PATTERN AS SUBJECT
Making a Good Design Even Better

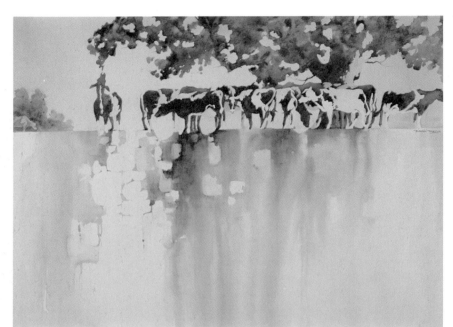

COWS/CAMOUFLAGE
BY DEAN DAVIS, MWS
watercolor on Arches
140 lb. hot-pressed
paper, 14″ × 20″
(35.6 × 50.8 cm),
collection of Mr. and Mrs.
William G. Sanderson.

Contemporary is an approach of thinking, not a style. Seeking patterns opens the world to you and can initiate a highly individual interpretation. Here the artist discovers a shadow pattern that combines with and continues the pattern in the trees and the cows. How much more exciting this response is than the usual rendering of this kind of scene.

MAKING a good design even better requires a combination of vision and intellect. Reflecting on my art school days, I remember being given a baffling assignment. My professor wanted me to paint everything I saw over the garage roof at the rear of the school. I was not even permitted to include the roof in the composition. Truthfully, it was the most uninspiring scene I have ever faced—a complete nothing and especially *not* a "subject." The challenge forced me to reach deep within myself for anything and everything I knew or had ever learned. I concentrated on extracting the essence from the scene and developing patterns.

This experience had a profound effect on me. I realized that painting involves more than conveying a subject. In fact, the subject can be anything; it really doesn't matter. And I'll prove it to you.

WHAT ARE PATTERNS?

Patterns are unique combinations and arrangements of shapes that underlie the identifiable scene. Look at the two sketches on page 153. On close examination, you'll discover that the same basic pattern underlies both compositions. That is, the shapes and values are the same sizes and positioned in the same places in both sketches. The color themes and subjects are different. But the outstanding feature in both examples is not the subject, but the *pattern!*

Now prop the book up, open to this page, and stand across the room. With a little distance between you and the paintings, you'll begin to see how pronounced the pattern is—even more than the subject chosen. When exhibitions are screened and juried, the underlying pattern—not the subject or the technique—projects a painting. Although perhaps unconsciously, you, too, have probably responded to a painting with an outstanding pattern structure when you surveyed an exhibition.

If you look for a subject only, you may be passing by the many possibilities in an ordinary scene, possibilities that remain invisible until your mind extracts a pattern. Of course, a pattern by itself is only an arrangement of shapes, values, and colors. It is how you perceive that pattern, then extract and design it, that makes a personal statement.

COMBINE SHAPES

Learning to see a pattern is a step beyond seeing individual shapes. By combining two or more shapes, you create a new shape with a more interesting contour. Suppose, for instance, you are confronted by a rooftop that is a rudimentary box shape. It doesn't contribute to the painting, so you search up and down the street to select another rooftop. But don't just add another box shape. Try hinging two roofs together to create a better shape. The result is a pattern that is more varied than the original box shape (see the illustration on page 154).

An easy way to attempt a pattern, then, is to connect

EMPHASIS ON PATTERN

Examine these two sketches closely. If you look beyond the obvious color and subject differences, you'll discover a striking similarity. Both sketches have the same basic compositional pattern. Indeed, the pattern is the subject.

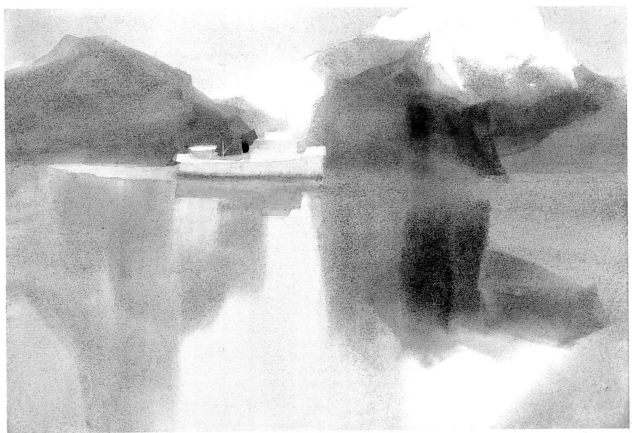

FJORD FERRY

BREAKFAST DISHES

CONNECT SHAPES INTO A PATTERN
Combining shapes can lead you to a more interesting pattern.

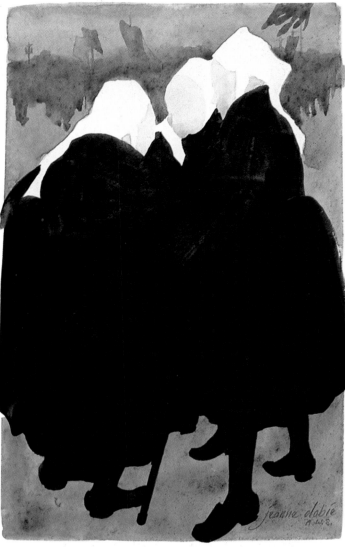

several shapes. My painting *Three Bretonnes* (opposite) illustrates this point. I first tried arranging the dark silhouettes of the three women in several configurations and finally produced a single commanding shape, which was more eye-catching than any of the three individual shapes. At this point I found myself intrigued not so much with the women's figures as with all the pattern possibilities of their feet. The older women wore distinctive, oversized, heavy shoes, some with buckles (similar to those depicted on Pilgrims in history books). I decided to accent this feature and the sturdy stance of a hardworking people. More combinations were tried. Here, though, the consideration was not just the pattern of visible feet, but also the pattern of the spaces "between" the feet. When the pattern was finished, or when I thought it was finished, I still felt that the final shape seemed unrelieved. Looking around, my eyes settled on a workshop participant with a cane and an endearing hunch to her shoulders. She was immediately integrated into the left figure. The small sliver of relief space between the cane and the figure was vitally needed.

Can you combine more shapes in your painting for an even stronger composition? In *Three Bretonnes*, the white hats presented another pleasing pattern. Even the myriad bodies in the procession were blended together. Now pause and try to imagine the painting with each of the women depicted separately and the simple silhouettes of their clothing painted in many different values or colors. Or picture all the people in the procession individually described. A pattern means seeing a larger overall design, one that is powerful and more arresting than separate subjects.

USE A PATTERN FOR UNITY

When you join shapes of similar values (but different hues) and continue the pattern as long as possible, you unify and collect cluttered or floating shapes. The colors of each shape may be different, but the value can be kept compatible to unite them into a larger underlying pattern. If you took a black-and-white photo of your scene to reduce the colors into values, you would readily see the pattern.

THREE BRETONNES SKETCH
watercolor on Arches 140 lb. hot-pressed paper, 11½″ × 7½″ (29.2 × 19 cm), collection of Alfred and Meta Bains.

THREE BRETONNES
watercolor on Arches 140 lb. cold-pressed paper, 21″ × 15″ (53.3 × 38.1 cm), Charles and Emma Frye Museum, Seattle.

In both the sketch and the final painting, my interest was in creating an arresting pattern. The three figures, the white hats, and the background procession have all been simplified to lend emphasis to the overall design.

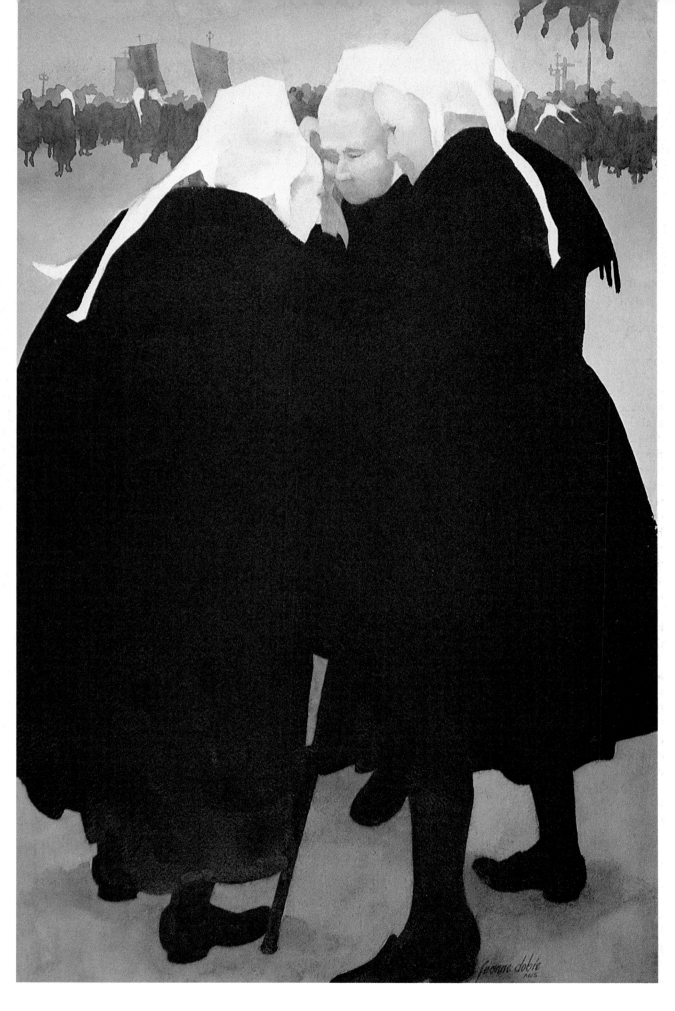

WARM SUN
BY REX BRANDT, NA, AWS, DF
watercolor on Arches 140 lb. rough paper,
14" × 20" (35.6 × 50.8 cm), collection of Nell Storer.

Patterns can be created through color as well as shape. Here the artist has skillfully woven a color pattern so powerful that it complements the figure and becomes an interest in its own right.

Working with a pattern counteracts the tendency to paint shapes one at a time, to see all the distracting details, and to add all the minute changes in values. One of my students confessed that she took off her glasses to avoid seeing everything. She now paints the blurred watercolor world in larger, bolder patterns. Don't let your eye be stopped at the edge of a house because you perceive the house as an object. See it as part of a larger pattern. Then paint the larger pattern.

Colors, too, can be commingled or grouped together for more impact. In the painting *Warm Sun* by Rex Brandt (above), a pattern of color plays the starring role and leads the viewer through the composition. Bright accents are skillfully positioned within a forceful and highly distinctive structure. The impact is much stronger than if the artist had painted the numerous colors as they actually appeared, scattered throughout the scene.

A pattern does not infringe on your individual way of painting, instead, it gives you a stronger foundation. You can choose to leave the shapes, values, and colors in their pure state and enjoy the interplay of color patterns or the reactions between shapes. Or you may prefer to translate them into recognizable subjects—green shapes into field patterns, a gemlike orange accent into a rooftop. You pour so much of yourself into creating a work of art—be sure to design a good pattern to showcase it!

CONCLUSION
Unlocking Your Creativity

HAWAIIAN TUTU
BY SUSAN MCGOVNEY HANSEN
watercolor on Fabriano 140 lb.
cold-pressed paper,
15½" × 13" (39.4 × 33 cm),
collection of the artist.

The goal of a painting is not duplicating the subject, but adding an intangible quality called "content." Color can contribute to your painting's meaning by conveying your reactions to the subject. In this sensitive portrait of a Hawaiian grandmother (tutu), the artist uses a soft color palette to describe her feelings.

D o YOU methodically turn out good paintings? If so, then you are not *reaching,* stretching yourself; you are merely working within your capabilities.

Too often, artists adopt a style or a technical method that traps them in a standard approach. They begin a painting by considering how best to paint the scene in watercolor, oil, or whatever, rather than with an idea or concept. The goal is to develop not a way to paint, but a way to think, interpret, and create. Each painting should be a unique experience, leading you to new ways of seeing.

The viewer should be aware of what you are expressing and not how expertly it is expressed. We are not simply watercolorists, oil painters, or whatever—we are artists. Can your painting transcend its medium? Does it rely on running washes, special effects, and technical tricks, or do you employ your medium to best convey your interpretation? Don't aspire to be a technician. Aspire to be an artist!

As a juror, I look for artists, not merely well-executed paintings. Have you ever wondered why sketches are often better than final paintings? When we sketch, usually in limited time, we unconsciously seize the large, major components, which are the basis of a stronger, more forceful composition. Later, when the final painting is executed in the studio, the tendency is to lose the original essence by adding all the extras and breaking up the solid shapes into disjointed smaller areas.

Try to keep your ideas alive throughout the painting process. Too often we affix the final painting in our minds. Instead, let your painting grow, gradually acquiring form and personality, like a developing child. An idea or concept is malleable, pliable. Your job is to nurture it, enhance it, and guide it to maturity. Keep your painting susceptible to your reactions until the end.

Your art should be as individual as your handwriting. Just as no two people are alike in this world, no two artists should paint alike. Everything that makes you different—your background, your philosophy, your associations, your experiences, your goals—all these things should be part of your art, making it unique.

At the end of a workshop, I leave my artists with this parting thought:

Have you ever looked into a lake or pond or even a rain puddle and discovered with surprise that the reflection looks better than the actual scene? Something indefinable happens when the subject is transposed. It is not quite the same as the scene; it is an "image" of the scene. When we, as artists, view a landscape, our minds also act as mirrors, reflecting what we see much like the lake or pond. Therefore, to be creative, we should paint the *reflection* in the mind, and not the scene.

INDEX

THIS IS NOT THE END, BUT THE BEGINNING
BY BOB PHILLIPS
Opulent Order of Practicing Scribes,
mixed media on Arches 90 lb. hot-pressed
paper, 14″ × 16″ (35.6 × 40.6 cm).

Edited by Sue Heinemann and Bonnie Silverstein
Designed by Bob Fillie
Graphic production by Ellen Greene
Text set in 10-point Palatino